Stanley Morison

His typographic achievement by James Moran

Visual Communication Books
Hastings House, Publishers
10 East 40th Street, New York 10016

First edition 1971
Published in the United States by
Hastings House, Publishers, Inc.

Library of Congress Catalogue Number 75–159047
ISBN 8038–6706–9

Designed by Herbert Spencer and Hansje Oorthuys
The text has been set in Bembo, Monotype Series 270
and the headings in Times Semi Bold, Monotype Series 421
Made and printed in Great Britain by
Lund Humphries, Bradford and London

The photograph on page 1 is of Morison in his
Fetter Lane office in 1933.

Contents

Author's Apology & Acknowledgement

This book is sometimes critical of its subject, and I would therefore like to make it clear that in my dealings with the late Stanley Morison I always found him courteous and helpful. I knew him only during the last fifteen years of his life, and met him most often between 1953 and 1963. I learned from him a certain amount about his background and origins, which is not available in published works. Beatrice Warde was originally responsible for introducing me to Morison and with her I worked and corresponded until the end of her life. She gave me additional facts about Morison's life when, during the first months of 1968, I was writing the special issue of the *Monotype Recorder* devoted to Morison.

Until I began investigating his life and works in some detail I accepted most of what Morison wrote about his own achievements, although I was puzzled at times. In the talks with Beatrice Warde, she volunteered, but in so oblique a fashion that, at the time, I did not realize the significance, that among the research she intended to undertake in her old age was an investigation of Morison's writings. I took it that she was merely going to expand some of his findings, but, looking back, I think she meant to enquire carefully into Morison's claims in relation to the 'Garamond' type, but was too loyal to Morison to say so openly. I still do not fully understand the Morison-'Garamond' situation, but I hope I have managed to throw some light on it in this book. I have not changed my mind about Morison's stature as a major figure in the history of printing (if I had, I would not have undertaken to write this work), but coming upon various odd facts and contradictions, I have thought it my duty to report them, in an endeavour to provide as objective a study of Morison as possible. Readers will form their own judgement as to whether or not I have succeeded.

I am greatly indebted to a large number of people who have provided information about Morison, some of it for my earlier monograph, but as this has also been found useful in compiling the present work, I would like to take the opportunity of thanking those who helped me on the earlier occasion, some of whom have expanded the material they gave me. Sadly, a number of them have died since I first began my investigations. I would also like to thank those who have been good enough to reply to my more recent enquiries.

My warmest thanks are therefore due to John Dreyfus, Walter Tracy, Allen Hutt and Harry Carter for typographical guidance, and to Alick Dru for help in the fields of theology and sociology, and to W. Turner Berry, R. K. Browne, Sir Patrick Bishop, Mrs R. Bradbury, Anthony Bell, Charles Batey, T. F. Burns, Nicolas Barker, R. C. H. Briggs, Christopher Bradshaw, J. Charlton, Brooke Crutchley, Douglas Cleverdon, Will Carter, Arthur Crook, Allen Campbell, John Carter, Bernard Dunne, W. R. Easthope, Alfred Fairbank, H. R. Finberg, Livia Gollancz, Ashley Havinden, Hector Hawton, the late C. W. Hobson, Ellic Howe, the late Eric Humphries, Basil Harley, John Tarr, Ernest Ingham, Herbert Jones, Alan Jones, the late Daniel Longwell, the late Victor Lardent, Sir Francis Meynell, Jack Matson, G. W. Ovink, R. Palme Dutt,

Graham Pollard, Reynolds Stone, Herbert Simon, the late Timothy Simon, Rollo Silver, Tom Scott, A. J. P. Taylor, Col. Oscar Viney, the late Canon John Vance, James M. Wells, Hugh Williamson, and Berthold Wolpe. I apologize if I have, inadvertently, omitted the name of anybody who has been of assistance to me.

I am nevertheless responsible for the contents of this book, and any errors or failings, which no doubt the critics will point out.

James Moran

Introduction

During the last thirty years of his life Stanley (Ignatius) Arthur Morison (1889–1967) was accepted as the most outstanding typographical authority of the day, and since he was a man of distinctive character, possessed of forceful views and a wide-ranging mind, he did not fail to make a powerful impression on the specialized world of printing and publishing, in which he exercised considerable influence.

His friends cherish memories of the Johnsonian, jovial, table-thumping, argumentative 'S.M.', whose breadth of knowledge was so impressive in a mostly self-educated man; but, in time, these memories must inevitably fade, and new generations of typographers, printers, and publishers, less concerned with his personality than were his contemporaries, will want to know the extent of Morison's contribution to their art and industry.

For it is in this field of endeavour that Morison's name will live, although his interests and activities covered a wider span. Morison was a fascinating human being, but his political views, however forcefully expounded, were not uncommon; he would not have claimed to have been a major liturgical authority, and his incursions into the wider sphere of national affairs might justify a brief mention in a history of recent times, but no more. This book will tend, therefore, to concentrate on his typographical achievement, although it is impossible, and, indeed, undesirable, to try to separate his many activities. The extraordinary story of how this man came to occupy the position he did cannot be appreciated unless some reference is made to his origins, his religion, his views, and even to his failings; and his achievement will be better understood if it is looked at against the background of what went before. The narrative, therefore, does not begin with Morison, but with the situation in printing and typography at the time of his birth.

Future generations will want to know exactly what Morison was professionally. He disclaimed the description of 'typographer', in the modern use of the word. At various stages of his life others called him a printer, a designer of printed matter, 'typographical artist', or even 'our layout artist', but he preferred to be known as a 'typographical consultant'. Nevertheless, John Dreyfus has made a case for Morison as typographer by reference to Joseph Moxon's well-known statement in his *Mechanick Exercises* (1683–4): 'By a typographer I do not mean a printer, as he is vulgarly accounted. By a typographer I mean such a one, who by his own judgement, from solid reasoning within himself, can either perform, or direct others to perform from the beginning to the end, all the handy-works and physical operations relating to typographie.'

From 'solid reasoning within himself' Morison directed the work of others. He was not a particularly good artist in the sense that he could draw a beautiful and accurate type layout in the manner of a Bruce Rogers; what mattered to Morison was the idea, and he conveyed this to a skilled compositor, sometimes in the most rudimentary fashion. The results were often brilliant, being the

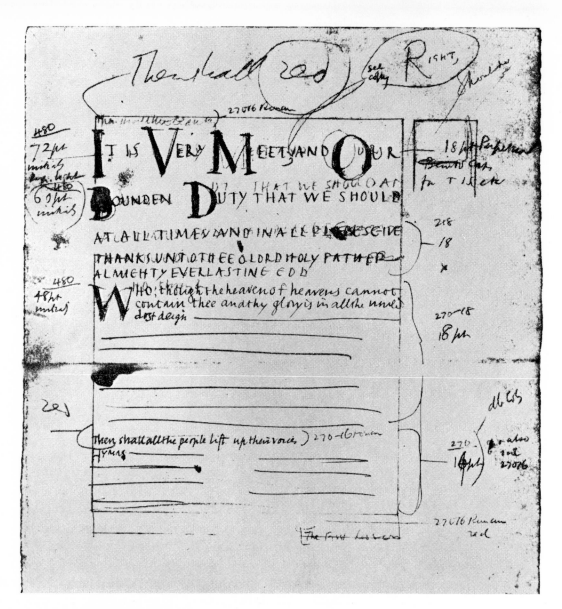

Then shall the Dean say:

I<small>T IS</small> V<small>ERY</small> M<small>EET</small> R<small>IGHT</small>
<small>AND</small> O<small>UR</small> B<small>OUNDEN</small> D<small>UTY</small>
<small>THAT WE SHOULD AT ALL TIMES
AND IN ALL PLACES GIVE THANKS
UNTO THEE O LORD HOLY FATHER
ALMIGHTY EVERLASTING GOD.</small>

W<small>HO,</small> though the heaven of heavens cannot contain thee, and thy glory is in all the world, dost deign to hallow places for thy worship that the majesty of thy glory may be revealed and gifts of grace poured forth upon thy faithful people.

T<small>HEREFORE</small> with Angels and Archangels, and with all the Company of Heaven, we laud and magnify thy Glorious Name;

Evermore praising thee, and saying:

H<small>OLY, HOLY, HOLY, LORD GOD OF HOSTS, HEAVEN AND EARTH ARE FULL OF THY GLORY: GLORY BE TO THEE, O LORD MOST HIGH.</small> Amen.

THE FORM AND
ORDER OF THE SERVICE

THAT IS TO BE PERFORMED
AND THE CEREMONIES THAT
ARE TO BE OBSERVED IN THE

CORONATION
OF THEIR MAJESTIES
KING GEORGE VI
&
QUEEN ELIZABETH

IN THE

𝔄𝔟𝔟𝔢𝔶 𝔠𝔥𝔲𝔯𝔠𝔥 𝔬𝔣 𝔖. 𝔓𝔢𝔱𝔢𝔯

WESTMINSTER

ON WEDNESDAY
THE 12TH DAY OF MAY
1937

CAMBRIDGE UNIVERSITY PRESS

Left: Morison's rough sketch for a page of prayers for the opening of Liverpool Cathedral, printed in a limited edition in 1942, and the final printed page below.

Above: double-spread title-page (original size 9¾ × 7¼ in.) designed by Morison, with wood engraving by Reynolds Stone. The larger size of capitals are set in Perpetua, the smaller in Bembo.

product of reasoning power rather than a pedestrian copying of letterforms on to a layout pad. He would also alter proofs until a desired result was achieved. This technique earned him the soubriquet 'The Printer's Friend' among the compositors of the former private printing office of *The Times*, but it is not a practice which can be commended to either the working typographer or aspiring author of today.

Allied to Morison's thought processes was his absorption of the great traditions of printing, which gave dignity and sometimes magnificence to his productions, though not to the extent of restricting him when he felt a totally new approach was required. There was, therefore, no dichotomy in Morison's output, although, superficially, there might appear to be so. The violent, yellow book jackets designed for Gollancz rub shoulders uneasily with, say, the dignified title-pages of the Coronation service books, but they were all part of the process of excogitation – the finding out by thinking – which characterizes Morison's work.

As an exponent of formal calligraphy, Morison was not really outstanding, and in later years his failing eyesight did not permit of close work. In any case, it was not his *métier*, as he was much more at home with the chancery italic, which he adapted for his own personal use, after experimenting with a number of hands. Morison's script was at first neat and careful, later becoming fast and highly individual, but legible and immediately recognizable.

Although he possessed creative sensitivity, Morison was not an artist-craftsman of the standing of those with whom he worked. If he had been, the world might

have been the poorer, since his role, as it worked out, was to be a much wider one, involving the encouragement and guidance to creative workers and, equally important, to be the persuader of commercial interests, and the organizer of the manufacture of an outstanding range of typographical material.

It is to Morison, the typographical provider, that one must turn to find the historical figure, one whose activities change the course of human affairs, even imperceptibly. His memory is not well served, however, by the misleading impression that he was an isolated phenomenon, or even that he was a typographical pioneer.

The making of type is only a means to an end – the printing of a communication meant to be read. Nevertheless, the type-face (the image on the page) is an important factor in this process, because if the design is poor, if it is illegible or unreadable, communication is impaired and the object of the printing is rendered useless. Recognizable alphabetic characters are the result of a complicated process of development, but the basic forms are now acceptable to the general run of readers, however much *avant-garde* designers may dislike this fact. When, therefore, one speaks of reviving type-faces of the past, or of designing new ones, certain mental reservations are required. Ignoring the manufacture of archaic types for printing antiquarian studies, the intelligent reason for reproducing any early type-face is because it approaches a high standing of legibility and readability. In other words, it is not important when a type-face was designed if it meets with the modern reader's approval. Since, however, in the past, type-faces might incorporate conscious archaisms or distortions arising from primitive manufacture, the case can be made that a handsome type used in early printing is positively improved by the elimination of oddities, altered to suit a new set of printing requirements, and manufactured by advanced engineering techniques.

Rarely does an artist design a completely new type-face, if he adheres to the conventional alphabet and is conscious of the requirements of the human eye, which do not change. Attempts to revolutionize type-design completely – that is, by departing from the conventional alphabet – are made from time to time, but are never acceptable to the general reader. Bizarre display faces for advertising, on the other hand, may have a limited appeal for their attention-attracting qualities, but even these cannot depart too far from the norm without being self-defeating.

By the time Morison became active in printing there was nothing particularly novel in reviving type-faces of the past, or in the commissioning of new ones, but the combination of Morison's research and his harnessing of a composing and casting system to this process made all the difference qualitatively and quantitatively. The ubiquity of the Monotype matrix spread Morison's creations, if they may so be called, much more extensively than type cast by individual typefounders, and certainly to a much wider audience than could be reached by a few specially designed founts for private printers.

At the same time, Morison was not alone in the field, and he could not have done what he did without the inspiration of his predecessors. What is probably true is that Morison's influence was more pervasive than, for example, that of his nearest counterpart in Britain, George W. Jones, Linotype's consultant, because of his deeper research and his extensive writing and editing. Two other factors should not be discounted: the subtle and continuous publicity by Morison's close companion – Beatrice Warde – and his own association with opinion-makers in matters of typography, who were not exclusively the master printers, with whom Jones was accustomed to mingle, but rather the new, young book designers,

THE
intelligentsia
OF GREAT BRITAIN
BY DMITRI MIRSKY
(ci-devant Prince Mirsky)

including estimates of

Bernard Shaw	Eddington
H. G. Wells	**Jeans**
J. M. Keynes	Cole
G. K. Chesterton	E. M. FORSTER
Bertrand Russell	*Lytton Strachey*
D. H. LAWRENCE	T. S. Eliot
Aldous Huxley	Dean Inge
Virginia Woolf	Laski
WYNDHAM LEWIS	**MALINOWSKY**
Middleton Murry	

&c. &c.

We (the publishers) ask our friends to forgive us:
we don't agree with **everything**
~~Prince~~ MIRSKY says. 👉

22 Park Crescent, W1

Dear Simon: It was very good of you & your Mrs. (to whom my regards & recollections — still distinct through the mists of time) to send me such a nice box of Montrachet & apple-blossom with your kind congratulations.

Gratefully yours

Stanley Morison

May 7 1939

Oliver Simon Esq

14

Dear Hutt : Many thanx.
I didn't think it a good
article - or, in fact, any
good. But R.B.F. would
not be put off & nagged &
nagged until I had to do
something. this was the
result. Good mis print
(or error rather) "Wet"
for "web" somewhere at
the point of defining the
zenith of printing reached
when the rotary perfecter was
communicated.

S.M

8. 6. 56

advertising men, journalists, artists, and letter-cutters.

Nor did Morison restrict himself to any particular period of printing, whereas Jones kept close, most of the time, to a style reminiscent of the early sixteenth century, which, although combined with impeccable press-work, in the minds of the unthinking may have associated him with archaism. Jones, shrewd businessman that he was, could also act the aloof patrician, whereas Morison, despite appearances to the contrary, was very much aware of the need to go down into the market place.

The importance of the new breed of book designers, typographers, and layout men cannot be underestimated. John Johnson, Printer to the University of Oxford, admitted in a 1933 lecture: 'Within the council meetings of the Master Printers of commerce I have never yet heard the design of a type-face mentioned.' A

minority of printers, including those, such as Oliver Simon, who had come into the industry from the outside, was aware of the importance of type design, but it was the publishers and advertising designers who set the pace. In the 1920's a new climate began to be created, and, as a result, there was a transformation in the look of printed matter in no more than twenty years. Morison's contribution was important, for parallel with his work as typographical consultant to the Monotype Corporation, to the University Press, Cambridge, and to *The Times* newspaper, he maintained a steady flow of books, pamphlets, and articles on typography, which were read by the growing band of enthusiasts who could translate his ideas into fact.

Morison was not without his failings, one of which was to present himself as more influential in his early days than he actually was. This not unusual human tendency is not very reprehensible, and in Morison's case may have been allied to a desire to establish some unifying philosophical principle in typographical development, of which he considered his own achievements a part. On the other hand, it may be that all human activity, including the way in which alphabetic characters are formed, is the result of free will and largely accidental, and a study at the relevant times of Morison's work gives the impression of an eclectic approach, rather than as being part of a comprehensive plan. This makes his achievements none the less impressive, and, from a practical point of view, neither enhances nor diminishes the utility of a particular type-face, but Morison's interpretation of his work does pose problems in the wider field of typographic studies.

Morison was, psychologically, very complex and his restless mind was for ever looking for certainty, whether it be about a particular kind of type or the greater meaning of life. He accused his friend Eric Gill of being a philosophical anarchist, because this is what he feared in himself. This fear of having to accept that life, after all, might be a series of accidents could have driven him to the fairly common extreme of trying to fit everything into a predetermined pattern. The dread of anarchy within himself caused him to seek the discipline of the Catholic Church, with which he had a complicated relationship and which did not preclude for some time a contradictory flirtation with Marxism.

The outcome may be judged. It was entry into the Catholic Church which brought him into a new atmosphere, from which his interest in typography stemmed, and from this into the world of printing and publishing, in which he was to make his name.

Above: a Morison attempt at formal lettering for Canon John Vance (facsimile).

The background

Stanley Morison was born in the year 1889, at a time when the quality of printing was at a low ebb. A number of inter-acting tendencies had brought this about – rapid technical development from the middle of the nineteenth century; a great increase in trade and commerce, and hence in advertising; political and social changes in attitudes towards a free press; and the increase in elementary education, all tending to make printing a rapid, cheap process, in which there was neither time nor inclination to pay attention to the appearance of the product. The task of a group of men, of whom Morison was one, in the first quarter of the twentieth century was to show that mechanical progress and mass demands were not incompatible with quality.

Printing machine rooms had been transformed in a comparatively short space of time after the repeal of the restrictive 'Taxes on Knowledge' – the advertisement tax in 1853, the newspaper stamp duty in 1855, and finally the paper tax in 1860. Hand-presses gave way to the cylinder machine, although this was hardly a new concept, having been invented by Friedrich Koenig in 1811. It had been, however, ignored for better quality work, being looked down upon by craft-printers, who regarded it as a 'type-smasher'. The repeal of the taxes, and the consequent founding of new newspapers and competition for readers, stimulated the demand for cylinder presses, which manufacturers were able to meet with improved versions. As duty no longer had to be paid on each ream of paper, the way was also open for the technique of feeding paper from the reel and the development of the modern rotary press. From 1865 onwards, cheap, mechanically made paper, based on wood pulp, was increasingly in use, and mechanization reached the typefoundry, even if it took time to penetrate the composing room. British typefounders had been slow to adopt machinery, and only hand-moulds had been shown at the Great Exhibition of 1851. Complaints that Britain was behind America led to the adoption of the Bruce casting machine by leading firms. The Bruce type of machine, invented by David Bruce, of New York, as early as 1838, was known as 'pivotal', but though it speeded up the production of type, it was still necessary to break off the jets and dress the types by hand after casting. The first machine to cast ready-dressed types was the Johnson and Atkinson design, patented in 1859.

The fastest type-casting machine was the rotary version, invented by Frederick Wicks in 1878. It was designed to furnish type in the very large quantities required by the growing newspaper industry, and for the primitive composing machines which gradually appeared.

The effects of the Elementary Education Acts of 1870, 1876, and 1880 were beginning to make themselves felt by the time of Morison's birth, and the demand for cheap, easily assimilated periodical literature was being met by George Newnes (1851–1910) who founded *Tit-Bits* in 1881, by Alfred Harmsworth (later Lord Northcliffe) (1865–1922), who copied Newnes by starting *Answers* in 1888. They were followed by Cyril Arthur Pearson (1866–1921) with *Pearson's Weekly*.

The combination of speed, cheap paper and ink, fierce competition and a newly literate public could hardly have made for high standards of printing, and there is little indication that the new entrepreneurs cared much about this aspect. The rapid development of advertising had led to the debasement of letter forms, and most typefounders by this time were having to consider the quantity rather than the quality of their products.

It would be misleading, however, to assume that all printing in the Victorian era was of low quality, since the technical changes did not make themselves felt in some quarters, and a select number of printers and publishers continued to cater for a small, cultured minority, which adhered to the older, more classic ideas of what printed matter should look like. Good printing and typography never died out completely, and design-conscious publishers could still find enough printers with whom they could co-operate, and thus begin the gradual moves towards type-face reform.

Since mechanical typesetting was in its infancy, these first tentative efforts in reform were applied to founders' type, but as the major aspect of Morison's career was the combination of the composing machine with superior type design, the background to mechanical composition should not be overlooked.

In contrast to the machine room, mechanization had made little headway in the composing rooms, the majority of which hardly differed technically (and often in appearance) from those of 400 years earlier. Except in a few houses, composition was by hand from founders' type. As late as 1914, the great majority of members of the Typographical Association (the English provincial printing trade union) were hand compositors. The early composing machines, which set founder's type (to be distributed after use) made but little impact on the general printing trade, and were mostly confined to the newspaper section. The rare attempts at mechanical composition in the book and periodical field had been abandoned by 1889. While machines for setting foundry type continued to be made for several decades, those printers who were really interested in mechanical composition, and they were mostly newspaper proprietors, waited for a more advanced combined composing and casting machine, based on the matrix and not on the type sort.

Dr William Church, first known patentee of a composing machine (1822), had indeed reasoned things out and had proposed not only a composing apparatus but also a typecaster which could feed it with newly cast types. If Dr Church's proposals had been adopted, the few pioneers would have avoided the tedium of distribution, and the hindrances caused by dirty, sticky type, which were among the drawbacks of early composing machines. By 1889, John Walter III, of *The Times*, and his engineer, John Cameron Macdonald, had caught up with Dr Church's ideas and in consequence *The Times* was set by a Kastenbein machine, fed daily with new type cast on the Wicks rotary typecaster. This was a technical step forward, but *The Times* still had to obtain its matrices from the typefounders. It did not go in for cutting its own types, nor would it have been thought desirable to do so.

The machine the newspapermen were waiting for came, after a great deal of experiment, in 1885, with an improved version in 1888. Known as the Linotype, it was the invention of Ottmar Mergenthaler, who had emigrated from Württemberg to the United States in 1872. Basically, the Linotype stores a large number of single matrices in a sloping magazine. These are released by keyboard action and assembled in words, separated by space bands. The completed, justified line is brought to the orifice of a mould and there cast into a type-high slug, or

line of type. After casting, the line of matrices is raised to a distributor and each is released back into its own channel in the magazine.

Another system, known as the Monotype, was invented by Tolbert Lanston, in Washington, D.C., in 1887. This consisted of a keyboard for punching perforated paper and a mechanism which made types and spaces and composed them in justified lines according to the perforations in the ribbon. In 1890 Lanston adopted the use of adjustable moulds on a wheel. Metal was injected in rotation as the dies were centred over the moulds, but this idea was dropped in favour of the matrix-case when, by 1894, Lanston's bankers began testing the market. The Monotype system consists of two units – the keyboard and the caster. Cast types are ejected singly and assembled in a channel until a line is completed. In 1897 a British company was formed to purchase all but the American rights of the system. The first Monotype was installed in Britain in 1898, but the first with the larger matrix case began work in 1900.

Neither the Linotype nor the Monotype could have become a commercial proposition without the aid of another mechanism. The great number of matrices required by these combined composing and casting machines could not possibly have been produced by the hand-punch method. There existed, however, a punch-cutting machine, invented in 1884 by Linn Boyd Benton to aid him in his patent for self-spacing types. By agreement, this machine was used for making punches for the newer composing machines. It is odd that Benton did not foresee that by this action he was signing the death warrant of the typefoundries and, in particular, the one with which he was associated – American Type Founders. Perhaps the threat was not immediately apparent, as the composing machine companies did not attempt to design their own type, relying on copies of those available from the typefoundries. It was when they began to enter the field of type-design that competition became fierce, and ATF eventually went under (to rise again, but not wholly based on type manufacture.)

The standard of typographical taste in the year 1889 showed a slight improvement on that of a few decades previously, of which Morison wrote: 'From 1820 to 1860 printing was undoubtedly in a sorry condition at home and abroad.' With a few exceptions, printers used debased forms of 'modern' type-face, thin and attenuated, which were not assisted by poor printing. Yet these faces had a noble ancestry, being derivatives of the *romain du roi* cut by Grandjean for Louis XIV, and of the types cut by Fournier, Didot, and Bodoni, characterized by hair-line serifs and contrast between thick and thin stems. In the hands of a William Martin, who cut a 'modern' for the printer William Bulmer, the effect could be handsome, but, again, in Morison's words: 'After Bulmer came a deluge of modern faces, all possessing extremely thin hair lines and all now repugnant to our taste . . .' As well as these modern text types the printer had at his disposal all kinds of bizarre display faces, which he sometimes used with reckless abandon. These types arose from the competition of the rival process, lithography, with its freedom for the artist to draw elaborate letter forms; from the improved techniques of letter-casting, and from the demands of a newly industrialized society. According to Charles Jacobi's *Printers' Vocabulary* (1888) there was even one called 'Chaostype', an appropriate description for most of them.

Part of the improvement noticeable by 1889 came from the interest of a few publishers and printers in the type-faces used in the period before 'modern' had become so dominant. William Pickering, a publisher of taste, had, as early as 1827, had a book printed for him by Thomas White, of Johnson's Court, 'in the

types of John Baskerville' – in reality an imitation of Baskerville cut by Moore and Fry's typefoundry. Pickering later met Charles Whittingham, the younger, a printer, of Took's Court and the Chiswick Press. Together they worked on a number of books, reviving Caslon's 'old face' in 1840. The term 'old face' arose to describe roman faces derived from those cut by Francesco Griffo for Aldus Manutius at the end of the fifteenth century, which modified the first or 'Venetian' romans, which often had flat serifs and little differentiation in the thickness of strokes. Old face usually refers to types with bracketed serifs and oblique emphasis.

The example of Pickering and Whittingham was followed by others, but 'Old face' was considered suitable for certain classes of work only – devotional books and those with a period flavour – and not for the ordinary run of printed matter. The trend was, however, sufficiently impressive to attract the attention of the typefounders of the 1860's. They either, as in the case of Figgins, began to revive their original romans, or, as with Miller and Richard, to cut adaptations known as 'old style'. But there they stopped. No effort was made to investigate the origins of type. The typefounders merely saw that those designs they curiously described as 'medieval' pleased what they called the *literati*, and if Miller and Richard and Caslon could make a profit out of this requirement then the others saw no reason why they should not follow suit.

The only attempt to copy an early type design (apart from Figgins' cutting of a Caxton type to reprint a Caxton book) was made by the Chiswick Press, which in the 1850's commissioned an obscure founder, William Howard, to copy a type-face used by Johann Froben, of Basle, in the early sixteenth century. This type, known as Basle roman, had fifteenth-century characteristics, and was pre-'old-face'. Little used by publishers, it later attracted the attention of William Morris, whose interest in printing had been aroused by his neighbour, Emery Walker. In the year of Morison's birth he had two books printed by the Chiswick Press in the Basle type, but he soon wanted to have complete control of the printing craft under his own roof. He therefore founded the Kelmscott Press and went about designing his own type-face.

It was Morris, the champion of hand-crafts, who introduced photography into type-design, with both its advantages and disadvantages, and it is interesting that he, perhaps unconsciously, arrived at the idea that more than direct photography was desirable. Morison, in 1923, had not realized this when he attempted a revival of a 1499 type-face, although the results, as he said, were 'not disastrous'.

In the *Note on his aims in founding the Kelmscott Press*, Morris wrote: 'There was only one source from which to take examples of this perfected Roman type, to wit, the works of the great Venetian printers of the fifteenth century, of whom Nicholas Jenson produced the completest and most Roman characters from 1470 to 1476. This type I studied with much care, getting it photographed to a big scale, and drawing it over many times before I began designing my own letter; so that I think I mastered the essence of it, I did not copy it servilely; in fact, my Roman type, especially in the lower case, tends rather more to the Gothic than Jenson's.'

The inference is that it was a Jenson type which he copied. On 21 November 1889 he had written to F. S. Ellis: 'Walker and I both think Jenson's the best model, taking all things into consideration. What do you think again? Did you ever have his Pliny? I have a vivid recollection of the vellum copy at the Bodleian.' It has therefore been thought that Jenson's *Pliny* supplied the model.

Despite this, S. C. Cockerell in a short history of the Kelmscott Press in Morris's *Note on his aims* wrote: 'Among the first books so acquired was a copy of Leonard of Arezzo's *History of Florence* printed at Venice by Jacobus Rubeus in 1476 in a Roman type very similar to that of Nicholas Jenson. Parts of this book and of Jenson's Pliny of 1476 were enlarged by photography in order to bring out more clearly the characteristics of the various letters; and having mastered both their virtues and their defects, Morris proceeded to design the fount of type which . . . he named the Golden type.' In the *Arts and Crafts essay on Printing*, first published in 1893, under the authorship of Morris and Emery Walker, there is this passage: 'Of Jenson it must be said that he carried the development of Roman type as far as it can go . . . Jenson, however, had many contemporaries who used beautiful type some of which – as, e.g., that of Jacobus Rubeus or Jacques le Rouge – is scarcely distinguishable from his.'

Probably Jenson's type first impressed Morris and stimulated his desire to design a similar type, but he also took something from Jacobus Rubeus. This discursion has been indulged in to underline the difficulties inherent in discovering the exact origin of some 'regenerated' type-faces, particularly when the originator is unclear himself – a situation which will be encountered in Morison's career.

Morris's Golden type, finished in 1890 and first used in his *Golden Legend*, was not faithful to Jenson, as Morris admitted. The great American authority, D. B. Updike, in his *Printing Types* comments: 'If Morris admired Jenson's fonts, it is hard to see why he did not copy their best points more closely. One has only to take a Kelmscott book and compare it with a good specimen of Jenson's printing to see how far away one is from the other.' Updike and others did not like the blackness of the Golden type, but Updike was firmly on Morris's side when it came to the best model for type revival. He wrote: 'Jenson's roman types have been accepted models for roman letters ever since he made them, and, repeatedly copied in our own day, have never been equalled.' This was a kind of typographical Pre-Raphaelitism which prevailed until Morison's arrival on the scene. T. J. Cobden-Sanderson's Doves type was also based on Jenson, and each of the succeeding private press owners felt they had to follow.

Despite these activities by amateurs very little attention was paid by the general printing trade to the design of type. The typical printer of 1889 had three kinds of type – 'modern', 'old style', and 'fancy'. The body face was designated by the name of the typefoundry, perhaps a number, and its size. The 'fancy' type might well have names, and the one well-known body type with a name – 'Clarendon' – was used as a heavy or bold type, 'Clarendon' and 'bold' becoming synonymous. As an example of the vague and uninformed attitude to type-face design one can take the by no means ordinary printer, Charles T. Jacobi, of the Chiswick Press. In his *Printers' Vocabulary* he could lump together indifferently 'old face type', 'old style type', and 'old cut type'; describe 'Antique' as 'founts of old or medieval character, such as Caslon's', and write of Clarendon: 'a bold or fat-faced type is generally thus described; the older founts were called "Egyptians"'. 'Egyptian' itself received the following notice: 'A fat and ugly-faced kind of type. There is nowadays a larger and more graceful selection of these fancy types to be chosen from'; and 'Modern': 'founts of recent date, the reverse of antique or old-faced type.' If they really had been the reverse of old face they would have looked very peculiar. The odd notion of what 'medieval' conveyed to typefounders was encountered by Morison and Francis Meynell in 1914 when they approached a well-known typefounder for printers' ornaments,

and were told that he could show them no sixteenth-century examples because 'the books were then all written out by the monks'.

A large-scale printing house such as Richard Clay's, of London and Bungay, listing its types in 1887, as often as not left out the name of the typefounder and simply entered, for example, 'small pica' or 'long primer'. It was taken for granted that the prevailing style was 'modern', unless otherwise mentioned – then 'O.S.' would be added – for example 'Long Primer O.S. M & R' – in other words the old style put out by the Scottish typefounder Miller and Richard. Apart from the Clarendons and Egyptians the only types designated by name were those used for special purposes – Ecclesiastic (a black letter for Church work), or those for a particular language – Greek, Hebrew, German or Anglo-Saxon. Occasionally a printer or publisher would have these special-purpose types cut. Clay's had Anglo-Saxon for the Old English Text Society and the Chiswick Press the Caxton for Caxton reprints.

Clay's and the Chiswick Press were not only known for the quality of their work, but as specialists in typesetting. If they were not particularly typographically conscious what of the less distinguished printing houses? For the humble jobbing printer, Crisp's *Business Guide for Printers* (1881) states baldly: 'Letters are either *plain* or *fancy*. The plain includes Roman, italic, old English (or black); all other varieties belong to the fancy sorts.'

An example of the effect of the paucity of good book founts at this time can be seen in the career of Bernard Newdigate (1869–1944) who at one time collaborated with Morison at the publishing firm of Burns and Oates. He was to achieve fame as printer-typographer at the Shakespeare Head Press and as the author of the Book Production Notes in *The London Mercury*. When Newdigate set out to rescue his father's printing firm at Leamington in 1890 the only book types he found were not very inspiring 'old style' and 'modern' founts. He did his best with these until 1905 when he was introduced to Caslon old face. This made such an impression on him that he became a master of its use, and his typographical style was influenced by it for the rest of his life. He was delighted to find in 1920 that the cases of the Shakespeare Head Press were well stocked with Caslon, and many of his best-known productions were set in this type. It is only fair to add that when Newdigate began to appreciate the benefits of the Monotype Corporation's type revivals, he used Garamond, Poliphilus, and Centaur, but he would often revert to Caslon, with which he felt most at home.

While Pickering, Whittingham, Morris, and such figures as Cobden-Sanderson may be said to have given the typographical revival an initial stimulus, it was in the United States that it first began to penetrate the commercial printing field. Why this was so it is hard to determine precisely, but it may be that the greater volume and more advanced techniques of advertising in America had something to do with it. The success of the composing machine in the United States may have also put the typefounders on their mettle earlier than in Britain. Certainly a number of men, some well known, others relatively obscure, were responsible for a major advance in type-design in the first quarter of the twentieth century, and they constituted a direct influence on Morison, who was to carry on their work.

The United States

The first, small signs of interest in type-design in the United States began with the rediscovery of Caslon's faces. Caslon types, or those which closely resembled them, had been the typographic staple for English-language printing in the new republic. Isaiah Thomas, of Worcester, Massachusetts, proudly announced on the title-page of his 1785 type specimen: 'Chiefly manufactured by that great Artist, William Caslon, Esq; of London'. Despite the traditional use – the Declaration of Independence was set in Caslon's types – the influx of 'moderns' gradually drove Caslon out of the type cases of American printers.

In 1859 the Johnson typefoundry of Philadelphia imported Caslon strikes, or perhaps even punches, from England and cast type known as 'Old Style'. The foundry later became MacKellar, Smiths and Jordan, which was one of those which formed the American Type Founders company. Enthusiasts for Caslon types, including Walter Gillis, who wanted to use the types for setting *Vogue*, found 'Old Style' in MacKellar's specimen book and accordingly ordered founts. Another devotee of Caslon, Will Bradley, who established the Wayside Press at Springfield, Massachusetts in 1895, ordered Caslon types from the Dickinson foundry of Boston, and when he received the packets of type the labels were so old that they had faded almost white. Daniel Berkeley Updike opened his own Boston printing office in the same year as Bradley and two years later imported Caslon types from England, continuing to use them for much of the work of the Merrymount Press.

This greater demand for Caslon forced the typefounders to issue their own versions, or import the type from England. A very early attempt was made in 1903 to set Caslon for *Vogue* on the Monotype by using side-hole matrices in the caster, but this was abandoned, and not until 1915 was Caslon set by Monotype in the United States, followed a year later in Britain. The Mergenthaler Linotype company, however, cut a limited range of Caslon for use on its composing machine as early as 1902.

The 'Jenson' revival did not originate with printers but with a typefounder, Joseph W. Phinney, of the Dickinson typefoundry, who, impressed by Morris's Golden type, asked if he could reproduce it commercially. Morris shied away from this suggestion and would not give permission. It then dawned on Phinney that if Morris could copy a Jenson type there was nothing to stop him doing likewise, and in 1893 the foundry, which in the meantime had become part of ATF, issued Jenson Old Style in fourteen sizes. It was closer to the Jenson of 1471 than the Golden type, which is to be expected, considering Morris's experiments, and Phinney even attempted a matching italic. Today it is easy to be critical of Phinney's effort, but, bearing in mind the state of typographical knowledge of the time, it was a brave attempt. Some thirty years later Morison was to find the problem of deciding on italics to accompany revivals of roman faces not easy to solve.

The comparatively little-known Phinney was thus one of the pioneers in the

revival of old type-faces, but a much more famous figure also gave it a stimulus. This was Theodore Low De Vinne, acknowledged as one of the world's most outstanding printers. De Vinne (1828–1914) has many claims to fame, among them as the pioneer of printing on dry paper; for his use of surfaced paper; for his researches into the origins of printing and for his writings on typography, which profoundly influenced Morison. De Vinne became known as a first-class periodical printer and for *The Century* magazine a special type-face was cut – initiating the idea of naming a face after a periodical. Century, commissioned by De Vinne and cut by Linn Boyd Benton, of ATF, was designed to provide a blacker and more readable face than the debased moderns and one more appropriate to De Vinne's improved printing techniques. If anything, Century, which gained popularity as a newspaper face and eventually for headlines, derives from the 'Scotch' faces of the early nineteenth century, which were a sturdier version of the lighter 'moderns'. The hair lines were thickened up and the serifs shortened, the result being a face which provided a more pleasant aspect for the reader than he would come across in most periodicals of the day.

De Vinne also led the movement for simplicity in typography and in the four-volume series, *Practical Typography*, gave advice on choice of type, correct composition, and on the minutiae of book design, which Morison drew upon for his own famous essay, *First Principles of Typography*.

The type-face called 'De Vinne' was not sponsored by the man of that name. Gustav Schroeder, a type-designer of the Central Type Foundry, of St Louis, recut a face of French origin, popularly known as French Elzevir, and renamed it De Vinne in honour of the New York printer. One American writer, Dr James Eckman, sees it as a forerunner of Morison's Times New Roman.

There was a scholarly printer on both sides of the Atlantic towards the end of the nineteenth century – De Vinne in New York and William Blades in London, and both accumulated large libraries of books on printing. There was also a London typefounder, Talbot Baines Reed, who, a rarity in his trade, began to investigate the origins of English types, culminating in his book *Old English Letter Foundries*. Some of De Vinne's books went to the American Type Founders library after his death, and the Blades collection was purchased by the Governors of the St Bride Foundation. Reed's type specimens and some books joined those of Blades in the St Bride Foundation Printing Library. Both libraries, ATF (now in Columbia University) and St Bride's, were to have an influence on the course of Morison's career.

It cannot be said that the taste of De Vinne, Blades, or Reed was very developed. Their own books were printed very much in the late nineteenth-century idiom. Morison, in a striking passage in his book on Reed, explained how the typefounder, because of his membership of a nonconformist sect, did not have the opportunity of being influenced by finely printed devotional works, produced, for example, by the Chiswick Press. The passage, incidentally and perhaps intentionally, also explains Morison's own awakening to good printing.

An examination of De Vinne's specimen books reveals a much wider range of types than that of most printers, including an unusual number of gothic types; but they seem to have been accumulated in the spirit of a collector rather than that of a typographer, and Morison detected a difference between the type collections of De Vinne and Updike. Updike was not interested in the rare and curious; his eye was set on the acquisition of general purpose founts.

Updike, another great American printer, was influential both by his practice of printing and the commissioning of type-faces, and by his writings, which,

again, were a source of inspiration to Morison. The two men came to know each other well, and, in time, Morison was able to persuade Updike that there were sources for reviving type-faces other than Jenson and the Venetians. Updike had two faces designed for his own use – Merrymount, in 1894, by the architect Bertram Goodhue, who was later responsible for the Cheltenham series; and Montallegro, by Herbert Horne in 1904. Merrymount shows the influence of Morris, but Montallegro is really more attractive, being a light roman derived from an early Florentine fount.

Updike's great work, *Printing Types, Their History, Forms and Use*, first published in 1922, was based on a series of lectures he gave as part of a course on the technique of printing in the Harvard University Graduate School of Business Administration during the years 1911–16. Probably nothing comparable to this series could have been held in Britain at the time, and when Updike's book was finally published it was greeted by Francis Meynell as 'the most important book yet published on the history and meaning of fine printing'.

Among those thanked for their helpful criticism in the first edition there appear the names of J. W. Phinney and H. L. Bullen. Phinney has been described as comparatively little-known, by which is meant little-known today. In his time, discriminating students of type-design, such as Updike, were well aware of his work. Bullen, although better known as a person, is often thought of simply as the man who built the ATF typographical library (from the books of which some of Updike's illustrations were taken), but Bullen was, in fact, much more than a librarian. He was intimately concerned with the revival of some of the most important type-faces in the early part of the century and constitutes an important link with Morison.

Updike saw clearly the inherent weakness of 'modern' type-face design, and why it was more liable to corruption than 'old face'. He wrote: 'I have said that Grandjean, Baskerville, Bodoni and the Didots had a mischievous influence on type-forms; for the *derivations* from types that their work made popular culminated in a kind of letter which was capable of greater vulgarity and degradation than was ever the case with older founts. The ordinary English, French or Italian book printed between 1830 and 1850 was very often a cheap and mean-looking production. Perhaps Bodoni and the other great persons were not wrong in their own day; but they put type-forms on the wrong track.'

Printing Types was not without its errors, as Updike was the first to admit in a preface to the second edition in 1937. By that time a great deal of research had taken place on the history of type, and Updike acknowledged the work of Morison, among others. Updike also began to see the merits of types based on other models than Jenson, writing: 'In the light of Mr Morison's researches I am inclined to give a little less credit to Jenson's types and more to the roman type used by Aldus in the *Hypnerotomachia Poliphili* than formerly. He is right in thinking that the Aldine roman capitals, which are not so tall as the lower-case ascending letters (following the traditions of earlier MSS.), give a more harmonious effect to the type in mass than Jenson's capitals from which our modern usage is derived. Morison also contends that the roman types of Aldus represent the beginning of the old-face group and that Garamond in designing his roman types did not model them on Jenson's roman fonts, but on the Aldine letter.'

While Updike refers in this passage to Morison's 'researches', this is probably not the exact word to describe the process. Morison was influenced by many people, and had come to see the superiority of the Aldine letter over the Venetian.

He was introduced to the *Hypnerotomachia* by a British publisher, who suggested reproducing the type in which it was printed; and had learned something about Garamond through the writings of H. L. Bullen. Updike, himself, he had heard of through A. W. Pollard, of the British Museum, and he was one of those who looked forward eagerly to *Printing Types*, which had been announced well before publication. When the book arrived Morison read it thoroughly, and was particularly struck by the section on eighteenth-century French types, which was to colour his thinking later on. Morison's first study in typography, *The Craft of Printing*, he later described as 'pre-Updike' and of only aesthetic value, indicating how important Updike's work was to his own development. From Pollard he also learned of the work of another American, Bruce Rogers. Morison never had the opportunity of meeting De Vinne, but both Updike and Rogers became his friends in time.

Bruce Rogers (1870–1957) is more particularly known as a prolific and original book designer, but in 1901 he produced for the Riverside Press a type called Montaigne, for use in a monumental edition of the *Essays of Montaigne*. In this type Rogers tried to avoid both the blackness of Morris's types and the thin effect of contemporary book faces. Montaigne was modelled as closely as possible upon photographs of a page from Jenson's *Eusebius*, but partly because of the conventional training of the punch-cutter, it was only partially successful in Rogers's view. For the Metropolitan Museum, New York, in 1914, he designed another type-face, Centaur, in capitals only. Once again it was based on Jenson, but this time Rogers had the page enlarged to five times the original size, and worked over the letters with pen and brush for further photographs. These served as models for Robert Wiebking (of the Chicago foundry, Barnhart Brothers and Spindler), who modified some of the designs in an effort to improve them. The face, with accompanying lower-case, was later made available for the Monotype machine.

De Vinne, Updike, and Rogers all fit into the pattern of American type-face development, but the other figure of importance, Henry Lewis Bullen, is one whose influence is still difficult to assess. How much certain type-faces owe to him and how much to Linn Boyd Benton's son, Morris Fuller Benton, will perhaps never be known. But since Bullen was responsible for accumulating the great ATF library, from which he gained a formidable amount of knowledge, it is reasonable to assume that he supplied the inspiration, and Benton the mechanical skill, or, as is often the case, there may have been an interplay of ideas between the two men, which produced the final result in the shape of type-faces for ATF.

Beatrice Warde, Bullen's protégée, maintained that Bullen was the first to realize and exploit the implications of the Benton punch-cutter, and, certainly, Benton senior at first had not understood what his machine might achieve. She also said that Bullen invented the concept of a 'type family', but Dr James Eckman credits Morris Benton with this idea. It may well be that once again Bullen thought the matter out and that Benton put it into practice.

In a way, Bullen was to ATF what Morison became to Monotype – a man with a knowledgeable background, which owed little to school or university; with business acumen (he had been a remarkable publicist and salesman) and with a personality forceful enough for him to be listened to with respect. His closeness to the ATF president, Robert Nelson, during the key period, 1908–26, was also an important factor in his career. Morison, too, never failed to maintain a close contact with the powerful.

Unlike Morison, however, Bullen was connected with a contracting trade, and ended his days, after the death of Robert Nelson, rather sadly. Morison was with Monotype until the day of his death. At one crucial point in Bullen's career, in 1901, he was offered a contract with the Machinery Trust in London. Since the Trust eventually amalgamated with the British Linotype company, it is interesting to contemplate what would have happened if Bullen had taken the job and had harnessed his energy and talent to a composing machine manufacturer rather than to a typefoundry. Morison, in 1921, curiously, said he would have liked to have been a typefounder, but he ended up as a consultant to a composing machine manufacturer, which made all the difference to his achievements.

Bullen had first joined ATF in 1892, and when, three years later, Robert Nelson was appointed general manager Bullen was chosen as general advertising manager. With Nelson's authority he brought together under one roof all the type specimens, books, and literature of the various typefoundries which had been consolidated in the new company. He had an important part in the planning and production of the ATF specimen book, but committee work did not please him and he left the firm in 1901. He rejoined in 1908, and in his spare time built up the library always associated with his name. The date of rejoining is significant because it was the beginning of a period when ATF was having to reassess its role as a supplier of type.

While the Linotype and Monotype had been making inroads into typefounders' profits, the competition was not felt particularly at ATF because the composing machine was not yet considered suitable for display type. ATF poured out tons of type such as Roycroft, and then Cheltenham and Century Expanded. Goodhue's design for Cheltenham, originally intended for the Cheltenham Press of New York, was not strictly followed by the punch-cutters, but the result was to prove exceptionally popular after it was first exhibited in 1903. Why this was so is hard to determine, but once launched it proliferated into a comprehensive family, which had the effect of appealing to small newspapers in particular, which wanted one basic headline type. By 1909 ATF was working full out to satisfy the demand for the display sizes, and Benton's Century Expanded, designed in 1894, also kept the casters busy.

A hint of what was to come was the fact that in 1902 Cheltenham was to be cut for machine composition on the Linotype and for display by ATF. This was an uneasy relationship, and in 1906 the Mergenthaler Linotype brought out a Cheltenham of its own, and the more far-sighted of ATF's directors must have seen the writing on the wall. Another small sign may have been noted, but it would have been difficult at the time to have accurately assessed its significance. Frederic W. Goudy, perhaps the world's most prolific type-designer (more than a hundred designs are known), had produced in 1903 a type, named after his Village Press, for his own use, and launched himself, whether he intended to or not, on a career of type-designing. In 1908 he designed Goudy Light for Monotype – a type which is best forgotten, except that it marked an early, tentative step by the American Monotype organization in the direction of a typecutting programme. In the same year the firm produced Bruce Rogers's Riverside Caslon, and in 1911 Goudy's Forum capitals.

To survive, ATF had to respond to this challenge, and before the entry of the United States into the war in 1917, when its factory facilities were converted to the war effort, ATF began to make the pace in type-design. Century and Cheltenham had, after all, been initiated by outsiders, but in 1911 Benton designed Venetian, an indication that he and Bullen could not get away from the

Jenson influence. As with other companies, when ATF saw a popular design they would try to incorporate it in their programme. Goudy had designed Kennerley in 1911 for the publisher Mitchell Kennerley, and ATF were able to absorb it into their typecutting plans. While this type has some Venetian tendencies, at the same time Goudy was approaching the concept of 'old face' with a degree of differentiation between the strokes, and a shortening of the ascenders and descenders.

Despite this example, when Benton came to design Cloister in 1913 it was based on the inevitable Venetian model. That is not to say that it did not have its good points, and it certainly found favour with its users. Its italic was inferior, being partially based on that of old face. Goudy, on the other hand, was trying to escape from the restrictions of Venetian, and with his Goudy Old Style, which ATF cut in 1915, he used Renaissance lettering as a base, although he later regretted the short descenders. Goudy Old Style was lighter in colour than Kennerley, and showed more differentiation in weight of line, and thus had a better appearance in the smaller sizes.

Mergenthaler Linotype tried to get away from the influence of Jenson as well, and in 1915 produced Benedictine roman and italic. The design was adapted by Joseph E. Hill, working with E. E. Bartlett, Mergenthaler's adviser, from a type they found in various books printed by Plato de Benedictus in fifteenth-century Bologna. It is not a face which would be acceptable today, and the italic, too calligraphic in form, would be unattractive to the modern reader, but it showed that the Mergenthaler adviser had taken the point, and was now seeking inspiration in old books. The firm persevered and in 1919 brought out Elzevir No.3, a composite face produced by Bartlett, and named by trade custom rather than as an indication that it was a face used by the Elzevirs.

While each typefoundry and composing machine manufacturer was experimenting, mostly under the influence of Venetian faces, Bullen had been studying the history of type and had come across Anatole Claudin's four-volume *Histoire de l'Imprimerie en France au XVe et au XVIe siècle*, begun in 1900, the prefatory notes of which were set in a type which excited his interest. Claudin had died in 1906 before the work had been completed, and it was finished by Arthur Christian, director of the Imprimerie Nationale, who had revived the use of historic types held by the French national printing office, including those in the preface of Claudin's work, which were known as the 'caractères de l'Université', and which Christian mistakenly attributed to Claude Garamond.

Bullen thought that ATF should revive the 'Garamond' types, and from 1914 onwards ATF gradually began to plan a series under that name. Bullen carefully noted in later publicity that the matrices in the Imprimerie Nationale were 'reported, upon eminent authority, to have been cut by the illustrious *Garamond*'. Bullen did not himself say they were Garamond's work, and conveyed his doubts to his assistant, Beatrice Becker (later Warde), which in 1926 were to have a startling result. It was thus Bullen who was the first to question the 'eminent authorities' in Paris.

No publicity was undertaken for the ATF 'Garamond', but the fact that during 1916 and 1917 the firm was producing a series of eminent merit leaked out and certain typographically conscious printers 'forced their orders on the Company', to use Bullen's words, as each size was completed. The first of these printers was John Henry Nash, of San Francisco, who was followed by Bruce Rogers, Thomas Maitland Cleland, D. B. Updike, William E. Rudge, and Edwin Grabhorn, all famous names in the history of printing. Cleland was called in to

collaborate with Benton on the design of the type, which represented an important change of approach by type-designers. To Douglas C. McMurtrie, an American typographical authority, it was 'one of the most beautiful roman types ever produced', and he was surprised it had not been copied before.

The war held up production and it was not until about 1919 that the existence of the Garamond series became generally known, and it was another year before limited supplies reached Britain through the initiative of C. W. Hobson, of the Cloister Press. Morison, who joined the Press in the summer of 1921, thus came into contact with the ATF Garamond, and with Bullen's writings about it. The years 1921 and 1922 were the last Morison was to spend with one printing or publishing firm only, and ushered in his new career as typographical consultant, and although he did not visit America until 1924, the work of the typographical pioneers in that country had already made an impression on him.

It is now, therefore, appropriate to look at Morison's early life to ascertain, if possible, how an unprivileged youth with no background in printing, came to occupy the position of typographical arbiter, and one of the most important figures in printing history.

The early Morison

Although Morison always insisted he was a Londoner, he was born in Wanstead, Essex, on 6 May 1889. His close knowledge of North London arose from the fact that his family moved to Hornsey when he was 6 or 7 years old, and that he continued to live there until he was in his 20's. His father, Arthur Andrew Morison, a clerk who became a commercial traveller with Pawsons and Leafs, textile merchants in the City of London, claimed Scottish ancestry (as the Andrew in his name may indicate), but if this were so, it was rather remote, as for several generations the family had lived in Worcestershire. Stanley Morison occasionally mentioned the Western Isles as the ancestral home, but this may have been a family myth.

Arthur Morison was clearly unable to cope with the pleasures of life as a salesman, tended to be impecunious, and was addicted to violent bouts of drinking, and eventually he deserted his family when Stanley Morison was about 15. On 4 June 1887, at the age of 29, Arthur Morison had married Alice Louisa Cole, aged 24, at the Clapton Park Congregational chapel in Hackney, a district in North East London, where they both lived. Arthur Morison described his father as a solicitor, but this was untrue, as he was probably a farmer and small-time merchant. Alice Cole recorded her father as a 'brewer's collector'. Among the witnesses was her mother, Julia Cole.

By 1887 the Congregationalists were a respectable nonconformist religious group, but only two decades before had still been subjected to various restrictions, including exclusion from higher education. They derived from the Independents, followers of Robert Browne, who stood for the voluntary principle, as opposed to every form of absolutism. Like others who oppose absolutism, the Independents, of whom Cromwell was one, during their brief lease of power under the Commonwealth were not particularly liberal towards their opponents. Morison's Puritanical outlook may have been moulded by the background of Congregationalism, of which he later displayed some knowledge, although, owing to his mother's influence, he moved to agnosticism.

For it was Morison's mother, Alice Cole, who proved to be the most important influence in his early life. Her mother and father had lived in Bloomsbury before moving to Stepney, when that area was still considered as a suburb of the City of London, and not part of the 'East End' as it is today. Alice was born on 5 March 1863, in Perceval's Buildings, Whitechapel Road. These buildings no longer exist, but were near to the London Hospital. The family's move may have been in order to be nearer to the father's workplace in the City or to be near other Coles. A Mrs S. Cole made window blinds in a shop near the Buildings. Charles Cole, Alice's father, was described as a broker's clerk, and was probably connected with a brokerage firm in the commodity markets in the eastern part of the City, and as such, on the face of it, a respectable member of the lower middle-class. But there may have been a radical tradition in the family. Charles Cole, of Stepney, was a supporter of the London and Westminster radical tailor, Francis Place, who

continued even in old age to sponsor reform societies. The Charles Cole in question could have been Alice Cole's great-grandfather. The Sydney Arms, Commercial Road, not far from Perceval's Buildings, was one of the main Radical meeting places.

While Francis Place represented the more moderate element in the movement for political reform, it derived, in part, from the Corresponding Societies, which followed the French Revolution, and from the publication of Tom Paine's *The Rights of Man*. Paine's writings continued to be very popular among the radicals and Morison's mother was a devoted adherent of Paine's doctrines and an early member of the Rationalist Press Association.

When Morison's father deserted the family the Coles were as helpful as possible, but in the end Mrs Morison had to earn a living as a shop-keeper in order to feed and clothe her family. Janet Stone, in a radio broadcast devoted to Morison on 2 February 1969, described him as 'a totally working-class youth'. Whether the English passion for subtle class distinctions has undergone change or not in the last fifty years, the Morison family would not have been regarded at the turn of the century as 'working class', no matter how small the income. None of the immediate forebears had been a manual worker, and indeed belonged to that narrow clerical and administrative stratum of society which was terrified of sinking into the working class.

Morison was inclined in later life to say he had only had a 'board school' education, giving the impression that he was sent to some kind of Dickensian charitable institution. More prosaically, board schools were elementary establishments, set up under the 1870 Education Act, which the bulk of town children attended, compulsorily after 1876. Despite lack of material means, Mrs Morison still had a little family influence through her father's connexion with the brewing trade, and Morison obtained a scholarship to the Brewers' Company school, founded by Dame Alice Owen in 1614, situated in Clerkenwell, which would be considered a grammar school today. He was unable to stay long, leaving in 1903, in order to help his mother with some earnings, however small.

In the Edwardian period it would have been difficult to obtain a position as a bank clerk, as Morison did, with a labouring background and a purely elementary education. It is understandable that he may have regretted the fact that he did not attend a university, but, as it turned out, this would have been of little use in the career he eventually followed. While he may have wanted to be a lawyer, as he sometimes said, the experience he received in ordinary commercial life was far more valuable than anything Oxford, Cambridge, or the Inns of Court could have given him.

In later life, Morison became something of a 'character', and it was part of his act to contrast his humble 'working-class' origins with the supposedly affluent backgrounds of his friends, although, in the nature of things, there are more people with poor than wealthy parents. When discussing railways with his friend, Canon John Vance, he remarked: 'You know, Guvnor, I started life on the foot-plate of an engine.' The analogy was not very sound – and a railway enthusiast might have been more informed – as, in his day, it was obligatory for locomotive engineers, trade union aristocrats, to begin their career as firemen.

From the point of view of posterity it was better that Morison did not go on to university, and while his early life was hard, he compensated for any material deprivations later in life, and taught himself more than he could ever have learned in formal educational establishments. At the same time, there was nothing in the family background which might have interested him in printing and

typography; he did not sit beneath the table, like his later colleague, Francis Meynell, while mother and father corrected proofs and discussed literary matters. The districts in which he lived provided no particular inspiration, and his school had no special connexion with the printed word. A minority of boys went on to university, but most were found jobs in 'business' – preferably in the City – and that is where Morison went briefly as a clerk in a mining company – described by him as 'shady', but there is no reason to believe that this was anything but a typical Morison anti-Capitalist epithet. In February 1905 he became a clerk in the London City Mission. Among the jobs allocated to him was to read *The Times* each day, and, in particular, the obituary columns to see who had died, in the hopes that the Mission might benefit from their wills. Morison was therefore enabled to read an expensive newspaper which he was unlikely to have bought personally on his modest salary. His seven years with the Mission, to use his own words, provided him with an intimate knowledge of Protestant varieties, since it was supported by both the established Church and nonconformist sects. In the light of Morison's future development none of them could have had any attraction for him.

Morison followed in his mother's footsteps for a time. Paine was a deist, but it was a short step from deism to rationalism, and Morison began to read Bradlaugh, Huxley, Spencer, and the German Ernst Haeckel, whose *Riddle of the Universe*, a popular rationalist handbook, had been published in England in 1900. Morison had already cut his teeth on James Frazer's *Golden Bough* by the age of 14. The works of Haeckel, his translator Joseph McCabe, a former Catholic monk, and an American rationalist popularizer, John Tyler, were particularly devoured by Morison. Other reading included such rationalist periodicals as *The Literary Guide and Rationalist Review* and the *Agnostic Journal*. In his late teens Morison began to find the rationalist teachings an insufficient guide to life. He was confused; rationalism not only did not answer his questions, but seemed to justify a ruthless indulgence in his own desires, against which the Puritan in him revolted.

He was ripe for a change, but not back to nonconformism, which seemed as drab as the streets in which he had to live. He had no father to turn to, and his mother, the instructor in the doctrines which he wished to give up, obviously could not help. So he found a substitute set of Fathers and a new Mother.

Reading McCabe's replies to Haeckel's critics he could not but notice the amount of attention given to the Jesuits. A very popular reply to Haeckel, *The Old Riddle and the Newest Answer*, by John Gerard, s.j., f.l.s., had run into several editions (two in its first year, 1904). Morison may have been listening to speakers from the Catholic Truth Society in Finsbury Park, near his home, and come to the conclusion that the Catholics might help him. Having no knowledge of the organization of the Catholic Church, but remembering the reference to the Jesuits, he found out that the Jesuit headquarters were at Farm Street, Mayfair, and made straight for what was one of the most charming parts of London, which, in itself, must have been something of a revelation. In Morison's own throw-away phrase he began 'hanging around' the Jesuits, and maintained that his conversion to Catholicism arose from preliminary arguments with a Jesuit priest, a total stranger, smelling faintly of port. The priest was naturally a stranger, but the process could hardly be called 'hanging around' – the Jesuits would be much more thorough than that. The young man was subjected to that process known as instruction, and the principal agent was Father Charles Nicholson, s.j. (1854–1934), who had transferred from Stonyhurst to Farm Street

in 1903, becoming Superior a few years later. At the same time the Jesuits saw in Morison one who might become a valuable asset to the Church, and at Farm Street Morison entered a new world not only of colourful, emotional religious ceremony, but of wide intellectual discussion.

At Farm Street there was a 'Writers' House', where there lived those who specialized in propaganda for the Faith, among them the Father Gerard, who had written the book against Haeckel, and Father Herbert Thurston, who became Morison's particular friend and collaborator. At the end of 1908 Morison was ready for baptism. There was no question of his having been baptized in another Christian church and so the way was open. But Farm Street, at the time, was not recognized as a parish church, and so the ceremony had to take place in the Church of the Assumption of Our Lady, Warwick Street, on 28 December 1908. He was baptized Stanley Ignatius (after the founder of the Jesuit order) by Father Nicholson, and his godfather was Peter Judge. It might be thought that Morison would remember this date, but later he always referred to his submission to the Catholic Church as being in 1909.

Morison's conversion to Catholicism also brought him into contact with a different kind of book and superior printing to that to which he was accustomed. Whatever the philosophical merits of the rationalist literature it cannot be said that, at the time, it was typographically inspiring. Journals were badly machined and set in double column pages, a poor descendant of the eighteenth-century style. The publisher of the *Agnostic Journal* occasionally let an 'art compositor' loose on headings and advertisements, but these merely reflected the depraved taste of the period, and would not have attracted particular attention. The English edition of Haeckel's book, with its feeble title page, full points after every heading, and, despite moderately good machining, set in a thin 'modern' face, with all the composing faults arising from piece work, could not have aroused any special typographical interest either, although Morison may have wondered about the 'slippery Jesuitical politics' it condemned. In contrast, at Farm Street he saw missals such as the *Missale Romanum* ('Parisiis – Typis Adriani Le Clere'), which, although printed as far back as 1864, was still in use. The use of old face, the letter spacing of the capitals, the initials and the rubrication must have been revealing.

About this time Morison made a trip to Belgium, earning the passage money by addressing envelopes after working hours. He visited the Abbey of St André, at Bruges, and was struck by the plain chant, which affected him all his life. The rubricated books of plain chant and liturgical work, set in the best black-letter, and devotional works in old face were in complete and rich contrast to everyday reading matter. Morison explained the reason why only Catholics and high Anglicans tended to come across these books, when writing about Talbot Baines Reed, the typefounder, in these words: 'Industrialization and the rising cost of metal made "fine" printing impossible, except for certain kinds of church work which the Chiswick Press was able to print upon commission in Caslon or other "old face", with Gregorian chant in red and black. Much of this class of work was accomplished in the 1870's and 1880's in a style intended to rival the best missals of Plantin. But it was the style of a pro-papist sect unknown, because obnoxious, to Reed, the needs of whose Congregationalist churches were met by a hymn book . . .' Morison, naturally, knew about the Congregationalist hymn book, but, as a Catholic, discovered a kind of printing denied to Reed.

There was another influence drawing him towards a study of printing. The English Jesuits had a long association with the craft, going back to the sixteenth

century. Henry Garnet, the Jesuit Superior, who was executed after the Gunpowder Plot, had before joining the Society worked with Richard Tottel (the law printer, and Master of the Stationers Company, 1579 and 1584), and, as a Jesuit, had his own secret press in England. The Jesuits maintained for many years a printing press at St Omer, where books in English were printed. Henry Hills, supplier to the King and publisher of Jesuit schoolbooks, took refuge there after the deposition of James II. At the time of Morison's conversion they still maintained a press at Roehampton, run by a Jesuit Brother, John Griffin, and Morison's particular friend, Father Thurston, had written articles in 1902 and 1903 for the American Catholic magazines, the *Ecclesiastical Review* and the *Dolphin*, on 'The Printing Press in the Service of the Church'. There was another influence. After he left school Morison began devoting his Saturday afternoons to visiting the British Museum, where his attention was drawn to early printed books.

So Morison became more than a general reader, as his curiosity had been aroused in the processes by which books were produced and the reasons for the difference in appearance between one book and another. According to Frank Sidgwick, in an article in *The Fleuron*, No.3, Morison combined 'his hobby of printing with clerical duties in the London branch of the Société Générale Bank . . .' For Morison had obtained a new post. Perhaps because of his conversion to Catholicism, working for a Protestant organization had become embarrassing, but whatever the reason, Morison in 1912 became a bank clerk at the French bank in Old Broad Street. Here Morison's streak of Puritanism made him object to the rude stories the other clerks told in the basement office, to which they were confined, and he was generally very unhappy.

Morison's 'hobby of printing' turned to more active interest on 10 September 1912. On his way home from the City on that day he bought at King's Cross station a copy of *The Times* containing a printing supplement. Morison considered it a 'spectacular' production and, on reading it through, determined to study typography and type design. The idea of the supplement belonged to Lord Northcliffe, who on taking over *The Times* had modernized the plant, replacing the Walter rotary presses with Hoes, and the Kastenbein composing machines with Monotypes. An examination of the supplement (which for content is superior to that of 1929, which had an equally important effect on Morison's career) indicates why Morison became so absorbed in it.

Firstly, he was able to obtain some badly needed knowledge of the history of printing: 'From Gutenberg to Morris', 'Early Printing in Scotland', 'Private Printing Presses', and 'Calligraphy and Printing' are among the titles of articles. Others outlined the state of printing in Germany and the United States. He learned, for the first time, of the names of De Vinne, Updike, Rogers, and Goudy. Secondly, there were made available to him contributions on every aspect of printing and the allied trades, including one on 'Typography', which outlined the way in which printing surfaces were prepared, described type and its manufacture, explained the difference between the three main design groups (classed once more as 'old style', 'modern', and 'fancy'), and alluded to casting and composing machines.

Since, eventually, Morison was to be so closely associated with the Monotype Corporation and *The Times* it is interesting to note the feature devoted to the contribution *The Times* had made to the techniques of printing; and another on the situation in 1912, which contains a description of the Monotype keyboards and casters which the newspaper had installed. Morison remembered the

Note. We require at the offices of The Imprint the services of a young man of good education and preferably of some experience in publishing and advertising. We prefer that applications should, in the first instance, be made by letter, addressed to the Business Editor, The Imprint, 11 Henrietta Street, Covent Garden, London.

cluttered-up Monotype advertisement seventeen years later, when the 1929 supplement was in preparation, and which was to have startling results. In the light of Morison's subsequent studies it is important also to note two features: 'Origin and growth of the British newspaper', and one on the University Press, Oxford – particularly the section headed 'Archbishop Laud and Bishop Fell', from which he learned about the types Dr Fell had presented to Oxford, and which he was to study himself years later.

The supplement pointed the way forward for the young Morison. In a reference to Morris there appeared the passage: 'New founts were wanted, and are still wanted, in order that there may be sufficient variety, each good of its kind, for every sort of book.' Morison was to assist in supplying that 'sufficient variety'. The article 'Calligraphy and Printing' must have been of vital interest, not least because of its concluding passage: 'We may borrow a phrase in daily use by printers and urge the hand printer or private printer shall "set the style" for the machine printer in the printing of today and tomorrow. Let him strive after the finest type-faces; for which purpose he shall either be a calligrapher himself, as Morris was, or at least in close association with a calligrapher; for, let us repeat, the designing of beautiful types can only come from the practice of calligraphy. The types from which he sets "at case" shall in turn serve as models of good lettering for the dies and matrices of the composing machine. Let him show, too, how letters and words shall be grouped and spaced; and then his pages shall give measure and margins for those of the machine-set book.'

While calligraphy is the basis of printer's type, the most readable type-faces have not been those produced by calligraphers, as Morison was to discover, but the article stimulated him to enquire into the typographic origins of type, to try out various hands himself, to associate with calligraphers and then go beyond to discover what was valuable among 'modern' designs, which owed more to the punch-cutter than the calligrapher, and to revive the best of them. He also studied the writings of De Vinne, and later was to lay down how letters and words should be spaced, and what measures and margins should be used in book design.

Morison also saw in the supplement large reproductions of pages from Kelmscott and Ashendene books, which brought him in touch with the work of the great private presses; but his eye was also caught by an advertisement for the new periodical, *The Imprint*, soliciting subscriptions (twelve shillings per annum, post free). Morison bought the first issue (13 January 1913) and was delighted to see at the end of the Notes: 'Note. We require at the offices of The Imprint the services of a young man of good education and preferably of some experience in publishing and advertising. We prefer that applications should, in the first instance, be made by letter, addressed to the Business Editor, The Imprint, 11 Henrietta Street, Covent Garden, London.' He applied for the position at once.

Although he had no experience in publishing and advertising, Morison made up for this deficiency by sufficiently impressing the publisher, Gerard Meynell,

with his views on printing, for this to be overlooked. Meynell (1877–1942) was not only interested in the design of printing, but as head of the Westminster Press became a leading authority among the master printers on costing. Among his other claims to fame is that it was he who suggested to Frank Pick that Edward Johnston should design a sans serif type for the London Underground. Apparently, what finally obtained the position for Morison was the fact that he told Meynell he was tired of being a bank clerk, and he could not have struck a more sympathetic chord. He was not to know that Meynell had been in the family banking business at exactly the same age as himself, had disliked the work and had transferred to printing in 1900. The result was that Morison got the job.

A more felicitous start in business for the future typographical consultant could not be imagined. Meynell had founded *The Imprint* with F. Ernest Jackson, J. H. Mason, and Edward Johnston with the aim of raising the standards of printing. The group constituted itself the board of editors, with Meynell as the 'Business Editor', and an impressive advisory committee was established, including the distinguished private printer C. H. St John Hornby, of the Ashendene Press, and the equally distinguished commercial printer Theodore De Vinne, of New York.

Apart from Meynell, the two editors who exercised the most influence over Morison were J. H. Mason and Edward Johnston with their writings, but, additionally, Mason had shown how a new type-face could be designed for the Monotype composing machine. But the Monotype Corporation needed advice. The Monotype advertisement in the first issue of *The Imprint* was totally undistinguished, but Mason must have suggested a simpler approach to design, since the advertisement in the next issue shows an improvement. In a review of the May 1913 *Monotype Recorder* in *The Imprint*, No.8, he dropped a heavy hint: 'Now and again, at the very least, we think the Monotype Corporation would be well advised in producing exemplary work – the machine is quite capable of it.' The process of educating the Monotype Corporation typographically had begun, with Mason as the teacher. This was to provide a basis for the work Morison was to start ten years later.

Morison himself did not contribute to *The Imprint* until the penultimate issue (No.8), with an article entitled 'Notes on Some Liturgical Books', a clear indication that he had come to good printing through the medium of the Church. He had not been idle since his interest had been aroused at Farm Street, as he had read a number of histories of liturgical printing, E. Gordon Duff's *Westminster and London Printers*, and, as well as continuing his visits to the British Museum, had discovered the Victoria and Albert Museum as a place to study book production.

While Morison had been accumulating knowledge, the Monotype was gaining acceptance as a composing machine in Britain. Prejudice was being overcome, but very little had been done by the Lanston Monotype Corporation (the word Lanston was dropped in 1931) to initiate new type-faces. The Corporation's engineers were too preoccupied with improving the technical operation of the machine to devote much thought to the aesthetic aspects of its products. The earliest founts on the Monotype were therefore merely copies of the Clarendons, grotesques, 'old faces', and 'moderns' issued to the trade by the typefounders.

News of American developments began to get through and, as the managing director of Monotype, H. M. Duncan, was an American, with a personal interest in type-design, there was a possibility of change. When, in 1911, J. M. Dent requested a new roman and italic for use in his 'Everyman's Library' Duncan readily agreed that it should be cut. Dent was not in any way opposed to mechanical composition, as were some of his contemporaries, but he could not

bring himself to abandon the Morris doctrine completely, and he asked the Corporation to cut Veronese from a heavy fifteenth-century original. If this face has any significance, it is as marking a transition in type-design from private press requirement to that of mechanical composition.

Meynell's founding of *The Imprint* produced another step forward. As an up-to-date periodical it was decided to set it mechanically, but Mason did not like the idea of using a modern face, preferring Caslon. Meynell consulted Duncan, who pointed out that Mason's requirement for a great primer face on an 18-point body was technically impossible. After discussion, Mason designed a new face modelled on Caslon, but with a larger x-height and with an italic which harmonized more closely with the roman than it did in Caslon. Imprint, as the new face was called, was well received and made available to the trade in general. In the words of Beatrice Warde: 'After that it became possible to think of mechanical composition as an instrument of creative craftsmanship.'

In the same year, 1913, there appeared Monotype's first original contribution to jobbing typography – Plantin. By this time British typefounders were being roused from their lethargy by competition from the composing machine, and in about 1910 P. M. Shanks & Co. brought out Plantin Old Style, which, whatever its merits (and the italic is particularly good), had more in common with Caslon's faces than those of the famous Antwerp printer. The success of this type indicated to F. H. Pierpont, Monotype's works manager, who was not particularly keen on new type-faces, that a chance could be taken on a face of this name, and so the Corporation, for the first time, took the initiative in making a new type. It was called series 110, and was based on a type shown in a 1905 specimen book of the Plantin-Moretus Museum in Antwerp, but never used in Plantin's lifetime.

Thus by a series of extraordinary coincidences Morison was not only launched into printing, but came at once into contact with Monotype composition and with the concept of designing type specially for its use. Nevertheless, there is no evidence that he was particularly struck by this circumstance, and, since there was little type-designing activity in Britain during the next few years, it is understandable that he was, typographically speaking, influenced to a greater degree by American trends, which tended to be almost exclusively concerned with foundry type.

For some reason *The Imprint* failed to publish a full twelve monthly issues. Up to July 1913 issues appeared with regularity, dated the 17th of the month; and then the August issue came out, dated the 27th. There is a gap until 27 November, when the ninth and final number was published. The Notes, written by J. H. Mason, are datelined 'Weimar, August 1913'. He had gone there in July at the invitation of Count Kessler, the private press owner, and it looks as if the absence of Mason, the chief contributor and editorial organizer, was the reason for the non-appearance in September and October. There is no mention in No.9 that it was the last to be published; indeed Mason promised to give an account of Kessler's press and the work proposed there, later. It must have been after No.9 had been issued that Meynell decided he could not continue to back *The Imprint*, a decision accelerated by a demand that the contributors be paid for their work. Whatever the cause, Morison's period at the *Imprint* was brief. Fortunately, Gerard Meynell was able to introduce him to his uncle, Wilfrid Meynell, managing director of the Catholic publishing firm of Burns and Oates. While being a Catholic had been an embarrassment in the London City Mission, it was a positive advantage at Burns and Oates. Morison was also fortunate in joining a firm run by a man who was no ordinary publisher, but one who was interested in

NOTES ON SOME LITURGICAL BOOKS : By STANLEY A. MORISON

O F the various classes of early printed books, none is more interesting or worthy of study than the books which were used in the services of the Church. It was upon these that the scribes and illuminators lavished their best skill and ornament. In the Middle Ages the arts of calligraphy and of illumination and miniature painting were brought to perfection, and as MS. Liturgical books were those which the first printers had to equal in order to make a livelihood, their liturgical productions were objects of more than ordinary care. Liturgical books, however, are interesting, not merely on account of their beauty, but also for the sake of the relation which they had to the life of our forefathers. In the Middle Ages, when society was pervaded with the influence of the Church, these books were those most familiar to the people. Such books were often the treasured heirlooms of families—we learn from early wills that the Breviary was a book very commonly bequeathed alike by parsons and layfolk.

The devotional expressions of Judaism—psalm-singing and lections from sacred books—were continued by the early Christians, and the recitation of these at regular hours of the day is mentioned by St. John Chrysostom (347-404). " So ancient a custom," says Mgr. Batiffol, " is it for Christians to consecrate by prayer the times we call *Terce, Sext* and *None*. Christian piety associated the commemoration of Christian mysteries with three points of time which divided the day into three stages : at the third hour (9 a.m.) the commemoration of the condemnation of the Saviour; at the sixth (noon) of His crucifixion; at the ninth of His death." (Pierre Batiffol, " History of the Roman Breviary," Eng. tr. Baylay, 1912, p. 13). Gradually what was the pious exercise of ascetics became obligatory on all the clergy, and a further development of this devotion or " office," as it is called, was reached in the sixth century, when St. Benedict wrote his *Rule*, in which " we have the oldest and most complete scheme of the canonical hours to be found in the history of the Church." (Jules Baudot, " The Roman Breviary," Eng. tr. 1909, p. 43). By the time of St. Gregory (540-604) the office was in need of revision, and " it was St. Gregory who collected the prayers and liturgical uses of his predecessors, and assigned to each its proper place, and thus the liturgy owes its present form to him. The Liturgical Chant also bears his name, because it was through his means that it reached its highest development." (Suitbert Baumer, " Hist. du Bréviaire Romain," I. 289.)

good printing and book production. He used the services of Newdigate as a designer, and within the firm he had placed his youngest son, Francis, at the tender age of 21, in charge of the design of books. Morison became his assistant.

Wilfrid Meynell and his wife Alice, the poet, were kind to Morison, who was much impressed by home life at their country house, especially with the preparations made for the home-coming of the master at weekends. It was his first contact with substantial middle-class life. Wilfrid Meynell also encouraged Morison to widen his intellectual interests, persuading him to write for the *Dublin Review* and *The Tablet*.

The combination of circumstances, which are so prominent a feature in Morison's life, continued to operate at the Burns and Oates period. From Meynell, the Catholic publisher, stemmed many of the important friendships which shaped the future. Morison was able to meet Catholic authors and to discuss liturgical matters with them, including Edmund Bishop (1846–1917),

an authority on the Book of Common Prayer and collaborator with Cardinal Francis Gasquet, liturgical historian. Many years later Morison recorded his gratitude to some of these men in his *English Prayer Books*. He also met such figures as Bernard Newdigate, Eric Gill and, perhaps most important of all, Adrian Fortescue. Newdigate's father was a Catholic convert, and his brother, Charles, became a Jesuit priest.

Bernard Newdigate renamed his father's firm the Arden Press, and worked for Burns and Oates from 1905 onwards. When the press was moved to Letchworth in 1907 it was taken over by W. H. Smith's, Newdigate continuing to advise the new proprietors. By coincidence, one of Meynell's authors, Adrian Fortescue, in the same year had been appointed parish priest at Letchworth. Fortescue was the major formative Catholic influence in Morison's life. To understand this influence it is necessary to go back in time to a period when Edward Johnston was beginning to revive the lost art of calligraphy and eventually to exert a great influence on almost every form of lettering. At his classes in 1899 at the Central School of Art and Crafts, Eric Gill was among the first students, to be joined a few months later by Fortescue, a newly ordained priest. Fortescue, a liturgical authority, was also a calligrapher of some skill, writing a beautiful personal script. He was also a competent artist, who illustrated his own books and designed book-plates, often armorial, for friends. Of a highly individual temperament, he had great difficulties with his Church superiors, and during the 'modernist' crisis tended to side-step and devote himself to the Orthodox Church and its liturgy. In time, he became the great authority on the Eastern Churches, and was reputed to be able to speak eleven languages.

Fortescue was a Jacobite, making his friends drink confusion to the Hanoverian king. Sure in his immense learning, he spoke in an authoritative, forceful way, disliking any subterfuge or what he thought was illogical thinking on the part of others. Far from considering himself unorthodox, he believed it was others who followed unhistorical paths, whether they were bishops or officers of the College of Arms. Fortescue made friends with Newdigate and impressed on him the role of calligraphy in good printing. He had his own hymn book printed by Miss M. Newdigate in 1912. This was the year in which Bernard Newdigate printed for Burns and Oates, at the Arden Press, an edition of *Ritus Sevandus*, described by Morison as 'a splendid piece of typography'. The next year Newdigate printed a missal, which was always known as the 'Fortescue missal' at Burns and Oates. Fortescue not only wrote for Burns and Oates but also designed lettering, some of which was in use until the firm closed down.

Morison met Fortescue through the Burns and Oates circle, although he may have heard him preach in London earlier. According to Canon John G. Vance, who knew both men well, Morison was captivated – heart, mind, and spirit – by Adrian Fortescue, being deeply impressed by the other man's learning, and absorbing as much as possible from him. He was influenced by Fortescue's mannerisms, too – his method of speaking, his clothes, and, unfortunately, his tendency to speak *ex cathedra*, for Morison eventually was not entirely free from intellectual arrogance.

Eric Gill, the stone cutter, was a friend of Francis Meynell's brother Everard, and became one of Wilfrid Meynell's protégés. Meynell senior helped Gill to get the commission for the Stations of the Cross in Westminster Cathedral, having, before Gill became a Catholic, commissioned an altar stone in 1911, commemorating the poet Francis Thompson. Just after Gill was converted in 1913 Meynell had some holy water stoups made by him, and in 1922 Gill was

responsible for Alice Meynell's gravestone. Gill was very much in the Meynell-Newdigate-Fortescue circle to which Morison was drawn.

A year after his conversion Gill, who had known Fortescue from Johnston's classes, went off to Letchworth to debate with the priest in a liturgical controversy. This may appear an astonishing action on the part of a new convert, but that was ever Gill's way. After being converted to the idea that his lettering could be transformed into type he suddenly became a typographical authority. Gill was quite early on connected slightly with book design. When, in 1915, Francis Meynell designed a new edition of *Ordo Administrandi Sacramenta*, using what are known as the 'Fell' types, he got Gill to engrave a device of 'arms' of St Thomas of Canterbury, with the petition *Nos ne cesses Thoma tueri*, for the half-title. So popular was the device that it survived as the basis of the Burns and Oates publisher's mark. It was not strictly heraldic, being of a rectangular shape, but in the centre were the three choughs attributed posthumously to Thomas à Becket. The effect was not spoiled by the fact that Gill thought they were martlets.

The two young men, Stanley Morison and Francis Meynell, worked harmoniously together and designed a number of books, some of which were printed at Oxford in the Fell types. Dr John Fell, between 1667 and 1672, imported from Holland punches and matrices for the use of the University Press, at Oxford, but the types cast from them eventually were neglected until they were revived by Dr C. H. O. Daniel at his private press from 1877 onwards. Morison had read about the types in *The Times* printing supplement and communicated his enthusiasm for them to Meynell, who, in 1915, persuaded the Controller of the University Press to let him have two cases of the Fell type, English size. A 'printing works' was set up in Meynell's small dining-room at 67 Romney Street, Westminster, from which only two books were issued, each in an edition of fifty copies – *Ten Poems by Alice Meynell* and *The Diary of Mary Cary*. Morison helped to compose some of the pages of *Ten Poems*, one of the few occasions when he actually set type.

They had other joint enthusiasms, one of which was the rediscovery of printers' flowers. Morison began to be interested in black-letter and used the Figgins' cutting of the Caxton type with good effect, as, for example, on the title-page of the 1917 edition of *The Layfolk's Ritual*. This book was probably a joint effort of the two designers, as it exhibits Meynell's typical use of a line of flowers, but, in any case, Morison was soon in no position to determine the fate of the book. The two men shared similar views on politics and religion, and when conscription was introduced in 1916 both declared themselves conscientious objectors. They decided to run their own anti-conscription organization for Catholics, called the Guild of the Pope's Peace, of which Meynell has commented: 'Seldom, I think, can a propaganda body have had such handsome printing! It had little else.'

A pamphlet of 1917 (printed by the Pelican Press, which Meynell had started the previous year), entitled *The Pope and the War*, carries a note to the effect that the Holy Father had shown his appreciation of the Guild's *Little Book of Prayers for Peace* by according the compiler his special blessing. It is also noted that the *Prayers* are 'finely printed in the Fell types', but whether the Pope appreciated that these types were named after a Protestant bishop is not known.

Morison, at the age of 26, was liable for military service as an unmarried man, and made haste to change his status. On 18 March 1916 at the Catholic church of St Peter-in-chains, at Stroud Green, he married Mabel Williamson. He was living at Woodville Road, Golders Green and she at Parkhill Road, Hampstead. For

the occasion Morison's father's profession was transmogrified into 'Cigar merchant' perhaps to keep up with the Williamsons (two of whom were witnesses) as the late John Henry Williamson, the bride's father, was described as 'Art Silversmith, Master'. Morison, perhaps not too sure what to call himself, put down 'publisher's reader', not a strictly accurate description of his work, but good enough for outsiders who would not have understood what he did.

In view of the later disagreements which led to separation it can be noted that Mabel Williamson (according to the marriage certificate) was seven years Morison's senior, but was in reality much older. By all accounts she helped him with his Latin, but after the war, when she was some 50 years of age, the little cottage where they had gone to live in Hampstead rang with the noise of their arguments so that all the neighbours could hear. Morison was perhaps not suited to the married state. In any case, he was not, initially, to enjoy it for long, as in May 1916 compulsory military service was extended to include married men.

Morison failed to register under the Compulsory Service Act and was arrested. He also failed to make a case as a conscientious objector and was drafted to the army, where, refusing to obey orders, he was sent for court-martial at Aldershot. Here, the doyen of the guard-room was R. Palme-Dutt, later one of the founders and most influential leaders of the Communist Party of Great Britain, who had successfully tripped up various stages of his own court-martial on technical grounds. Palme-Dutt found Morison, the only Catholic there, a delightfully companionable person with a sense of humour; and because of their different views there was, says Palme-Dutt, abundant scope for discussion. However, in the light of later events Palme-Dutt may have made a greater impression on Morison's outlook than he imagined.

Sent to Wakefield jail Morison met other war-resisters, including Walter Holmes to whom he taught a chancery writing hand, used at the head of his 'Worker's Notebook' in the *Daily Worker* for many years. Through Holmes, Morison met Dona Torr, sometime librarian of the old *Herald* newspaper, who taught him German and who was later to be very helpful to him in arranging the separation from his wife. In prison Morison took part in G. B. Shaw plays, but was generally very unhappy.

Morison's bitterness against society was very great at this time, and increased when he found that he was in danger of being disenfranchised for five years for refusing work of national importance during the war. After the war, in 1921, Morison and Meynell helped in the design of Palme-Dutt's magazine, the *Labour Monthly*, but Dutt comments: 'Subsequently the difficult economic path of a self-supporting journal compelled us unfortunately to cheapen, I fear, the original very beautiful layout.' There was an interesting sequel. When Morison wrote his *History of The Times* he asked Dutt, as a personal favour, to review the first volume in the *Labour Monthly*, and promised a substantial donation to the fund if he could see his way to do this. Dutt accordingly wrote a review under the title 'The Times writes its own obituary'.

Among Morison's fellow-prisoners were individuals who took part in the formation of the Communist Party of Great Britain in 1920 and in 1923 such were Morison's feelings that he applied to join. At the time the Communist Party was a small sect, mostly of middle-class origin, and Morison, as a Catholic, could not possibly have passed their stringent doctrinal requirements, and his application was refused. But he was useful to them outside. It was he who persuaded Eric Gill, early in 1930, to cut in wood a bold sans serif titling for the *Daily Worker*. A hammer and sickle were superimposed on a proof and a stereotype made of

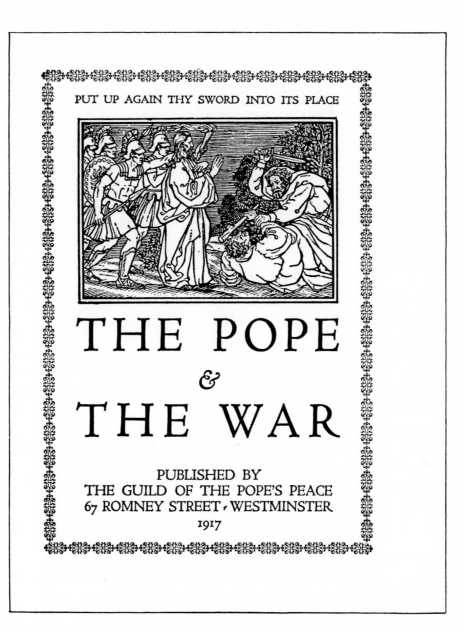

PUT UP AGAIN THY SWORD INTO ITS PLACE

THE POPE
&
THE WAR

PUBLISHED BY
THE GUILD OF THE POPE'S PEACE
67 ROMNEY STREET · WESTMINSTER
1917

the whole, the design being used for two years. In later 'Popular Front' days, in the late 1930's, the Communists would probably have welcomed so distinguished a personality as Morison into their ranks with much publicity, but by then he had moved away from them.

Morison's socialism and republicanism were hardly derived from participation in political struggles or from a deep feeling for the exploited poor, but from a personal resentment against his own early poverty, mixed with the doctrines he had received from his mother, and the way he was treated during the war. As he grew older, and more successful, the resentment began to die down, and he became a more tolerant and mellow personality. Nevertheless, Morison's mixture of Catholicism and rationalism puzzled many of his friends and admirers, who did not understand that it was his rationalist approach which had led him into the Catholic fold. He needed discipline and some code of life to guide him. He explained to Turner Berry, the St Bride Librarian, that otherwise there was no restraint, for example, on his stealing any book he liked from the library.

He reasoned that such a code could not come from imperfect men, but from some supernatural power and that, since a religious doctrine was necessary to

uphold the code, the Christian religion based on the perfect man was the one for him, and that the Catholics seemed to be the truest exponents of this faith. The fact that he approached the Jesuits as representatives of the Catholics is an historical accident, but had he not done so, he may have ended up a Catholic in some important sphere, but not in the particular field in which he became pre-eminent.

Just the same, the Catholics gained a distinctly odd recruit, to the end a very 'English' Catholic, with socialist ideas, who described his Church as a 'bunch of macaroni merchants'. In his *Writings of Challoner* (1946) he regretted that, because of the paucity of copies of the *Sarum Missal* after the Reformation, English Catholic custom had yielded to the Roman. Quite early he was on the side of the modernists, and found the Papal encyclical, 'Pascendi', condemning 'modernism' mental torture.

Morison's views were buttressed by the writings of the French Catholic writer Charles Péguy, who was killed at the battle of the Marne in 1914, having discovered him before his works became generally known in England. Péguy was interested in social problems, and ran a socialist bookshop in Paris. Morison bought Romain Rolland's *Péguy* in two volumes and had them specially bound. Péguy shared Morison's seemingly paradoxical mixture of conservatism, socialism, and Catholicism, of a strong sense of the past, as living on particularly in the liturgy, combined with a quite modern sense of reality.

Morison brought with him from the rationalist and Puritan camp certain psychological impedimenta, among which was the desire to be known by his initials – 'S.M.'. Although this curious habit eventually spread to 'big business', in Morison's day it was the way in which leading rationalists and socialists were referred to – Madame Blavatsky being known as H.P.B., George Bernard Shaw as G.B.S. It was a kind of egalitarian honours list, and to be thus known was a sign of arrival among the *illuminati*. A few, very few, old acquaintances got away with the use of Morison's first name, which he called his 'handle', although an exalted mortal, such as Lord Beaverbrook, was permitted to use it in return for being called 'Max'. Morison loved tycoons and peers as much as he did champagne, and some of his friends, irritated by this, considered him an old-fashioned snob. Others tended to overlook his faults because of his joviality and his obvious talents.

Morison tried hard to study while in jail but it was really not a very rewarding time. The four years which followed his release in 1918 represent a prelude to the major creative period of his life.

Prelude

At Burns and Oates, Meynell and Morison were working for a firm not in the mainstream of publishing, which had a comparatively small output of books. Nevertheless, their influence on book design was not insignificant as their 'florid' style was noted outside. In later years, Morison felt the style was archaic, agreeing that the ornaments were copied from the seventeenth and eighteenth centuries. In the 1920's there came a reaction against this type of decorative element and Oliver Simon, at the Curwen Press, for example, began using contemporary artists to design borders, initials, and headpieces. Morison gave up ornament almost entirely and, under new influences, began experimenting with simpler forms of book design. Meynell continued to be faithful to the early period for some of his Nonesuch Press books.

While the two young men were making their modest mark in the typographic world, others were not unaware of the depressed state of British book-design. Critics of the work of the Cambridge University Press included Sydney Cockerell, who had been associated with William Morris and Emery Walker, and an opportunity arose to remedy the situation when it was realized that Bruce Rogers was working in Britain. He had come to England at the end of 1916 to work with Emery Walker, but was thinking of returning to America the next year. Cockerell approached the University Press to see if the services of Rogers could be obtained to improve its work and, as a result, Rogers became consultant to the Press, and stayed in England until June 1919.

Rogers was a direct link between the typographic renaissance which had begun in the United States and which was about to take place in Britain. During his stay he was able to stimulate an interest in good typography at the Press, which was to provide a basis for Morison some years later. While at Cambridge, Rogers was able to test out his ideas that a fount of type he had bought in France was partially an original Baskerville cutting, and he made the suggestion that a 'Baskerville' might be used at the Press in as distinctive a way as the Fell types were used at Oxford. The war made it impossible to pursue any idea of producing new types, but a Baskerville was put in hand by Monotype soon after the war.

As Meynell tended to move away from Catholicism, Morison became more deeply immersed in theological matters, and, under the influence of Fortescue, began extending his range of knowledge of religious sects. He and his Jesuit friend, Herbert Thurston, were concerned at the growth of the cult of Theosophy, about which Francis Meynell had some information. But what was particularly worrying them was the fact that some Theosophists, including one 'Bishop' Leadbeater, had formed themselves into the Old Catholic Church, had begun to create priests and bishops and were using Church vestments and celebrating Mass.

This was an affront to Morison, and he prepared to attack them. This took the form of *Some Fruits of Theosophy – the origins and purposes of the so-called Old Catholic Church*, disclosed by Stanley Morison, with a preface by Herbert Thurston, s.j., published by Harding and More in 1919. The book may disclose

 HERE ENDS *LIVING TEMPLES*
written by Fr. BEDE JARRETT
of the Order of Preachers & printed
by STANLEY MORISON
at the PELICAN PRESS
for BURNS, OATES
& WASHBOURNE
In Purificatione
B.M.V.
MCMXX

NOS·NE·CESSES
THOMA·TVERI

¶ He that loveth cleanness of heart, for the grace
of his lips shall have the king for his friend.

Colophon with Morison's name
and Burns, Oates and
Washbourne publisher's mark,
designed by Eric Gill. The last
page of text (not shown) carries
the Pelican Press mark derived
from Geofroy Tory.

the objects of Leadbeater and his friends, but it also reveals Morison and Thurston
at their most vituperative. Phrases such as 'mumbo jumbo of the Jewish kabbala',
'ecclesiastical underworld', 'religious anarchy', 'Zulu witch doctor or rain-maker',
'clerical megalomaniac', 'schismatic ex-Latin', 'gaping dupes', and 'quacks'
abound. Jesuits are quoted on the reputation of Theosophy, and there is a certain
pursing of the lips over Helen Petrovna Blavatsky's 'marriages'. Mr Leadbeater's
pet ambition, it was stated, was to 'dump on the world a new god in the shape of
Krishnamurti – *alias* "Alcyone" '. This referred to J. Krishnamurti, born in 1895
in Madras, who was taken up by Annie Besant and other Theosophists as the new
Messiah. Whether Morison's baleful interest in the Theosophists had been
aroused because of Meynell's friendship with some of them can only be guessed
at, but by the time of the book's publication there was a certain irony about it as
Morison was taking over the Pelican Press, which owed its origins to
Theosophists.

The typography of *Some Fruits* is not very distinguished. Morison was well
versed by now in the language of printing, as shown by some of the footnotes,
but he had not quite grasped every aspect of book design. The book has a
pleasant Caslon-based title-page, perhaps designed by Morison, but inside there

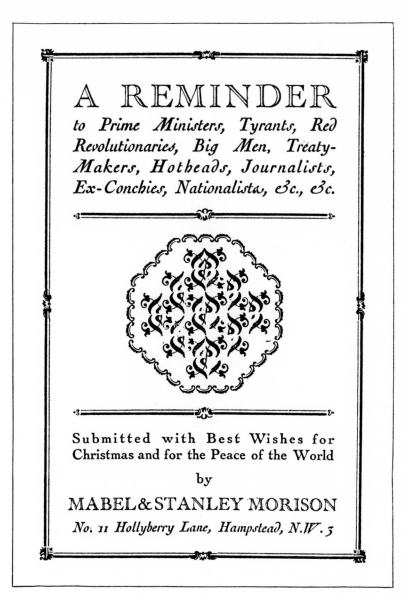

are the usual faults of composition – too much space after full points and between initials, for example, and a mixture of old face and modern types. At the time the printers, Hazell, Watson, and Viney, in common with most others, had little concern for typographical design, but were to improve greatly in the next few years.

Francis Meynell had fallen out with his father over politics and religion. He had spoken in favour of women's suffrage at a public meeting and had incurred his father's wrath, which, however, was slightly abated when Mary Dodge, a rich American woman, sent Burns and Oates £500 to donate books to poor Catholic churches as a token of her appreciation of the young Meynell's speech. Through Mary Dodge he met George Lansbury, who invited him to join his newspaper, the *Herald*, in 1916. Meynell then achieved the backing of two Theosophical ladies, who endorsed the policy of the *Herald*, to set up the Pelican Press, with the object of publishing any new gospel which might emanate from Krishnamurti. Early in the summer of 1916 the Press opened at 2 Gough Square, moving in 1918 to 2 Carmelite Street.

In the absence of any gospels from the new Messiah, other printing work was carried out, which made its mark eventually not only on typographical history

in general, but on that of advertisement typography in particular. When Meynell took on more responsibilities at the *Herald* in the spring of 1919 he asked Morison to take over his position at the Pelican Press. Thus Morison benefited, indirectly, from the hated Leadbeater and his 'ecclesiastical underworld'.

The Pelican Press was an extraordinary firm and existed as a press in name only, since all the work was carried out by the Victoria House Printing Company, printers of the *Herald*, but its style must have shaken some of the old-guard Labour men. However, though tiny, it was responsible for a much-needed revitalizing of typography in the commercial field.

Morison was now 30 and living with his wife in a cottage in Hollyberry Lane, Hampstead, conveniently near to the Catholic church of St Mary. The new position at the Pelican Press was his first with independent authority and he took it seriously. Connexions were kept up – there was no falling out with Burns and Oates. One book printed for this firm, *Living Temples*, by Bede Jarrett, carries the imprint 'printed by Stanley Morison at the Pelican Press'. The text is set in 11-point 'Italian' with 48-point Cloister initials, lines of flowers being used to break up the sections. Cloister is used for the title-page, and when Morison wanted some black-letter for one of the advertisements at the end of the book he used his favourite of the time – Figgins' Caxton. The 'Italian' was one of the machine faces of the Pelican Press, and the others were 'Old Face', Plantin, and Imprint, which had been 'improved by the addition and substitution of special letters and ligatures designed to the order of the Pelican Press'.

Morison's letter to Sidgwick about the Pelican Specimen sheet.

Morison's first Christmas with the Pelican Press was the occasion for sending out a characteristic greetings card – typographically and editorially – fleurons, Moreau-le-jeune, and Cochin types were used to set 'A Reminder to Prime Ministers, Tyrants, Red Revolutionaries, Big Men, Treaty-Makers, Hotheads, Journalists, Ex-Conchies, Nationalists &c., &c.' The reminder was a quotation showing how idealists can become despots, which was signed 'J.N.F.', who it has so far proved impossible to identify. Morison probably thought the initials sufficient for those in the know.

On 19 January 1921 Morison wrote to Frank Sidgwick, the publisher, explaining that 'the specimen' sheet was not ready but that he would forward one when it was off the machine. Sidgwick had seen a proof of the specimen at an Arts and Crafts exhibition in Knightsbridge. The letter was not sent in an envelope but was folded in the old style, with the name and address written on the outside. When the specimen sheet arrived it turned out to be a *tour de force*, printed in black and red, and showing the 'unrivalled' collection of printers' flowers, initial letters, and 'factotums', decorative borders and the type-faces held by the Press. The specimen was contained in a distinctive envelope, 12 × 18 inches, and addressed by hand by Morison.

Meynell had originally wanted to use the name Phoenix Press, but was unable to do so because a firm of that name already existed. A Phoenix rising from a fire had been designed as the Press mark, but, in the circumstances it was slightly redrawn, the beak being lengthened into a bill – a pelican rising from the flames. This mark appeared on the envelope and the firm's letter-heads and must have caused a few laughs, but later the traditional heraldic pelican feeding its young with its own blood, adapted from a Geofroy Tory emblem, took its place, and this appeared on the specimen itself.

At this distance in time away it is difficult to gauge the effect of this startling piece of printer's advertisement, but nothing like it must have been seen before. It certainly had a great impact on Mr Sidgwick. Morison wrote on 28 January

THE PELICAN PRESS
A Branch of the VICTORIA HOUSE PRINTING CO. LTD.
2 CARMELITE STREET
LONDON, E.C.

Telephone City 1811

All business communications to be addressed to the Firm

In replying please quote Ref.

Dear Sir: I am sorry to say that I cannot not today send you a copy of our specimen sheet such as you saw at Knightsbridge. The copy there displayed is a proof only of a job which will not be finished until the end of this week. On the one side are full displays of Caslon, Cloister, Kennerley Forum, the Cochin & the machine faces while the other will exhibit a series of Ratdolt, Tory and Jean de Tournes borders which have been recut upon wood for use in this office. I hope the final production will retain your kind interest and I shall be very pleased to forward a copy when it is off the machine.

Yours faithfully,

Stanley Morison,

19 January 1921

F. Sidgwick Esq.

49

thanking him for 'the handsome appreciation of our type sheet', adding: 'Your praise is very sweet to my ears and I shall be very pleased to make your acquaintance'. Sidgwick was to prove a valuable customer, and became an admirer of Morison's work. He contributed the first of the series 'Contemporary Printers', devoted to Morison, in Number 3 of *The Fleuron* (1924).

In considering Morison's contribution to typographical studies, the Pelican Press period is of importance since for the Press he produced his first study on typography: *The Craft of Printing: Notes on the History of Type Forms* ('Ascension Day of the Year 1921'). In notes to the *Handlist* of his works, he writes: 'This item is pre-Updike and has only aesthetic value. It was, however, the writer's initial effort to outline for his own satisfaction the nature of the tools he was using as "layout artist" at the Pelican Press in succession to Francis Meynell; to determine the relation of Caslon and the Didots to Jenson and Aldus; and the connexion between calligraphy and typography.' The booklet reads well enough today, and is none the worse for ending in a paean to the Pelican Press and, in particular, to its magnificent type specimen ('for 5/–, a price very much below cost').

Envelope for the Pelican Press specimen sheet (reduced), addressed in Morison's hand, 1921. Printer's mark: a pelican transformed from a phoenix.

The wide margins of *The Craft of Printing* are used to accommodate side-notes – some factual, some comment – thus (in the text) 'a parallel degradation is noticeable in the contrast of most of our commercial types with the fine Roman and Italic of Jenson and Aldus' and (side note) 'see the daily newspapers'. He had become aware of the Aldus roman as well as that of Jenson, and already had his eye on newspapers as objects of reform. He had also come to the conclusion that Morris's characterization of Bodoni's types as 'positively ugly' had led to a general prejudice against 'modern' types, as such, and that there were types based on engraver's work which were acceptable – including the one in which the booklet was printed, the Cochin series.

Once the war was over typefounders and composing machine manufacturers could begin to think about new type-faces, as long as they felt there was a definite demand. The British Monotype organization had, in fact, begun cutting Caslon as early as 1916 but this was at the request of its first big customer, William Maxwell, of R. & R. Clark of Edinburgh. By 1916 it had become imperative to set this face mechanically, as Clark's were part way through a history of the British army when they ran out of type, and war production was interfering with supplies from the typefoundries. So, despite the difficulties of the times, the Monotype Corporation mastered the technique of reproducing for machine composition a heavily kerned type. The successful result overcame one of the last remaining points of criticism from publishers – that the difference between hand and mechanical setting was noticeable. The publisher of the history did not notice the difference, said Maxwell.

The decision to accede to their request and put Caslon on the Monotype was doubly fortunate for R. & R. Clark, as they had one customer, George Bernard Shaw, who insisted on the use of Caslon in his books. In the middle 1920's the resetting of the whole of Shaw's works by hand, as Shaw required, would have been an out-of-date, expensive drudgery. Maxwell took Shaw two different specimen pages, one hand-set and the other by machine. Both were submitted to Shaw without any indication of which was which, and Shaw chose the Monotype setting. Maxwell convinced Shaw that mechanical setting could equal hand setting in typographical quality.

In this atmosphere, the British Linotype organization, Linotype and Machinery Ltd, felt it ought to do something for its machines, and it found in George W.

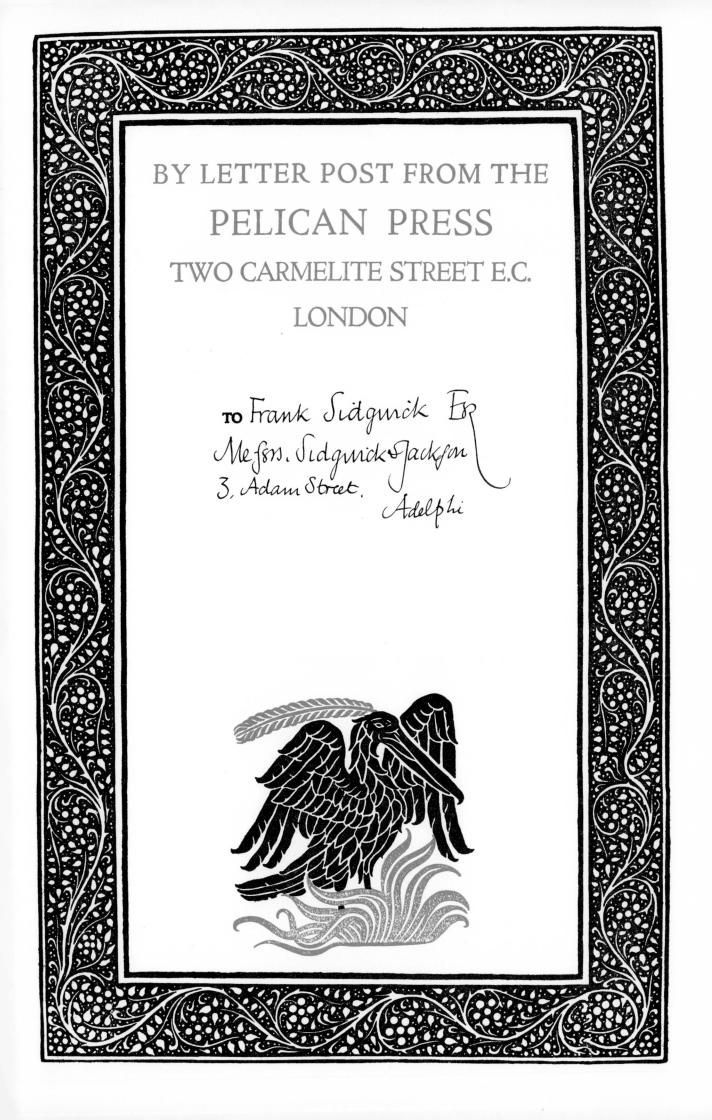

BY LETTER POST FROM THE

PELICAN PRESS

TWO CARMELITE STREET E.C.

LONDON

TO Frank Sidgwick Eſq
Meſſrs. Sidgwick & Jackson
3. Adam Street.
　　　　　Adelphi

Jones, who printed at the Sign of the Dolphin, in Gough Square, an admirer of both its Miehle presses and its line-composing machines. More to the point, he was a student of early printing and typography and they felt he could advise them on type-faces which might be revived. In September 1921, therefore, the company took the unusual step of appointing Jones as printing adviser – the title of typographic adviser would probably not have occurred to them. Jones immediately tackled the design and printing of the *Linotype Record* from the October 1921 issue, and began looking for a type-face which could rival the ATF Garamond. The results will be mentioned in the chapter devoted to Garamond, but here it is sufficient to point out that the Linotype company and not Monotype was the pioneer in Britain in appointing a special consultant on type-face design.

In the very month that Jones joined Linotype, Morison, although not unaware of the possibilities of reviving older designs, was apparently, from a letter which will be quoted, thinking in terms of foundry-cast type rather than the products of a composing machine.

While Morison was working at the Pelican Press, a Manchester advertising agent, Charles W. Hobson, was completing plans for the establishment of a printing firm which would specialize in 'quality and atmosphere and style'. Hobson was a rarity among advertising agents of the day, in that he believed that advertisements should be well-written, illustrated by able artists, and cleanly laid out with well-chosen typography. He had already been using some of the country's best printing firms, and in 1919 had met Walter Lewis, who had built up the Complete Press, at Norwood, after having been general manager of Ballantyne & Co., which had been taken over by Spottiswoode's in 1916.

In passing, since Lewis became one of the principal characters in Morison's life, it is an agreeable thought that their paths may have crossed in the Covent Garden area during 1913 when Morison was at *The Imprint* in Henrietta Street, and Lewis was works manager in Ballantyne's in the adjacent Tavistock Street.

Hobson asked Lewis to join him in his new enterprise, and the next year formed a company called the Cloister Press Ltd, issued a prospectus and application form for shares, and, more important, purchased a site for a factory about six miles from Manchester. Lewis spent a year not only planning the layout of the factory and purchasing the machinery, but also in writing to publishers, telling them that he had engaged former Ballantyne craftsmen, and that he wanted to produce work 'similar to the old private presses'. The factory was built at Heaton Mersey, then in rural surroundings, and in 1921 Hobson began to engage further staff. There is some conflict between the recollections of Lewis and Hobson as to which of them thought of Stanley Morison, but apparently both knew of his work, and a meeting between Hobson and Morison at the National Liberal Club, in London, led to an agreement that Morison should join the Cloister Press. Hobson recalled before his death in 1968 of Morison: 'My object was to lift him out of Fleet Street and transplant him in a daisy-sprinkled meadow at Heaton Mersey some six miles south of Manchester. It was there I had planned to build the Cloister Press. And it was Morison I wanted to help the composing room in the good care of the P's and Q's, to give each page a happy face, in short to be Master of Good Manners in this new and better printing house'. Hobson remained the copy-writer to the end. He also claimed warm friendship with Morison, but, if this were so, it was somewhat one-sided. Morison may have agreed with his ideas of typographical improvement, but the evidence is that he found Hobson, a tough northern businessman, unsympathetic.

Below: the top left-hand corner
of the opened out Pelican Press
specimen sheet (facsimile).

Pages 54 and 55:
Opening page of the Pelican Press
specimen, with a 'pelican in her
piety' printer's mark, and the
specimen when opened out (both
reduced).

TH

OF TH

The Type Specimens dis
desire a particular character and si

THE TYPES

BORDERS ORNAMENTS INITIAL
LETTERS FLOWERS & DECORATIONS

OF THE PELICAN PRESS

SET OUT FOR THE SATISFACTION
AND CONVENIENCE OF CUSTOMERS
AND PUBLISHED
ANNO DOMINI

M D C C C C X X I

No. 2 CARMELITE ST., LONDON, E.C.

THE TYPES
OF THE PELICAN PRESS

The Type Specimens displayed hereunder are grouped and numbered for the ease of customers who desire a particular character and size. In each case, where they are available, there are shewn the Roman faces (with small capitals) and the Italic letters. It is to be noted that the Italian, Plantin, Old Face, and Imprint types are available for machine setting, and that these faces have been improved by the addition and substitution of special letters and ligatures designed to the order of the Pelican Press

CASLON OLD FACE SERIES

THREE · ABCDEFGHIJKLMNOPQRSTUVWXYZ

FOUR · ABCDEFGHIJKLMNOPQQUQRSTUVWXYZ

FIVE · ABCDEFGHIJKLMNOPQQURSTUVWXYZ

SIX · ABCDEFGHIJKLMNOPQQU RSTUVWXYZÆŒ

SEVEN · ABCDEFGHIJKLMNOPQURSTUVWXYZÆ

EIGHT·ABCDEFGHIJKLMNOPQQUQu RSTUVWXYZÆŒ 1234567890 & abcdefghijklmnopqrst uvwxyzfifflffiffifflfflæœ · Old face 18 point

NINE · ABCDEFGHIJKLMNOQUR
abcdefghijklmnopqrstuvwxyzé 123456 *abcdefghijklmnopqrstuvw* Old face 24 point

TEN · ABCDEFGHIQURSTU
abcdefghijklmnopqrstuvwxyćd *abcdefghijklmn* Old face 30 point

ELEVEN·ABCDEFGHI
abcdefghijklmnopqrstućt *abcdfećtfi* Old face 36 point

TWELVE·ABCDEF
abcdefghijklmnopqćt *Quećtfi* Old face 42 point

THIRTEEN·AB
SUITABILITY
abcdefghijklmnoćt
abc Old face 48 point

14·ABCDEF
abcdi 60 point

15 ABCDE
abcdf 72 pt

ABCDEFGH

THE CLOISTER SERIES

THREE · ABCDEFGHIJKLMNOPQRSTUVWXYZ

FOUR · ABCDEFGHIJKLMNOPQRSTUVWXYZ

FIVE · ABCDEFGHIJKLMNOPQRSTUVWXYZ

SIX · ABCDEFGHIJKLMNOPQRSTUVWXYZ

SEVEN · ABCDEFGHIJKLMNNOPQRSTUVW
abcdefghijklmnopqrstuvwxyz&abcdefghijklmno *Cloister* 24 point

EIGHT · ABCDEFGHIJKLMNO
abcdefghijklmnopqrstuvwxyz & 12345 *abcdefghijklmnopqrstuvwxyz* Cloister 30 point

NINE · ABCDEFGHIJKLM
abcdefghijklmopqrstuvwxyzfi & *abcdefghijklmno* Cloister 36 point

TEN · ABCDEFGHIJKL
defghijklmnopqrstuvwxyzfi *abcdefghij* Cloister 42 point

ELEVEN · ACDEFG
abcdefghijklmnopqrstuv *abcdefg* Cloister 48 point

12 · ABCDEFGHI
abcdefghijklmnopq
12345 Cloister 60 pt

13·ABC· TITLING 30PT

14·A·TITLING 36 PT

15 · ABCDEFG
TITLING 48PT

19·ABCDefghijklmno · Cloister Bold 24 pt

20·ABCdefghij · Cloister Bold 30pt

21·ABCDEFghijklmno·36 pt

22·ABCDE fghijkl·42 pt

23·ABCDEFG·48PT

THE MACHINE FACES

FORUM CAPITALS (ONLY)

THREE · ABCDEFGHIJKLMNOPQRSTUVWXY Z · & 1234567890L · THE FORUM CAPITALS 14 PT

FOUR · ABCDEFGHIJKLMNOPQRS TUVW &1234567890 · FORUM 18 POINT

FIVE · ABCDEFGHIJKLMNO 12345678 & · FORUM 24 POINT

SIX·ABCDEFGHIJKLMN
1234·FORUM 30 POINT

7 · ABCDEFG · 36 PT

8·ABCD·48 PT

THE KENNERLEY SERIES

8·ABCDEFGHIJKLMNABCDE
FGHIJKLMN abcdefghijklmnop&
12345 abcdefghijklm Kennerley 24 pt

9 · ABCDEFGHIJKLabcde
fghijklm& · Kennerley 30 pt

10 · ABCDEFGabcdefg
hijklm · Kennerley 36 pt

THE COCHIN SERIES

THE MOREAU-LE-JEUNE

THREE - ABCDEFGHIJKLM
abcdefghijklmnopqrstuvwxyzæœfifffl 1234567890 The Moreau-le-Jeune 24pt

FOUR-ABCDEFGHI
JKLMNOPQRSTUV
WXYZÆŒÇQU1234
Capitals only Moreau full face 24 pt

THE FOURNIER-LE-JEUNE

FIVE - ABCDEFGHIJKLMNOPQRS
TUVWXYZÆŒÇ& Neither roman nor lower case with this letter Fournier-le-Jeune Initials 18 point

SIX - ABCDEFGHIJKLMN
OPQRSTUVWXYZÆŒÇ&
For discreet use only Fournier-le-Jeune 30 point

THE NICOLAS COCHIN

FOUR - ABCDEFGHIJKLMN
OPQRSTUVWXYZÇ&abcdefghij
klmnopqrstuvwxyzæœç fifffifffl 1234567890
0AB Nicolas Cochin, small face, 24 point

FIVE-ABCDEFGHIKL
MNOPQRSTUVWX
YZÇ& abcdefghijklmnopqrstu
vwxyz1234567890 These types
known as Nicolas Cochin 24 pt

SIX-ABCDEFG
abcdefghijklm·123568
nop N. Cochin 36 pt

SEVEN-AI
abcefinorstuvwx
Nicolas C. 60 pt

CAXTON BLACK LETTER

This form is available at 30 point
the Pelican Press 48 pt

CHARLES·W·HOBSON : 3. ST. JAMES'S SQUARE : MANCHESTER

TELEGRAPHIC ADDRESS: "PILOT, MANCHESTER" :: TELEPHONE : CENT.4744

ADVERTISING

July 16. 1920

Mess.ʳ Sidgwick Jackson

Dear Sirs:-

I send the enclosed knowing your interest in all that pertains to good printing. It may interest you financially. but if not I take the opportunity of officially notifying you of my connection as manager of The Cloister Press L.ᵈ From the Prospectus you will see what are our aims. We shall not be a "book house" in the generally accepted meaning, but I have planned the works to produce fine books such as Edn de luxe. I hope that I shall never print on "art" paper unless it be Matt. and with some of the old Ballantyne crafts men have every confidence of producing work, similar to the old private presses. I have chosen only about 6 faces of type as I am convinced that with the best craftmanship I can get as good a time from 6 times - ay better - than from a dozen

Yours truly
W Lewis

56

Left: a letter from Walter Lewis announcing his connexion with the Cloister Press and his plans for it.

Right: first page of Morison's Cloister Press broadsheet on fleurons (reduced). Economical use was made of the decorative unit, which had already appeared on the front of a four-page publicity circular entitled *Taste and Judgment*, and which ended up, suitably pierced, to incorporate the initials of the Lanston Monotype Corporation Ltd, on the cover of the *Monotype Recorder*, January/February 1922, as shown on page 71.

Page 58: the opening page of a Cloister Press broadsheet designed by Morison.

Page 59: the back page (in the form of an advertisement) of Morison's Cloister Press broadsheet 'The Forum Capitals'.

A DISPLAY *of* FLEURONS

Ornaments, Flowers, Head & Tail Pieces

Borders, Rules and Frames, etc.

At the disposal of Clients of

THE CLOISTER PRESS

A.D.

MCMXXII

Heaton Mersey, *near*

MANCHESTER

At the CLOISTER PRESS *Limited*

Herbert Simon recalled that Morison, in one of his anti-capitalist moods, would shrug his shoulders and say: 'I suppose that chap Hobson is going to see I do what he tells me.'

It was with reluctance that Morison agreed to join the Cloister Press, not liking the idea of living in the north of England, despite the 'daisy-sprinkled meadow' (he preferred paving stones, as he once told Eric Gill), but he had no option, as Meynell had been sacked from the *Herald* and had returned to the Pelican Press, leaving no place for Morison, and so he journeyed to Manchester in the summer of 1921. He had no intention of staying in the north of England. When Herbert Simon asked him: 'How are you going to like living in Manchester?', he replied: 'I don't think they will make me', and he began agitating for a London office quite soon. One of the benefits of being near

TYPOGRAPHICAL DECORATION & ILLUSTRATION

DECORATION has, from the early days of the craft, played an important part in printing. The rough wood-cuts of the 15th century, the elaborate and finished productions of the French and Italian Renaissance artists, the strips of conventional ornament which followed, and the small metal flowers of the past are sources of inspiration to present-day craftsmen. A sagacious and disciplined use of ornament will go far towards the making of a handsome book or seductive catalogue. Decoration in the hands of an able printer will of course effect much more than mere ornamentation. In addition to the purposes of utility, such as the emphasis of a title, or the rendering of one part of the printed page distinct from another, or the giving of special place to panels of more important sections, decoration can be made to express and reinforce the text. It can be used in a broad sense to give a luxurious character to a luxurious idea, to add a note of elegance or of fancy when required, and in the specialised sense ornament may be drawn to indicate a period of history, a subject or a story. It will suggest an atmosphere, convey the feeling of stability or antiquity of the firm concerned, or otherwise assist expression. The advertising of jewellery, furniture, plate, and other commodities in which there may be a " period " interest is naturally suitable for decorative treatment. Nothing could be more appropriate than that the decoration should suggest the selling points of the goods. ¶ To the production of all varieties of plain and decorated printing the CLOISTER PRESS brings understanding and enthusiasm. It is a mistake to suppose that printing of special character must also be a matter of special expense. The CLOISTER PRESS is willing to submit sketches and finished drawings from its studio. It has, indeed, an unusual competence in the field of illustration for advertisers. ¶ Nevertheless, while on the one hand it may be well to commission a drawing, the almost infinite uses of the printers' flowers should be borne in mind. These mobile ornaments are conveniently cast upon type bodies, and for a very large number of purposes are as appropriate as they are inexpensive. ¶ See the separate display of type-flowers.

GASTON RIVES

MARSHAL OF BURGUNDY 1601-1621

BY

FRANCIS PHILLIPS

LONDON

PRINTED FOR THE BOURBON SOCIETY AT THE CLOISTER PRESS

MCMXXII

The Cloister Press recommends the Old Caslon Black-letter for the occasional Ecclesiastical, Legal and other work in which an "old style" effect is desired

The Cloister Press has also secured a rare and interesting old French black letter which sorts agreeably with the Caslon and other old faces with which latter it may appropriately be used as a titling or heading. This letter is available only in one size, the eleven point Didot.

Telegraphic Address: Cloister, Heaton Mersey Telephone No.: Heaton Moor, 571

THE CLOISTER PRESS LTD
Parrs Wood Lane · Heaton Mersey · near Manchester

20th October,1922.

Dear Mr. Sidgwick,

Manythanks for your letter re our
Portfolio. The credit of display and
selection is entirely Morison's. All the
poor devil of a printer can claim is that
the press work is clean and sharp.

With regard to the source of the
"Maxims addressed to Young Married Ladies"
Morison has evidently picked it up from
some old book, of which, as you know, he
has a wonderful collection. I say this
because it is unthinkable that any modern
Dowager Countess would have the temerity
to express such an opinion.

The line block of the Pier Head
is by Horace Taylor. As a matter of fact,
he is rather annoyed with it, as it is
the blue block of a two colour subject.

I hope to be in London very shortly
when I will come and see you with probably
some interesting information with regard
to the development of this Press.

Yours sincerely,

F. Sidgwick, Esq.,
Messrs. Sidgwick & Jackson Ltd.,
3, Adam Street,
Adelphi,
London, W,C.2.

WL/BMW

Manchester was that he could study at the John Rylands Library, and life was
varied a little by scouting trips to Europe with Hobson in search of types and
papers.

While at Heaton Mersey Morison designed a series of broadsheets, the contents
of which were a mixture of the historical and commercial, neatly suited to the
customers the Press was seeking – book publishers as well as advertising managers.
Among the broadsheets were 'A Display of Fleurons', 'The Forum Capitals',
'The Goudy Letter', 'A specimen of Cloister Type (with a cunning arrangement
of a note within a side note), 'Caslon Old Face' (the text of which included some

☙Introducing the

Cloister Press to Publishers, Secretaries of Learned Societies, Schools, Churches, Universities, & all Kindred Bodies

The Cloister Press is newly established, but there are behind it several years of experience and endeavour in the art of fine printing. Its staff includes a managing director who has been for several years a designer of printing. As such he has produced a good deal of distinguished work, and has been included more than once in the small company of those who are thought to have raised the standard of modern printing in England. Associated with him is Mr. Stanley Morison, also widely known as a typographical artist. The manager of the Cloister Press is Mr. Walter Lewis, who was formerly with the Ballantyne Press and the Complete Press and has had a hand in much of the finest book production of recent times.

Morison described as a 'typographical artist', left, in a page from the Cloister Press booklet *The Distinguished Result i Printing* (1921). The 'managing director' is C. W. Hobson.

Right: an announcement explaining the origin of the *Manchester Guardian* printing supplement.

maxims addressed to young married ladies by a Countess Dowager), 'The English Black Letter' (which quotes the Elizabethan Statute concerning Labourers), and 'Typographical Decoration and Illustration'. These large pieces of printing enabled Morison to give scope to his 'lapidary' style of typography – well-spaced capitals and the sudden drop from a key line to smaller-sized subsidiary information.

Sidgwick wrote to Lewis, asking about the portfolio of broadsheets, and Lewis replied on 20 October 1922: 'The credit of display and selection is entirely Morison's. All the poor devil of a printer can claim is that the press work is clean and sharp'. Sidgwick had asked what the source of the maxims was, and Lewis replied that Morison 'picked it up from some old book, of which, as you know, he has a wonderful collection'.

One of the earliest broadsheets was devoted to the 'Garamond' type, which American Type Founders had cut in 1917. The Cloister Press had imported supplies from America. The layout of the broadsheet is slightly less decorative than the others; the title is high on the page, and at the foot is a description set in a mixture of upper and lower-case, which hints mildly at some of Morison's experiments of later years.

In 1921, at the point of Morison's arrival, a small four-page leaflet had been sent out as a first showing of the 'Garamond' (special customers received a french-fold leaflet on hand-made paper). Sidgwick received a copy, and was keen to be the

THE CLOISTER PRESS LTD
HEATON MERSEY · NEAR MANCHESTER

DEAR SIR

SOME months ago we had the pleasure of issuing a little brochure entitled "The Rewards of Better Printing."

In issuing that brochure we indicated that we should send out later from the Cloifter Press, a monograph on the relationship of Distinguished Printing to Business Development, and we had the pleasure of receiving from you a requeft for this monograph when it should appear.

As time has gone on we have somewhat modified the conception of this second booklet, which has eventually taken a rather different form from that which was expected, and has appeared as a Supplement of the "Manchester Guardian." You will see that the Supplement has been produced and printed by the Cloifter Press, and we have much pleasure in forwarding you a copy of the special edition in the hope that it may be of interest to you, and perhaps of some assiftance in solving the important business problem of better and more effectual printing.

We shall hope to have the pleasure from time to time of sending you further productions of the Cloifter Press which bear upon the same queftion.

Meanwhile we are, dear Sir

Yours faithfully

THE CLOISTER PRESS LTD

The Cloister Prefs
Heaton Mersey Nr Manchester
announces that it has established a
London Office to which communications
respecting printing &c should be
directed

N.B. the addrefs
St Stephen's House
Westminster S.W.1

January MCMXXII

first publisher outside the United States to use the 'Garamond' type. He decided to use it to set *Catherine*, by R. C. K. Ensor, and asked for a note about the origins of the type to accompany the book. Morison provided this in the shape of a small leaflet, the contents, as he explained later, not being based on any independent knowledge, but on the then unchallengeable authorities.

Whatever the origins of the Garamond type, it made no difference to the enthusiasm with which it was received, once publicity material began to circulate. Other typefounders decided to follow ATF's example, and add a 'Garamond' to their range of types. Linotype was stimulated, and both the Philadelphia and the London Monotype organizations decided to cut their own versions.

In the meantime, in the autumn of 1921, as Oliver Simon recalled, a small group met to discuss publicity for the cause of good printing. In addition to his employer, Harold Curwen and himself, there were present G. W. Jones, Fred Phillips, of the Baynard Press, and a representative of the Cloister Press. The presence of Jones is significant as it must have been at this meeting that this 61-year-old man, long acclaimed as one of Europe's finest printers, and now consultant to Linotype, first met Morison and Simon, the young representatives of the new wave in typography. Phillips, at 42, was one of the few commercial printers with any idea of the importance of design in jobbing and business printing. The discussion, according to Simon, was both diffused and heated, and reached no conclusions, possibly because Jones, the patriarch, could not see eye to eye with his juniors. Phillips was probably more sympathetic, as later he became

Card sent to announce the
Morisons' return to London in
January 1921. Presumably Mabel
and Stanley are being welcomed
by Morisons' mother, who
occupied the cottage during their
absence in the north.

January Mcmxrij

STANLEY & MABEL MORISON

return to

No. 11, Hollyberry Lane

Hampstead, N.W.3

London

from ALDERLEY EDGE *Cheshire*

part of the Simon-Morison circle, which Jones avoided, or was left out of,
according to different points of view.

Simon followed the representative of the Cloister Press out of the meeting and
invited him to a cup of tea in a nearby Lyons teashop. His new acquaintance was
Stanley Morison, and very soon he was being regaled with some startling
typographical opinions. Simon saw Morison only fitfully after this first meeting
as Morison was often up at Heaton Mersey, preparing a printing supplement for
the *Manchester Guardian*. This had started life as one of Hobson's projects, a
monograph which the Cloister Press had intended to send its customers. As time
went on the conception was modified and the booklet, which eventually took a

rather different form from that anticipated, appeared as a supplement to the *Manchester Guardian* (as a leaflet explained to customers). The supplement was naturally produced at the Cloister Press, and, in Simon's words, 'was indeed a very fine affair and played a big part in quickening the tempo of typographical activities at the time'.

Morison eventually persuaded Hobson that the Cloister Press needed a London office, and that he should run it. Consequently, in January 1922, it was announced that an office had been established at St Stephen's House, Westminster, to which communications 'respecting printing &c' should be directed. The announcement consisted of an engraving of an italic script, presumably written by Morison. A letterpress-printed, hand-coloured card was sent to friends to announce the return of the Morisons to Hampstead from Cheshire.

From St Stephen's House on 23 May 1922, Morison sent Simon a copy of the *Manchester Guardian* supplement. The supplement's article 'The History of Printing Types' had perforce to rely for its comment relating to contemporary types on the American initiative in the preceding twenty years. Reference was made to the influence of Edward Johnston and the need for type-faces to be designed by living calligraphic artists, an opinion Morison changed within a few years. Some of the contents were reprinted in *A Brief Survey of Printing History and Practice*, by Morison and Holbrook Jackson, but both the *Guardian* supplement and this book were superseded first by Morison's 'Type Designs of Past and Present' in the *Monotype Recorder* double number, September–December 1925, subsequently published as a book by The Fleuron Ltd in 1926, and by *A Review of Recent Typography* published under the same imprint the next year.

At the end of 1922 the Cloister Press had got into financial difficulties, and Morison found himself without a job. The exact sequence of following events is difficult to establish, but the chronology is important since it closely relates to Morison's claim that he propounded a type-cutting programme to the Monotype Corporation in 1922, which is now about to be investigated.

Some claims investigated

This chapter will examine three claims made by Morison, by endeavouring to sift out the facts about his first connexion with the Monotype Corporation and about the earliest type revivals with which he could have been concerned. Unfortunately, the Monotype Corporation's records on the subject were destroyed in a fire at their Fetter Lane headquarters and it has been necessary to resort to outside evidence.

The claims are that he was appointed Monotype's adviser in 1922; that in that year he proposed and had accepted a programme of type revivals; and that he suggested not only the Garamond type-face to Monotype, but also a variation in the italic, which, he said, was based on one of Granjon.

That Morison was vague about dates has been demonstrated in relation to his own baptism, and only in 1968 did Brooke Crutchley discover that the date of Morison's appointment as typographical adviser to the Cambridge University Press was not an oft-repeated '1923' but 1925, which, on reflection, is clearly more accurate, as Lewis, Morison's sponsor, did not arrive at the Press until 1923. Whether Morison was genuinely forgetful, or whether, in certain cases, there was some object in giving events an earlier date must remain a matter of conjecture.

When accounting for his incorrect attribution of the caractères de l'Université, at the Imprimerie Nationale, to Claude Garamond (or Garamont), Morison would explain that he had been following the unchallengeable authorities of the time. In the same way, recent writers (including the present author), in describing Morison's typographical revivals, have relied on one who seemed to be the unchallengeable authority – Morison himself. Closer investigation, however, reveals that Morison's statement that he presented 'a programme of typographical design, rational, systematic, and corresponding effectively with the foreseeable needs of printing' to the Monotype Corporation in 1922 needs to be considered with caution.

Morison used the words quoted, and repeatedly referred to the 'programme', in *A Tally of Types*, published by Brooke Crutchley, Printer to the University of Cambridge, in 1953, when the printer asked Morison to comment on those of the Monotype faces which had been installed at the University Press. But an examination of each of the type revivals in its historical setting points to an individual approach on each occasion, arising out of some specific set of circumstances. The emergence of '1922' instead of 1923 in relation to his appointment may be connected with Morison's desire to be thought of as the only begetter of Monotype's 'Garamond' type, which could then be considered the first in the alleged 'programme'.

Morison began making his claim to Garamond as early as 1923. Updike had written on 25 June, asking whether the English Monotype Garamond was the same as the 'Goudy' Garamont type in the U.S.A. Morison replied on 25 July, stating that the English Monotype Garamond was cut at his suggestion; that it

was begun in January or February 1921; and that, at the time, 'we were ignorant of any American Monotype intentions'. How far this statement fits in with fact will shortly be examined.

Jack Matson, Monotype's managing director, has always thought, from conversations with Morison, that 1923 was the date of his appointment, and, certainly, before the 1939–45 war there seems to have been no doubt about it. In an article on the Pelican Press (*Signature*, 12 July 1939) Philip James wrote: 'Meynell then returned to the Press until he founded the Nonesuch Press in 1923, the same year in which Morison joined the Lanston Monotype Corporation'. The date was confirmed after the war. An article, again in *Signature* (March 1947), on Morison as 'Typographer' carries the following introduction: 'The editor is indebted to Mr John Dreyfus of the Cambridge University Press for compiling the following article. Information obtained from interviews with Mr Morison about his work and his opinions is embodied in the text . . .' Morison must have been the source of the information that his connexion was brought about by Walter Lewis in 1923, Lewis having convinced H. M. Duncan, Monotype's managing director of the day, that Morison possessed commercial ability as well as typographical knowledge. In the light of Morison's circumstances at the end of 1922 this statement seems fair.

During 1948 a committee of the Double Crown Club began compiling a register of members for publication in time for its 100th dinner the next year, and in Morison's biographical note there appears the following: 'In 1923 he became typographical adviser to the Cambridge University Press with Walter Lewis as the newly appointed University Printer. This association bore fruit in productions of the highest order. In the same year he joined Oliver Simon in founding *The Fleuron* and the Monotype Corporation as typographical adviser.'

These references occur a good deal of time after the event, and if one could be found nearer the time it might be more conclusive. The Frank Sidgwick article on Morison in *The Fleuron* (No.3, 1924) can be considered in this light, as the following passage may indicate: '. . . and last year the Cloister Press rocket, having shot into its zenith and burst dispensed its stars – Lewis to become Printer to Cambridge University, Morison back to London. He is now 'advising' the Lanston Monotype Corporation, contributing to *The Fleuron*, and compiling books for the firm of Ernest Benn, who are just publishing as I write his vast *Four Centuries of Printing* [*sic*].'

From this one may judge that Sidgwick wrote his article in 1923, in time for publication the next year, in which case 'last year' would reasonably refer to 1922, at the end of which the Cloister Press certainly underwent a change of ownership, and *now* in relation to Morison would refer to 1923 when *Four Centuries of Fine Printing* was published.

In the same month as the Double Crown Club's dinner (May 1949) the Monotype Corporation celebrated its jubilee, and, for the occasion, a booklet was privately printed, entitled *The Pioneer Days of 'Monotype' Composing Machines*, and here, in reference to H. M. Duncan, appears the first sign of the new canon: '. . . it was H. M. Duncan who called in Mr Stanley Morison in 1922 as Typographical Adviser, and empowered him to plan and supervise the cutting of what was to prove the most important repertory of book and periodical type-faces ever made available at one time.'

This was consolidated in 1960 when the *Newberry Library Bulletin* carried an article 'The Work of Stanley Morison'. The editor, James M. Wells, asked Morison to look over his manuscript, which Morison did, adding material and

Dear Mr. Caslon: I have seen proofs of Mr. Menut's Garamond and on the whole prefer the American version. For one thing, the original (& the U.S.) l.c. f has a beautiful kern but in the Peignot version there is a f like your Kennerley almost. Would it not be possible to recut some sorts if you had a concordat with Peignot? I very much want to have the cap J (this shd. be a descender the Caslon o.f.) both rom. and ital. cap Q, an original & ampersand for the italic.

I enclose for your interest a proof of the first job in which the American letter has been used. But if I were a typefounder (and I wish I were) I think that as the American Typefounders have a Garamond and Menut has one and Goudy is to cut one for the Lanston American Mono Company I should cut a face which was originated a little after Garamond's time by one of the Le Bé's who succeeded him. It is very like the Garamond in many ways, yet the R is more perfect (both rom. and ital.) Also I prefer Le Bé's M with the trifle-spreading legs in the smaller sizes, the general roundness of the italic as compared with that of Garamond (the original and the copy)

making amendments. He passed the reference to his appointment as typographical adviser to Monotype in 1922. He must have forgotten the earlier references to 1923, a date which was never altered in his entry in *Who's Who*.

Morison also forgot a letter (or a copy of a letter), which still survives, to one of the Caslons, of the Caslon Letter Foundry, from the Cloister Press, dated 19 September 1921, which reads: 'Dear Mr Caslon: I have seen proofs of Mr Menut's Garamond and on the whole prefer the American version. For one thing, the original & the U.S. l.c. f has a beautiful kern but in the Peignot version there is a f like your Kennerley almost. Would it not be possible to recut some sorts if you had a concordat with Peignot? I very much want to have the cap J (this shd. be a descender as Caslon o.f.) both rom. and ital. cap Q, an original & ampersand for the italic.

'I enclose for your interest a proof of the first job in which the American letter has been used. But if I were a typefounder (and I wish I were) I think that as the American Typefounders have a Garamond and Menut has one and Goudy is to cut one for the Lanston Mono Company I should cut a face which was originated a little after Garamond's time by one of the Le Bés who succeeded him. It is very like the Garamond in many ways, yet the R is a more perfect (both rom. and ital.). Also I prefer Le Bé's M with the trifle-spreading legs in the smaller sizes, the general roundness of the italic as compared with that of Garamond (the original and the copy).'

Morison also refers in the letter to a project by American Type Founders ('wh. is still in the "talk" stage') to fit up a foundry in Britain to cast Cloister and Garamond. He asks Caslon to recut various flowers, adding: 'If you do so I would willingly use my influence to secure orders from English and American presses.'

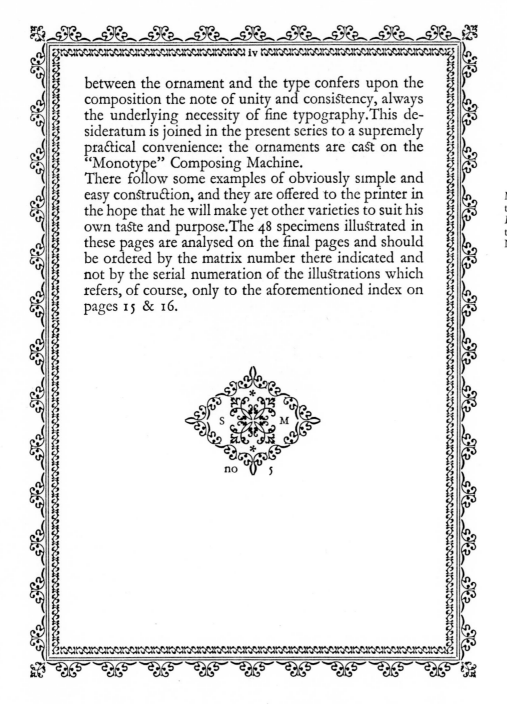

between the ornament and the type confers upon the composition the note of unity and consistency, always the underlying necessity of fine typography. This desideratum is joined in the present series to a supremely practical convenience: the ornaments are cast on the "Monotype" Composing Machine.

There follow some examples of obviously simple and easy construction, and they are offered to the printer in the hope that he will make yet other varieties to suit his own taste and purpose. The 48 specimens illustrated in these pages are analysed on the final pages and should be ordered by the matrix number there indicated and not by the serial numeration of the illustrations which refers, of course, only to the aforementioned index on pages 15 & 16.

Morison's initials at the end of the text of *Monotype Flower Decorations* (1924). No.5 refers to the matrices used – one pair of Nos.230–1, No.219, and asterisk.

The contents of this letter and its date indicate that Morison did not think another 'Garamond' was necessary and so was unlikely to have suggested one to Monotype nine or more months earlier as he told Updike. It would also not be overstating the case to say that he was wooing Caslon, the typefounder, and that the idea of working with a composing machine manufacturer did not enter his head.

In any case, Monotype records show that their Garamond was not cut until 1922 (as recorded correctly in *A Tally of Types*). If Morison made a slip of the pen and wrote '1921' instead of '1922' in his letter to Updike, the Caslon letter makes nonsense of his suggestion that they were ignorant of American Monotype's intentions at the time, since he specifically refers to Goudy's design for the American company.

In January and February 1921 Morison was busy at the Pelican Press but visited Manchester to discuss the Cloister Press job. In particular he was concerned

The Monotype Recorder

*A Journal for Users and Prospective Users of the
Monotype Composing and Casting Machine*

Cover (reduced) of the *Monotype
Recorder*, 1922, incorporating the
same decorative unit as used in the
Cloister Press broadsheet on
fleurons, reproduced on page 57.

January & February, 1922 *Vol. xxj, No. 187*

with the production of the specimen sheet, and with his first study, *The Craft of
Printing*, which was published on 5 May. The Pelican did not have the ATF
Garamond in its range of types, and Morison had no experience of working
with this face until at least August of the year when on the staff of the Cloister
Press, Heaton Mersey. He had a copy of the ATF publicity booklet on Garamond,
issued in 1921, but there is no way of telling exactly when this came into his
possession. It may not have been until he reached Heaton Mersey.

A proper start at Heaton Mersey was delayed because although Stanley and
Mabel Morison travelled to Manchester on 1 June, they were back in London in
a month's time to go on a trip to Italy with Hobson. However, the french-fold
leaflet on the Garamond type ('A first showing') had been quickly prepared by
Morison and was sent out to customers while he was away. It mistakenly
attributed the original type to Claude Garamond, and also the revival of the
actual type shown in the leaflet to the initiative of Bruce Rogers. This was

NOTES ON THE CRAFT OF
PRINTING

RINTING IN ITS early stages made slow progress despite its general excellence. Success for the new invention was not immediate, if only because the scribes and illuminators of the day were not ready to yield their interests in the printer's favour without a struggle. Indeed, these two professional classes, both inevitably enemies of the craft, managed to thrive for a hundred years or so after Gutenberg had produced *Cf. the type on* his famous forty-two-line Bible at Mainz in *page 4* 1456. It was, therefore, the necessity of the early printer's life that he should equal by his types the beauty of the works turned out by hand from monastic and other scriptoria, and he had to wear down the opposition of many high-and-mighty patrons of illuminating and writing to whom the press was a mere vulgar toy not to be encouraged by gentlemen. Illuminators were found, however, to apply their skill to the printed page,

Cf. the type on page 4

Opening page of Morison's first study on typography
The Craft of Printing: Notes on the History of Type Forms
(The Pelican Press, 1921).

repeated in the small leaflet sent out with the book *Catherine* by Frank Sidgwick. It was a curious error, as Morison knew perfectly well that Rogers had no typefoundry at his disposal and that ATF had been responsible, but as Rogers had been one of the half-dozen printers to head the queue for ATF's Garamond, and had shown Morison specimens, Morison must have thought he was

responsible for the type. On receiving a copy of the Cloister Press leaflet, Rogers told Morison that Bullen, of ATF, had been the inspiration, which Morison discovered for himself when he obtained a copy of Bullen's publicity booklet on the type. He then wrote to Bullen apologising for the attribution to Rogers.

July, however, was spent in Italy with Hobson, getting as far down as Fabriano. There, in the mills of Pietro Miliani, they saw, according to Hobson, 'the most lovely of all papers' being made. On the evening of their departure they were invited to a private celebration in honour of the Bishop of Fabriano, who was leaving to take up a new appointment. There was an immense buffet, and Hobson, excited by the strange new foods, could not deny himself the pleasures of eating, and in consequence the all-night journey to Florence was, for him, very disagreeable. Morison was not upset. Mrs Morison left for England before the two men, who eventually went on to Milan.

In the article about the Pelican Press in *Signature*, Philip James inadvertently overestimated Morison's role at the Cloister Press when he wrote :'. . . he was persuaded to organize the Cloister Press, Heaton Mersey, by the advertiser, C. W. Hobson, who had been an important client of the Pelican'. This not only has no foundation in fact, but overlooks the personalities of C. W. Hobson, the founder and managing director, and Walter Lewis, the manager. Lewis had been at Heaton Mersey since early 1920 doing the 'organizing'. He had taken a year to plan the works. James and others also overlook the fact that Hobson had a team of specialists at his disposal, including W. Haslam Mills, the famous copywriter, William Grimmond, the typographical designer, who had been with him since 1916, and Harold Taylor, a distinguished artist. Hobson was, however, the main inspiration, and considered Morison only as his 'associate'. Hobson had his own ideas about typography, and ordered Garamond from ATF during 1920, but by the time the Press started operating early in 1921 (before Morison's arrival) only an advance supply had arrived from America – consisting of the 6, 8, 10, 12, and 14 point. By the time Morison reached Heaton Mersey the 18, 24, 30, 36, and 48 point had been received, and one of his first jobs was to design the Garamond broadsheet. Morison was not in any way in charge at Heaton Mersey, but was the 'typographical artist'. This was one of the reasons why he wanted to get back to London and to independent action.

As has been pointed out, the 1914–18 war had held up the development of ATF Garamond, and so no publicity was undertaken for the type until 1921. News of the type began to reach Britain by 1920, and a few printers who had been converted to mechanical composition began pressing Monotype to cut a 'Garamond'. They were headed by Eric Humphries, of Lund Humphries, Bradford, one of the earliest users of the Monotype system in Britain. He recalled that a small group of printers, including himself, Harold Curwen, and Oliver Simon, called on William Burch, Monotype's company secretary, to press the case for a machine version, and that later Burch called them into his office and said : 'I have decided to ruin the Corporation, and I am going to cut Garamond'.

Coinciding with its decision to cut Garamond, the Corporation decided on a policy of entrusting the printing of each issue of its house journal, the *Monotype Recorder*, to a different printer, being a user of its products. For the January/ February 1922 issue the Cloister Press was chosen. Since Morison had no executive responsibility, it is most likely that the manager, Walter Lewis, who maintained contact with London clients, was asked to carry out this job by Monotype. As it happened, enough of the new Garamond type had been cast to make a preliminary announcement in this issue. A possible small example of Morison's lettering

occurs on the cover. A stock ornament, used by the Cloister Press for its publicity leaflet 'Taste and Judgment', has been pierced in four places and the calligraphic letters 'L M C Ld' dropped in.

The sequence of events in relation to Monotype Garamond, as revealed by Monotype's works records, is that in January 1922 H. M. Duncan decided that the face should be cut from an original at the Imprimerie Nationale, which he could obtain. The model turned out to be a modern piece of printing, *France-Amérique 1776, 1789, 1917: Message du President Wilson* (which suggests Duncan's American influence). From time to time the works wanted to look at other specimens, and in May a copy of the Cloister Press broadsheet on the ATF Garamond and a Stephenson Blake book were sent. In September a proof by Peignot of Paris 'supposed to have been taken from the original' was dismissed as rather a poor reproduction.

To speed up the completion of the first sizes of Garamond to meet the demands of Lund Humphries, who wanted the 12 and 14 point by the beginning of August, Monotype placed this face ahead of its Porson Greek in the cutting schedule. The reason for the urgency was because Eric Humphries had decided to exhibit Monotype Garamond to the world through the medium of the 1923 *Penrose's Annual*, which his firm published. Independently, Morison had been recommended to Humphries as a useful man by Oliver Simon, and Morison was asked to write a note on the Garamond type for the *Annual*.

This unusual coincidence may have strengthened an impression that Morison had something to do with the cutting of the Garamond and that he chose it to set the issue of *Penrose's Annual*, which he designed. This is not so, as the choice was that of Eric Humphries, who, by urging the Monotype Corporation on, had managed to get matrices ahead of anybody else.

In August, trials of the new type having proved satisfactory, proofs were sent to a number of people for criticism. Mr Blake, of Stephenson Blake, made his on 15 August, and Mr Morison, of the 'Cloister Press', on the 28th of the same month. If Morison had been Monotype's adviser at the time it is unlikely that he would have seen proofs only at the end of the manufacturing process. In fact, he was simply one of a number of people whom Monotype thought had an interest in their Garamond.

This is underlined by the fact that matrices were already available by the end of August, and the September/October issue of the *Monotype Recorder* announced that the series was completed from 12 to 36 point. Morison, in *A Tally of Types*, maintains that Garamond was completed in one size only (24 point) in 1922, which must have been a sheer lapse of memory, since he wrote a short article for the November/December 1922 issue of the *Recorder* at the request of R. C. Elliott, Monotype's publicity manager. The printing and design of the issue were entrusted to Gerard Meynell's Westminster Press, and an artist was commissioned to re-draw a head of Garamond from the original engraving by Léonard Gaultier, Garamond's brother-in-law.

Lund Humphries had worked at speed, setting the 1923 *Penrose's Annual* in the new type, printing and binding review copies, which were sent out in October. Bernard Newdigate received his copy, and planned his review for the February 1923 issue of the *London Mercury*. He was so impressed by the new type that he asked Monotype if his review could be set in it. Monotype were delighted at the thought of the publicity and made their own request. Could the review appear in the *Monotype Recorder*? The result was that Newdigate's February review appeared prematurely in the November/December issue of the *Monotype*

Recorder. While this bibliographical tit-bit underlines the rapidity with which Garamond was ultimately produced, it also emphasizes that Morison could have had nothing to do with its production.

By about September 1922, it was clear that Morison and the London office were to become the first casualties in the Cloister Press financial troubles, although these were not such as to preclude Lewis, as late as 20 October, from looking forward to giving Frank Sidgwick 'some interesting information with regard to the development of this Press'. In fact, the Cloister Press changed ownership in the November. Morison had seen the warning light, and friends, notably the Simon brothers, began looking round for alternative employment for him. Morison, himself, went off to Germany to study.

Letters from Germany, during October and November, to Oliver Simon concern *The Fleuron* and plans to become a book publishing house; there is nothing about being given an appointment at Monotype. Nor is there anything in Morison's letters to Updike, from London, as late as 20 December, to indicate anything except that he had left the Cloister Press. It is therefore probable that Lewis introduced Morison to Duncan early in January 1923. Duncan had obtained a life of Baskerville (probably that by Straus and Dent, 1907) and was thinking of cutting a Baskerville type. Records show that he asked 'Mr Morison' to let the works have a Caslon specimen book showing their version of Baskerville, but by 31 January, after a visit to the works, Duncan had decided that the Monotype Baskerville should be a direct copy of the original type-faces.

Duncan was a powerful figure at the Corporation, of which he was one of the founding fathers, and his word would have carried greater weight even than that of the autocrat of the works, Frank Hinman Pierpont. Duncan also had some idea of what was required in type-design, and when Lewis mentioned Morison to him he may have felt that Morison could assist him. In that case it is not improbable that they discussed various type-faces as potential revivals. But Duncan was a sick man who gradually withdrew from activities at Monotype and returned to America, where he died, in Philadelphia, on 9 October 1924.

The active direction of the firm fell increasingly on the shoulders of his successor, William Burch, who, Morison admits, was 'less imperative' than Duncan. Pierpont was strongly opposed to 'interference' from head office, and he and his engineers were not in favour of cutting type-faces for which there was not, in their view, an obvious demand. It turned out therefore that while Burch either confirmed or initiated Morison's appointment as a part-time adviser to the Corporation, there is no evidence that he authorized the fulfilment of a typographic plan. Bearing in mind the situation prevailing, everything points to the contrary conclusion – that Burch had to feel his way gradually. If a plan had been agreed, then Morison would not have had to connive with his friend Walter Lewis, the Cambridge University Printer, to suggest to the Corporation certain type-faces which the Press said it required, and which gave Burch a lever to use against the works manager.

Morison's description of a 'programme' as 'rational, systematic, and corresponding with the foreseeable needs of printing' does not fit in with what actually developed. Most of the revivals were not obviously part of some pre-conceived plan but rather were chosen because they were to hand and were felt to be desirable. Nor was there much system in the issue of type-faces which went from an 'old face' to a transitional, back to two 'old faces', on to a French eighteenth-century face, to a 'modern', modern romans, and a sans serif; nor was there any particular reason why there should be a system. The aim, which was

achieved, was to provide printers with a variety of the best type-faces, irrespective of origin, as opportunity arose, and which they could use for different kinds of work. 'The foreseeable needs of printing' had no meaning, as Monotype did not cease to issue new faces during Morison's lifetime and continues to issue them.

The Garamond and Baskerville were produced because rival typefounders had found them profitable; Poliphilus was suggested by an outside publisher; Bembo, Morison was not conscious of until after Poliphilus had been issued in 1923; Perpetua arose from Morison's persuasive talks with Eric Gill from 1925 onwards; Gill sans arose from a specific need for a display face in the late twenties; Bell from an accidental discovery in 1926; Centaur was offered to Monotype by its creator, Bruce Rogers, and such types as Goudy Modern (first cut in 1918) were already in existence. For some of the faces italics had to be found or invented. Indeed, rather than constituting a plan, the type-faces issued to the world by Morison were often brilliant improvisations, and are none the worse for that.

Part of Morison's thinking in the 1950's was devoted to a search for some unifying element in type-design and, as will be suggested, it may well be that he subconsciously tried to fit his own work into a pattern retrospectively. There may be another psychological reason for the insistence that Duncan accepted his plan in 1922. Morison never wished to give the impression that he was employed by others – he was the employer – 'the Corporation didn't hire me, I hired them' was his version. This may have been partially true in later life, when by using his position in one firm he could be said to be employing the services of another with which he was connected, but this was simply not true of early 1923 when he was in a desperate economic position, having to sell books and his stamp collection to make ends meet.

He was not the Morison of thirty years later, whose word carried great weight, the Morison known to those who have written and spoken about him most, but a hard-up, comparatively unknown figure. Duncan would not have stood for any high and mighty approach, and when Morison got the Monotype appointment it was carefully hedged in by Pierpont and his supporters. Though he hated to admit it, Morison had to do as he was told, just as at the Cloister Press. Only as he became famous and courted by industry did he achieve something near the status he desired.

That the Garamond demanded 'thorough investigation', as Morison wrote in 1953, was not apparent at the time, and it was only after he met Beatrice Warde that he appreciated the need for such investigation, and it was Mrs Warde, in the guise of Paul Beaujon, who finally solved the mystery of the origin of the types. In her report, however, and in Morison's writings there is no hint or suggestion that the italic cut by Monotype was anything but that of the caractères de l'Université.

At this point it would be as well to introduce Beatrice Warde more firmly into the narrative. Born in New York on 20 September 1900, Beatrice Becker graduated from Columbia University and was appointed assistant librarian by the Librarian, H. L. Bullen, at the American Type Founders Library in Jersey City. Here she had the run of the books because few people visited the Library, and was able to draw upon Bullen's great fund of practical knowledge. She married Frederick Warde, Printer to Princeton University, and together they organized a book exhibition entitled 'Survivals in the Fine Art of Printing', at the end of each section including 'revivals', thus becoming aware of the work of the 'Lanston Monotype Corporation (England)'. Beatrice Warde has recorded the sense of revelation she experienced when she examined the Monotype broadsheets

for Poliphilus and Blado. She then saw the man responsible for the broadsheets, Stanley Morison, first in the office of D. B. Updike and then at the ATF Library.

When in 1924 C. W. Hobson wanted somebody to scour Europe for good type-faces the Wardes were recommended. They travelled to England in January 1925. Morison asked Beatrice Warde to write an article for *The Fleuron* on the Garamond types, which was to establish her reputation and which will be referred to.

The relationship between Morison and Beatrice Warde is often thought of as one of master and pupil, but Beatrice Warde was very informed about typography and printing before she ever met Morison, and remained an independent scholar in the field. Her work as a publicist tended to obscure her scholarly inclinations, and she intended to put this right after her retirement by devoting herself to research, not least into some of Morison's claims. Unfortunately, eye trouble, illness, and finally death made this impossible, and it is therefore not easy to assess how important her knowledge was to Morison and to what extent she might have emerged as a leading typographical authority.

Nevertheless, the results of her researches into the 'Garamond' types are available in *The Fleuron*, No.V (1926) and in *The 1621 Specimen of Jean Jannon etc.* (Paris, 1927), and, by good fortune, John Dreyfus was able to record an interview with her before her death, which gave some of the background to the Garamond research and which was published in *Penrose Annual*, 1970, Vol.63.

It was H. L. Bullen who first doubted the attribution of the caractères de l'Université to Claude Garamond. At the ATF Library he had shown Beatrice Warde a specimen of the ATF version of 'Garamond' and told her that the original was definitely not a sixteenth-century type. He said: 'It is based upon the type at the Imprimerie Nationale, which is itself *attributed* to Garamond, but I have never found a sixteenth-century book which contained this type-face. Anyone who discovers where this thing came from will make a great reputation.' Bullen was prophetic. She began work on the article for *The Fleuron*, which was virtually ready for publication when she visited the British Museum to check a date. In the Bagford collection she came across a page printed by Jean Jannon and saw the type she had been searching for. She at once took the night train back to Paris, and was able to study the 1621 specimen of Jean Jannon, a relatively obscure printer-typefounder of Sedan.

When the *gros canon* type of the specimen was compared with the Imprimerie Nationale's 'Garamond', as the caractères de l'Université had come to be known, it left no doubt that the two were identical. Morison wrote of this discovery in 1953: 'It was shown that these romans were in fact excellent copies of authentic Garamonds by the expert seventeenth-century punchcutter Jean Jannon (1580–1658)', and: 'He was, in fact, for some years before 1621, occupied in an effort precisely similar to that being made by the Monotype Corporation in 1922: to imitate the typographical style, in its purity, of the great masters of the roman letter and to make available to the trade faces that had once been esteemed.'

Beatrice Warde's discovery meant entirely rewriting *The Fleuron* article, but, she said 'Morison never begrudged the additional expense or trouble'. It is to be hoped not, since a major piece of typographical scholarship was involved. She returned to New York, and there found an invitation addressed to M. Paul Beaujon to edit the *Monotype Recorder*. A few of the Monotype people were aware of the true identity of M. Beaujon, but others were astonished to meet a beautiful young American woman instead of the Frenchman they were expecting. She obtained a 'quarter-time' job editing the house journal, and then eventually

became publicity manager of Monotype and an evangelist for good typography. She retained an affection for M. Paul Beaujon and in her introduction to *The Crystal Goblet*, a collection of essays, published in 1955, she wrote of him: 'Like Enoch Soames, he will one day be seen again in the British Museum.' Regrettably this was never to be so.

Jan van Krimpen, the Dutch type-designer, thought for a long time about Morison's comment on Jannon in *A Tally of Types* and, since he was a man of independent character which quite matched that of Morison, he did not hesitate to disagree with Morison in print. In a closely argued article, entitled 'On Related Type Faces' in *Book Design & Production* (Summer, 1958), he criticized Morison's suggestion that Jannon had made 'an effort precisely similar' to that of the Monotype Corporation in 're-creating' Garamond's type, and put forward the case, quoting Morison's writings where necessary, that Jannon, as a late offshoot of the line of Griffo, Augereau (Garamond's master), Garamond, and Le Bé, was simply working in the same idiom, incorporating modifications which he thought improvements. It was doubtful whether he was aiming at a close facsimile, and probably did not know the names of the great punch-cutters of the past, including that of Garamond.

Van Krimpen's article is useful when considering Morison's separate claim (in *A Tally of Types*) that a Granjon italic and not the Jannon was recommended by him and reproduced by Monotype to accompany the 'Garamond' roman. Morison's essay headed 'The Italic of Robert Granjon/Originally cut for the Printers of Paris 1530/First recut by the Monotype Corporation 1922' is devoted to the uncertain situation in sixteenth-century Paris with regard to the development of the italic type-face. The *œuvre* of Granjon, if accurately distinguished, says Morison, would illustrate this remote branch of typographical history, but Morison does not help by adding to the confusion: 'As will be seen from the following text, Granjon's Paris italic was highly ligatured. He was, without doubt, second only to Garamond in expertness and greater in versatility.' Then follows text set in Monotype's 'Garamond' italic, derived, like the roman, from Jannon's cutting.

It is stated that Robert Granjon was active as a punch-cutter from about 1545. What therefore can one make of the date 1530 in the heading? A. F. Johnson (*Type Designs*, London, 1959) gives 1543 as the earliest date for the use of Granjon's italics. Of himself, Morison writes: 'Some slight knowledge of italic encouraged the Corporation's adviser in 1922 to regard the fount used at the Imprimerie Nationale in association with the "Garamond" roman as uncontemporary in appearance. It was not discoverable in the early productions of the Imprimerie Royale, though it makes its appearance within a few years of its foundation. Moreover, as engraving, the related italic does not equal the quality of the roman. Accordingly, the Corporation was advised to rely upon the earlier, and not the later, italics used at the Louvre. The italic used in series 156 is based on that used in the Imprimerie Royale in 1640. As the original used for the purpose was composed in the size of gros canon (about 36-point) the Corporation arranged its first size of roman and italic for keyboarding, and casting on a large body, in fact 24-point.' Presumably, Morison is referring to type shown in the 1643 Imprimerie Royale specimen, which was not rediscovered until the 1950's, when he says 'that used in the Imprimerie Royale in 1640'. Only some of the sorts of the face were shown in this specimen in roughly 48-point, but this is of no consequence since there is simply no record of the Monotype works following a separate pattern for the italic than the roman of 'Garamond'.

A few years later (1528), there appeared a small italic, which retained roman capitals, and drew away from the Aldine in one or two characters only, e.g., the lower case l, t. These types were doubtless cast in the foundry attached to Colines' office. In 1539, six years after Tory's death, a series of strikes resulted in the issue, by Francis the First, of a decree regulating the printing trade. One of the articles made the founding of type a separate craft from that of the printer. Claude Garamond consequently established himself as a type-founder. His types were sold to master printers abroad, such as Plantin of Antwerp and, of course, to those of his own country. In 1540 he cut the magnificent series of romans and italics which the Lanston Monotype Corporation, Ltd. has reproduced, and now offers to the printers of our day. These types display great vigour and freedom. While the roman is particularly clear and open, the

The somewhat confusing article in *A Tally of Types* is uninformative as to why a particular type may be attributed to Granjon, and is made more confusing by the fact that Morison could not have seen the Imprimerie Royale specimen in 1922. Late in 1922 he was familiar with Granjon's italics in the 1592 Egenolff-Berner specimen, reproduced by Gustav Mori in 1920, but the gros canon size was not included. Because of the aftermath of the war, copies of Mori's pamphlet did not reach England till quite late in the day, and, in any case, the Egenolff-Berner specimen sheet (rediscovered in Frankfurt during the 1914–18 war) shows authentic types of Garamont, and mentions his name. As Van Krimpen, with typical perspicacity, if not quite perfect grammar, points out: 'Familiarity with the Conrad Berner sheet of 1592 might have persuaded Mr Morison against having the *Caractères de l'Université* followed instead of the Garamont true vintage or, at least, to attach Garamont's name to the Monotype rendering of the *Caractères de l'Université*.'

In other words, if Morison saw the Granjon italics on the Egenolff-Berner sheet, and guessing there was a gros canon size, recommended this to Monotype as a model, he must have been quite blind to the implications of the Garamont types on the sheet.

By an extraordinary twist of circumstance, Granjon's name was perpetuated in modern typography, and by no other than Morison's rival, George W. Jones, Linotype's adviser. Not unaware of the desirability of providing attractive book-faces, Linotype in 1923 turned to Jones for advice. He examined a number of old books and was attracted to a fount of type used in the printing of Jacques Dupuys and Jean Poupy, both of Paris, and recommended it for re-cutting for the Linotype. The resulting type-face, issued in 1924, was named 'Granjon' by Jones by way of a compliment to the sixteenth-century punch-cutter, and not because it was thought that he was in any way connected with the type. Ironically, the type turned out to be one of Garamond's. Beatrice Warde (Paul Beaujon) wrote in her article in *The Fleuron*: 'But fortunately a true Garamont design has been given to the public: that admirable "later" Garamont of the Egenolff sheet which so distinguished French books from 1550 on, and had so good an influence over Dutch and hence English taste. The first and immeasurably

the best of modern revivals of this letter was that of the English Linotype Company.' After describing its characteristics, she continued: 'For some reason the face is called "Granjon". It would seem that Garamont's name, having so long been used on a design he never cut, is now by stern justice left off the face which is undoubtedly his.'

Although the situation is by no means clear, it is suggested that Morison met Duncan early in 1923, and may have discussed type-face revivals informally, but that his only connexion with Monotype 'Garamond' was that of an interested observer; that his actual appointment with Monotype was in 1923, and that Burch was not in a position to approve a type-cutting 'programme', even if one had been put forward; and, finally, that the suggestion that Monotype cut a Granjon italic to accompany its Garamond roman is a figment of Morison's imagination.

Whatever Morison's exact relationships may have been with the Monotype Corporation, by 1923 he had a part-time job with them and, as Sidgwick wrote later, began contributing to *The Fleuron*, advising publishers, and writing the first of his large books.

The Fleuron, Penrose, and Baskerville

Oliver Simon recalled in his autobiography that on an afternoon in the late summer of 1922 a group of printing enthusiasts met in Morison's office (still that of the Cloister Press) to consider a suggestion by Simon that they form a publishing society to produce a book a year to show that machine-set books could be as beautiful as the products of the private presses. Those present were Francis Meynell, Stanley Morison, Holbrook Jackson, Bernard Newdigate, and Oliver Simon. On the motion of Meynell they chose the name The Fleuron Society, but this was about the only item of agreement. Two further meetings were held at which little agreement was reached, Newdigate upholding his belief in the superiority of the hand-set book. It was finally decided to liquidate the Society, but Simon suggested to Morison that they might do something immediately tangible by launching a periodical devoted to typography.

The discussions had to continue by letter as Morison went off to the Continent and was pursuing his studies at the Berlin Kunstgewerbe Museum. He told Simon he worked from ten in the morning to three in the afternoon, going without lunch. He complained that it was cold and that he often wished he were back in his Hollyberry Lane home with its fireplace. Simon's idea for the title – 'Typographical Annual' – seemed too stiff to Morison, and, perhaps recalling his joint studies with Meynell, he suggested *The Fleuron*. There was the small problem that this was the name which had been given to the publishing society, but Holbrook Jackson had already agreed that this had petered out, and Meynell did not object to the use of the name, so *The Fleuron* it was.

The new owners of the Cloister Press required neither Morison's services nor the London office, and so Simon persuaded Harold Curwen to take it over for the Curwen Press, with the agreement that it could also act as the publishing office of *The Fleuron*. Simon and Morison remained there until they transferred to 101 Great Russell Street in the spring of 1924.

Simon considered his relationship with Morison up to 1924 to be a sort of private university of printing, although 'the walls of our office were likely to reverberate at any moment to the sound of the voice of Morison on comparative religion, Catholicism, Judaism, or ethics'. Herbert Simon, Oliver's brother, used to visit them when he came down to London from Birmingham (where he was managing the Kynoch Press). He recalled that Morison could not make up his mind whether or not to leave the world of commerce, turning his back on 'lucre' (to use his words), and enter a religious order. This was at a period when he had lost his chief mentor, Adrian Fortescue, who died early in 1923. Fortescue had been the main formative Catholic influence in his life. With his marriage breaking up as well, Morison was seeking some solace.

He found it in work and travel. There were no children of his marriage, and after separation he was free to spend more time on research and disputation. He overcame the desire to quit worldly affairs, but for the rest of his life assumed almost clerical garb. 'He looks like a Jesuit', various people told Beatrice Warde

before she met him, so that she recognized him at once in his all-black suit, and steel-rimmed spectacles. To one of his house-keepers he was known as 'The Dean' and when Lord Beaverbrook saw him for the first time he said he looked like a clergyman.

There was much meeting in tea-shops, and Morison would pontificate and tell his friends about the great writing masters of France and Venice; and he would dilate on the use of capitals, spacing, the unadorned use of small capitals, and other typographical niceties. While interested in his words, his friends sometimes were concerned with the state of his health. They thought he was not being looked after properly and plied him with eggs on toast and bowls of soup. This was indeed a difficult period for him. He had been forced to sell his stamp collection and £200-worth of books; his suits were shabby and he lived from one commission to another. But prosperity was not far away, and, in any case, he was never deterred from spending time on study, which provided him with the information with which he regaled his friends and which was to be useful to him in the period ahead.

He had become aware of the treasures of the Saint Bride Foundation Library while at the Pelican Press, which had its offices only a short distance away at 2 Carmelite Street, but the move to Manchester and other distractions had taken him away temporarily from this source of typographical information. He now made full use of the library with its large number of type specimens, many of them from the collections of the two typographical historians, Talbot Baines Reed and William Blades, to whom Morison owed much. The former Librarian, W. Turner Berry, remembers a gaunt-looking Morison, with the lining of his jacket torn, calling in and borrowing books 'by the car load', special permission having been granted by the Institute governors. But Morison also made visits to France, and travelled about Germany over the next decade. He was mostly made welcome, but the brothers Klingspor would not let him into their typefoundry just after the war because he was an enemy. The situation changed later.

Morison's interest in pattern books had been aroused by Dr Peter Jessen, of the Berlin Kunstgewerbe Museum, and he strengthened his knowledge of the writing masters. For a 70th birthday album for Francis Meynell he wrote: 'My dear Francis: It must have been about the year 1923 that you and I bought our first copies of the Writing Books of Tagliente and Palatino – Arrighi came after – and we both deliberately and permanently reformed our personal scripts, while never aspiring to become scribes. This is only a single illustration of our long and uninterrupted community of interests, calligraphic and typographic – and other – which will, I dare hope, continue long after your anniversary. *Ad multos annos* Stanley Morison.'

His studies of calligraphy led eventually to his contribution on the subject to the *Encyclopaedia Britannica*. He was subject to many influences. At some point in his German trips he found time to visit the Brandstetter Verlag, in Leipzig, where, before the 1914 war, Harold Curwen had spent a period of training. At Brandstetter he came across the typographical work of Jacob Hegner, a Jew turned Catholic, whose simplicity was in contrast to the earlier 'florid' Morison style. Morison asked: 'What does Hegner do here?' – in German *'Was macht Hegner hier?'*, and received the reply: *'Er macht Confusion!'* Hegner was what the Germans call an *Einmannbetrieb*, doing everything himself from translation to typesetting, if he could, in no discoverable order; and in a well-ordered German printing works he produced confusion. Nevertheless, the resulting product, typographically, was neat and orderly.

PENROSE'S ANNUAL

A progressive record of TECHNIQUE in the PRINTING, PROCESS ENGRAVING, GRAPHIC ARTS AND ALLIED INDUSTRIES

✦

Right: page from publicity leaflet for the 1924 (Vol.XXVI) *Penrose's Annual*, showing Morison's typographical influence.

Overleaf: two pages (facsimile) from Terence *Comoediae* (1772), set in Baskerville's Great Primer, roman and italic, from which Monotype's 'Baskerville' was derived.

THE object of PENROSE'S ANNUAL is to provide the Printing and Allied Industries with a record of progress and development. The text comprises critical and expository articles to guide Printers, Engravers, Publishers, Advertising Specialists, Papermakers, Photographers, Designers and all who are in any way interested in Printing. Illuminating articles are included on fine modern bookbinding, various aspects of enlightened publishing, posters, in addition to all the different technical processes. The text is MONOTYPE set in type which has been cast from matrices which have been specially cut after the successful models designed by BASKERVILLE, and is now given a first showing

✦

Hegner and the new ideas of the Bauhaus had a certain effect on Morison's attitudes – particularly on the binding of books, which he considered should be quite simple; but it did not inhibit him when he felt the typography of a particular piece of work should, if necessary, be startling or audacious. Morison adhered to no particular school of typographical thought, but drew what he felt was desirable from any source, leading to a varied set of productions.

If Fortescue was a source of strength during the early part of his career, in the early 1920's two other men should have earned Morison's gratitude. They were Walter Lewis and Oliver Simon, who were both active on his behalf, affecting introductions and getting him work. Simon hoped that *The Fleuron* would provide Morison with a source of income, but in the meantime he had to look for other work. Apart from the part-time position with the Monotype Corporation he became, in effect, a mixture of freelance publisher and publisher's adviser. Simon had been helpful in introducing him to Eric Humphries, managing director of Lund Humphries, which had led in 1922 to the decision to let Morison design the 1923 *Penrose's Annual*. In 1923 Humphries extended

ANDRIÆ
ARGUMENTUM,
C. SULPICIO APOLLINARI
AUCTORE.

SOROREM falso creditam meretriculæ,
 Genere Andriæ, Glycerium vitiat Pamphilus:
Gravidaque facta, dat fidem, uxorem fibi
Fore hanc: nam aliam pater ei desponderat
Gnatam Chremetis: atque ut amorem comperit,
Simulat futuras nuptias; cupiens, fuus
Quid haberet animi filius, cognoscere.
Davi suasu non repugnat Pamphilus.
Sed ex Glycerio natum ut vidit puerulum
Chremes, recusat nuptias, generum abdicat:
Mox filiam Glycerium insperato agnitam
Dat Pamphilo hanc, aliam Charino conjugem.

P.

P. TERENTII
ANDRIA.

PROLOGUS.

POETA cum primum animum ad fcribendum ap-
 Id fibi negoti credidit folum dari, [pulit,
Populo ut placerent, quas feciffet fabulas.
Verum aliter evenire multo intelligit.
Nam in prologis fcribundis operam abutitur,
Non qui argumentum narret, fed qui malevoli
Veteris poetæ maledictis refpondeat.
Nunc, quam rem vitio dent, quæfo, animum advortite.
 Menander fecit Andriam et Perinthiam.
Qui utramvis recte norit, ambas noverit.
Non ita diffimili funt argumento : fed tamen
Diffimili oratione funt factæ ac ftylo.
Quæ convenere, in Andriam ex Perinthia
Fatetur tranftuliffe, atque ufum pro fuis.
Id ifti vituperant factum : atque in eo difputant,
Contaminari non decere fabulas.
Faciunt næ intelligendo, ut nihil intelligant :
Qui cum hunc accufant, Nævium, Plautum, Ennium
Accufant : quos hic nofter auctores habet.
Quorum æmulari exoptat negligentiam

 Potius,

Morison's role by letting him design other pieces of printing, including the managing director's own letterheading, and a neat thirty-six page specimen book of types. This included pages showing various sizes of mostly Monotype faces, with details of how many words would occupy a square inch and a page. Why the 'copy' used should have been taken from a book on Masonry is not now apparent, but it could hardly have been Morison's choice.

Penrose's Annual was edited by William Gamble, and it had become the custom to provide details of the printing, binding, inks, paper, cloth, and even the machinery on which the book was printed. The type in which an issue was set was not mentioned. The 1922 edition happens to have been set in Imprint, which might have deserved a mention, although the hand-lettered orange and blue cover, it is stated, was designed by Messrs Percy Lund, Humphries and Co. Ltd. A change is immediately apparent with the 1923 issue, designed by Morison. He used a simple black binding with a plain front. The title and volume were gold blocked at the top of the spine, with the date at the foot. In the attributions inside the volume there reads: 'The text has been printed under the supervision of Stanley Morison', and 'The type for the text, with the exception of the initials, has been cast from matrices supplied by The Lanston Monotype Corporation Ltd.' The issue, as has been reported, was set in Garamond, and Morison contributed 'A Note on the Garamond Type', which, although not signed, is credited to him in the table of contents; and 'Printing in France', with special reference to the Imprimerie Royale, which is under his name.

The binding of this volume of *Penrose's* shows that Morison was already moving towards greater simplicity in book production. The next, 1924, volume followed much the same formula, although this time the binding was in dark blue cloth with a paper label at the top of the spine (and the traditional spare label inside). The reader was informed that 'the text has been printed under the supervision of Stanley Morison', and that 'This year's Penrose is composed in the new Monotype face which is a faithful reproduction of an historic type designed by John Baskerville'.

By January 1923 H. M. Duncan, Monotype's managing director, had decided to cut a Baskerville for machine composition. The decision was hardly revolutionary, and, as was the case with the Garamond, was based on the fact that there was already a demand for it. When the pendulum began to swing in favour of 'old face', it had been Caslon's type which was favoured, simply because supplies were still in some printers' cases, and the punches had been preserved to some extent. Those of Baskerville were lost, not to be recovered until well after Monotype's revival of Baskerville. Enthusiasts had been using Moore's imitations of Baskerville, although Bruce Rogers had obtained founts from France, which may partially have derived from Baskerville's original punches, and had urged the University Press, Cambridge, to make Baskerville its 'special' fount.

Once again ATF had set the pace, and in 1917 produced a Baskerville series, though this was derived from strikes purchased from Stephenson Blake, and hence was really a revival of Moore's imitations. Duncan, it seems, wanted to avoid imitation and to produce a 'faithful reproduction' of true Baskerville types. An internal Monotype production memorandum, beginning with entries from 17 January 1923, shows that Duncan sent the works a copy of a 'Life of Baskerville'. This was probably *John Baskerville, A memoir*, by Ralph Straus and Robert Dent (London, 1907), which carries facsimiles of Baskerville's types, from which Duncan wanted Monotype's version to be derived.

At the same time, Duncan went on: 'One of the Caslons brought out a

Baskerville face with improved italic', and the works thought they would like to see a specimen, although it was thought better to adhere to the original type as far as possible. Duncan asked Morison to let the works have a Caslon specimen book. Duncan then visited the works, and, as the result of a conference, it was decided to make a direct copy of Baskerville's types.

In fact, a particular Baskerville book was chosen as the model – this was Terence, *Comoediae* (1772), set in the Great Primer size. This could not have been Duncan's choice, as on 17 August 1923 he asked: 'Upon what interpretation was this face based?' on receiving some specimen types. The works replied: 'Baskerville type drawn from copy of Terenti printed in Birmingham in 1772', but who chose this book is not known. It may have been Morison.

Morison was not enthusiastic about Baskerville's italic, which he described as having neatness, modesty, and consistency, but as lacking in nobility and character. Perhaps he was hankering after something more lively and interesting, but at that stage was not quite sure what. In general, he felt that the Monotype Baskerville, while not more picturesque than Caslon, had better proportions, was clearer in the whole design, roman and italic, and was more efficient for present-day work.

The first number of *The Fleuron*, edited by Simon and printed by the Curwen Press, appeared in April 1923, being set in the Monotype Garamond. The Fleuron Society had not been a wasted effort after all, for its erstwhile members produced contributions for the new publication. Morison and Meynell had fallen out temporarily over Meynell's personal affairs, but Morison's own lack of success in marriage helped to heal the breach, and they co-operated on their now well-known *Printers' Flowers and Arabesques* for this issue of *The Fleuron*. The authors explain that while at Burns and Oates they had decided to embellish some books in the florid fashion, but being unsure of their ground, and lacking any help from the typefounders, had ignorantly decided that it had to be managed by photographing or re-drawing items from seventeenth-century books and having zincos made. But, they go on: 'In England the serious revival of the cult was undertaken at the inauguration of the Pelican Press in 1916. The typefounders' closets were ransacked, and in the following years the collection of the Press was greatly increased. The Curwen Press, the Westminster Press, and others were not slow to follow suit in a movement which has grown until it demonstrates its extent, its variability, and its real or potential charm, in every class of printing from every class of printer. The Lanston Monotype Corporation is now engaged in a most salutary extension of the revival, while both the late Claude Lovat Fraser and Mr Percy Smith have made new designs to take their place among the splendid variety of flowers which have never failed to bloom in the Spring of printing and which have kept their freshness through all the processional seasons.'

The last part of the quotation reads as if it were written by Meynell. In truth, decorative flowers do not suit 'every class of printing', as Meynell admitted in an essay in *The Colophon*, Part IV, 1930, when he wrote: 'The slogan of "fitness for purpose" had not yet informed us. A report of the great meetings which we held at the Albert Hall after the first Russian revolution was designed with the mannered elegance which would have suited better an essay by Walter Pater. And I remember myself writing a double-page political manifesto for the *Weekly Herald*, calling upon the proletariat to rise and to end the war, which was set in Cloister Old Face with a seventeenth-century flower border and sixteenth-century initials . . .'.

In this issue of *The Fleuron* Newdigate's *Respice Prospice* shows how much the

author had moved forward since the Fleuron Society discussions, since he refers to the strides being made in offset-lithography, the possibilities of photo-composition, and the need for new type-faces. On the last point Morison was able to satisfy him to some extent, but photo-composition was never a commercial reality during Newdigate's lifetime.

Morison reviewed Updike's *Printing Types*, and by his criticism indicated how deep his own researches had now gone. Updike had failed, he said, to mention that the canon size of type in a book printed in Florence in 1550–2 was cut by Garamond's pupil, Guillaume Le Bé, who he thought had had a great influence upon Italian typography. Italian printing after 1550 showed a definite change of type form, that is away from the Venetian and in favour of that style whose characteristics were termed 'old face'. In the second edition of *Printing Types* (1937) Updike added a note about these types and mentioned that Le Bé passed six months in Rome in the employ of Blado, printer to the Apostolic Chamber, adding: 'Blado is chiefly remembered for his fine italic – a modified form of Arrighi's second font', but curiously did not mention Morison's revival of this italic, possibly because it was not a faithful version.

On French types, Morison wrote: 'Updike seems unaware of the existence of specimen proofs of Guillaume Le Bé's Greek, Hebrew, Music, and roman types acquired by the Bibliothèque Nationale some thirty years ago . . .', and in his second edition Updike included information about the specimen.

An unsigned review of the 1923 *Penrose's Annual* reads: 'The twenty-fifth volume of *Penrose's Annual* comes with surprise. It has been stirred, as if by the kiss of fine typography, to a consciousness of the position it holds; it has awakened into eminence, beauty and character.' The expression of surprise is a little odd, because neither the editor of *The Fleuron*, Oliver Simon, nor his partner, Morison, could have been unaware of the redesigning of *Penrose* since the one introduced the other to Lund Humphries for this purpose.

In the second issue of *The Fleuron*, also set in Garamond, Morison revived the modern study of writing manuals in *Towards an Ideal Type*. He felt that those who had designed 'humanistic' type, based on Renaissance handwriting, had fallen between two stools as it was neither type nor script, although the essential form of the characters was perfect. A study of a number of these faces, produced by calligraphers, will bear out the correctness of Morison's criticism. The reader feels he is looking at a facsimile of a manuscript rather than at a printed work. Morison concluded in this article by asking: 'Will not some modern designer who knows his way along the old paths fashion a fount of *maximum* homogeneity, that is to say, a type in which the upper case, in spite of its much greater angularity and rigidity, accords with the greatest fellowship of colour and form with the rounder and more vivacious lower case. So in my submission we shall draw nearer an ideal type.'

This seems to confirm that Morison was not working to a hard-and-fast typographical plan at the time, but was seeking designers for his 'ideal type'. Eventually he found his men, and they produced types which met with varying degrees of success; and he tried to produce a type himself in conformity with his ideas. In the long run, the types which came off best were revivals, produced by modern techniques, in which the punch-cutter had not yet obliterated the influence of the scribe, but which were obviously derived from the cutting of metal and not the pen. Theorizing about an 'ideal' type did not help.

Frank Sidgwick, reviewing Morison's *On Type Forms* (1923), expressed a dislike for the setting in 14-point Riccardi. This type had been designed by

Herbert Horne for the Medici Society in 1909, and might seem an odd choice for 1923, except that the book was published jointly by *The Fleuron* and the Medici Society, which wished to use its private type-face. The managing director of the Society was Nigel de Grey, who had been with Heinemann before the 1914 war and who had been influenced by, among others, Bernard Newdigate. Slightly older than Morison, and with an impressive background in book production, he was able to persuade Morison to accept his way of thinking on the type and layout for the book. Morison admitted later that the setting of the text without paragraphing was an experiment which he did not repeat. De Grey was one of the publishers who encouraged the printing revival of the 1920's by giving Oliver Simon work for the Curwen Press and by sponsoring exhibitions of fine printed books at the Medici Society galleries. The exhibits at one of these were chosen by Morison.

In the third number of *The Fleuron* Morison joined with A. F. Johnson to write *The Chancery Types of Italy and France*, which indicated the way in which, with Johnson's help, Morison was working out the difference between the earlier Aldine italic and that which was used eventually as an auxiliary of roman type. In the course of the article the authors disagree with Updike slightly on this point. They wrote: 'But when the author of *Printing Types* proceeds: "This Aldine character became a model for all subsequent italic types" (Vol.1, p.129) we think we detect room for qualification. More exactly, perhaps, the Aldine type may be claimed to have suggested or to have made possible the general use of the chancery type in typography', and the authors refer to the second school of italic – the work of the scribe Lodovico degli Arrighi.

Morison wrote to Updike on this matter, and in the second edition of *Printing Types*, Updike included a lengthy note, which reads, in part: 'Mr Stanley Morison reminds me that italic is the one letter we now have that owes its origin to diplomatic calligraphy, and adds, "It is certainly the fact that more or less close reproductions of Aldine Chancery types were made by many printers in various parts of Italy and elsewhere. Nevertheless, the flowing italics of Garamond, Caslon, and others in use today are formed on very different proportions from those of the cramped design for which Aldus is responsible. There exist in typography at least two independent italics. The first made by Francesco de Bologna for Aldus dating from 1500 which continued in use for less than one hundred years – secondly, a flowing letter of distinctly calligraphic quality possessing considerable freedom in its line", the work of the scribe Lodovico degli Arrighi of Vicenza, called also Vicentino.'

From this it can be seen that Morison was delving into the question of the nature and function of the italic, and was soon to put his conclusions to practical effect, not always with the happiest results. His desire, on the one hand, for something more noble and exciting than Baskerville's italic, and, on the other, his rationalizing about what italic was supposed to do, lead him into some odd situations. In passing, the phrase 'the flowing italics of Garamond, Caslon and others in use today . . .' is a slight indication that Morison had no thought of a Granjon italic at that point.

A study of *The Fleuron* shows that the young typographical reformers were often 'taking in their own washing,' as the review of *Penrose's Annual* in Volume 1 indicates. They could hardly be blamed for this because much of the typographical initiative of the day was their own, and they also had their own message to put across. *The Fleuron* was an excellent medium for this. The following item was a hint by Morison to the Monotype Corporation: 'The Lanston Monotype

Corporation needs watching; we are inclined to suspect it of having at heart the interest of fine printing'. It was part of his campaign to provide ammunition to his supporters within the Corporation.

Volume 4 of *The Fleuron*, the last to be edited by Oliver Simon and to be printed by the Curwen Press, contained Morison's article 'On Script Types' of which he wrote later: 'For the first time the later writing-masters, French and English, are studied and evaluated in the terms of their effects upon the typefounders.'

The precise relationship between Simon and Morison will remain one of the mysteries of Morison's life, mainly because Simon was a self-effacing man, who did not care to challenge Morison, and was not alive (he died in 1956) when Morison made various statements about *The Fleuron*.

A detached observer might come to the conclusion that Morison thought, or wished to have it thought, that he played a more important role in his earlier career than in fact he did. Whether this was genuinely self-delusion it is difficult to say, but the connexion with *Penrose's Annual* presents a good example of the process. Several writers have been misled into thinking that Morison was editor of *Penrose's Annual* and, at one point, he clearly thought he had been himself. On the manuscript of the article 'The Work of Stanley Morison' for the August 1960 Newberry *Bulletin* he wrote: 'Morison, at Simon's instigation, was appointed editor of the *Penrose Annual*. For three years he edited and wrote for this periodical and played a part in turning it over from a purely technical process review into a broader typographical, as well as lithographic and offset chronicle.' Morison was never editor, and in the printed version of the Newberry *Bulletin* article the passage reads: 'Morison, at Simon's instigation, joined the staff of the *Penrose Annual*. For three years (1923–5) he supervised the printing of its text, edited and wrote much of it, and played a part in turning it from a purely technical process chronicle to one with broader typographical, as well as lithographic and offset, interests.'

The reason for the change of emphasis is obvious. It is easy to check that Gamble and not Morison was editor, and it is equally easy to turn back and see that the contributions, in the main, were of the type which Gamble had solicited in the past and continued to solicit after Morison's connexion with the *Annual* had ceased. Not so easy to refute is Morison's written-in claim on the same manuscript, repeated in the printed version, that he was the working editor of *The Fleuron* from the start, or that his mind could early be traced in the editorial policy. In fact, bearing in mind Simon's statement that the members of the Fleuron Society all produced contributions, the names and the subjects of the actual contributors, and the way in which Simon edited *Signature* in later years, the first four volumes bear Simon's imprint in more than the conventional sense. What is true is that Morison was the major contributor.

Among other contributors were men known to both Simon and Morison, such as Holbrook Jackson and Bernard Newdigate, but others are well-known to have been part of the Curwen Press *milieu*, such as Percy Smith, or to have been related to Simon, such as his brother, Herbert, or William Rothenstein, his uncle, or to have been a close friend, such as Hubert Foss. The subject matter could easily have been inspired by either Simon or Morison – the work of T. J. Cobden-Sanderson, or Emery Walker, for example – but others, such as that on decorated papers, have a definite Simon flavour.

Simon had invested £100, from his unspent second-lieutenant's pay while on Gallipoli, in *The Fleuron*, but the man who really took the brunt was Harold

<u>Fleuron</u>, ~~the~~ first three numbers edited by Simon, the other four

by Morison, ran from 1923 to 1930, and was undoubtedly the most

influential ~~distinguished~~ venture of its sort yet produced ~~during our century~~ *in English,*

It boasted an elegant format, handsome printing and illustration,

and, most important, a sharply critical and *an* ~~thoroughly intelligent~~

editorial policy, *in which Morison's mind can easily be ~~traced~~* ~~Its writers~~ Its contributors included Meynell,

(later) Beatrice Warde, ~~writing under the pseudonym of Paul Beaujon~~

Holbrook Jackson, A.F.Johnson, Newdigate, D.B.Updike, ~~and above~~

~~all~~ Morison himself, who published in it some of his best articles

on calligraphy and typography, ~~and their interrelationships. The~~ *I was the working editor from the first & Simon the active publisher*

The final number ~~carried~~ contained ~~his most famous~~ an article, *the which* ~~expansion of a piece originally written for the Encyclopaedia~~

~~Britannica~~, expressing his views on the r[?]ational design of print-

for books ~~ed matter~~: First Principles of Typography has since appeared in

Curwen. Simon was not a director of the Curwen Press at the time, and Harold Curwen concealed the loss which printing *The Fleuron* was causing from his fellow-directors. When, therefore, Morison did take over the editorship of what were to be the last four volumes, as had been tacitly agreed at the start, the Curwen Press reluctantly agreed to allow the printing to be transferred to the Cambridge University Press, which Morison had just joined as typographic adviser. The financial strain on the Curwen Press and the fact that under the new editorship there would be no personal connexion with *The Fleuron* led to this decision, a realistic one, but one taken with regret.

In fact, only three more volumes were to appear. Under Morison *The Fleuron* was published in a larger format, was more lavish, and contained more insets and specimens, but the issues were no more and no less 'scholarly' than those edited by Simon.

Herbert Simon was impressed by the remarkable emergence and acceptance of Morison as a typographical authority within a few years. It was to a large extent his work for *The Fleuron* which brought his name before a wider public, but without Oliver Simon there would have been no publication of *The Fleuron*. In the Newberry *Bulletin* article Simon is described as a man whose mild manner concealed remarkable energy coupled with sound organizational ability, and Morison as a man whose agressiveness frequently masked inaction. The manuscript (written by James Wells) credits Simon with the founding of *The Fleuron*; the printed version omits this point. Morison wrote in: 'Morison has been heard to say that he agreed with Simon's proposal but did not initiate it, although he had ideas about what the periodical should attempt. Once Simon

had prepared a production plan, Morison was prepared to contribute an editorial programme. The decision was eventually taken to publish seven numbers or parts, each of them a volume.' The decision was taken to publish eight volumes, according to Simon, and the suggestion that it was seven is an example of Morison's tendency to re-write history in the light of later events. His endeavour to reduce his old friend-in-need to the status of a production assistant can be counted as one of Morison's 'errata', to use Benjamin Franklin's word.

Fine Printing, Poliphilus,
the Double Crown Club

Some idea of the lack of good type-faces available to the British printer at the end of the 1914 war can be gained from the comments of men who were genuinely trying to improve the look of everyday printing. When Joseph Thorp wrote his book, *Printing for Business*, in 1919, he could conscientiously list only Plantin, Caslon, and Tudor Black as worthy of use. Matters had not improved much by 1923. Harold Curwen was asked to speak at Stationers' Hall on 12 January in that year, as part of a series of technical lectures, and in one of the few references to type in the whole series, he said: '. . . there are only about six good types in the world today'. When asked what they were, he mentioned, in fact, only four – Garamond, Caslon, Cloister, and 'the American Kennerley'. Of these, it may be noted, only one had originated in Britain.

In this situation it might be expected that the Monotype Corporation which, after all, employed a typographic consultant, would have been to the fore in producing new and acceptable type-faces; but this would be to misunderstand the position within the Corporation at the time. There was no universal acceptance that type-faces should be cut in anticipation of customer-demand, and Morison was looked on as an interfering outsider. Positive opposition came from Frank Hinman Pierpont, the works manager, who as one of the three founder-executives of the Corporation had considerable influence. On his advice the new firm had rejected the American company's method of depending on outside engineers, and had built its own works at Salfords, near Redhill, Surrey, where Pierpont reigned unchallenged over a group of like-minded engineers. He was a superb technician, who refused to tolerate anything but the best in men, methods, and materials, but he regarded Morison's ideas as 'a lot of rot'. Whatever individual Monotype directors may have thought of Morison, they would not, at the time, have backed him against Pierpont.

There was also the inbred conservatism of the printing trade itself. Many printers felt there were quite enough type-faces already, and that 'typographical' advisers were an unnecessary luxury. Unfortunately, Morison made little appeal to the one group in the Master Printers Federation which was keen on typographical improvement. The remark of Bertram Evans, one of the founders of *Printing Review*, sums up the suspicion that Morison was an interloping intellectual. Morison, he said, 'writes books about books in museums, and the books he writes go back to museums'. One of Evans's supporters, J. R. Riddell, principal of the St Bride Printing School, successfully blocked Morison's election as a governor of the St Bride Institute, with the comment that Morison was one of Turner Berry's 'long-haired friends'. When Morison later tried some experiments with the new Gill sans type the indignation of the more conservative printers was violently expressed.

In the circumstances, startling changes were not to be expected at the Monotype Corporation, and it was not until Morison became typographical adviser to the University Press, Cambridge in 1925 that opposition to the cutting

of new types began to recede. It was perhaps just as well for posterity that Morison had been offered only a part-time appointment with Monotype, and was able to take on the additional one at Cambridge. As a full-time employee of Monotype he would have suffered even more frustration than he did, and little would have been achieved.

Morison needed outside support to convince the Monotype staff. A certain amount was forthcoming, not from printers, but from publishers, including Francis Meynell, who had founded the Nonesuch Press. Meynell induced the Corporation to improve various Plantin characters, and to add others such as tied sorts, thus helping to create the situation where outside suggestions were accepted as normal. If only publishers would express a desire for new faces, and if their printers could be persuaded to use them in books, opposition within Monotype would crumble. Morison set himself the task of winning the publishers, for which he was well placed, as he was working for several.

The cutting of Poliphilus can be seen as a result of this roundabout approach. Harry Lawrence, formerly of the publishing firm of Lawrence and Bullen, had the idea of producing a translation of Aldus Manutius's *Hypnerotomachia Poliphili* (1499) and suggested that a type-face be copied from the book. This was agreed, as Lawrence was a distinguished figure in the publishing world, and the face was re-created as it stood from sheets supplied by him from an imperfect copy of the book. The translation project seems to have come to nothing, but there was a publisher who was willing to use Poliphilus, a printer who would install the matrices, and an author who was more than happy to have his work composed in it. The publisher was Ernest Benn Ltd, which Victor Gollancz had joined in 1921; the printer was the Printer to the University of Cambridge, now Morison's old colleague, Walter Lewis, and the author Morison himself.

Technically the reproduction of the type from the original book was a success, and Morison claimed it was possible to compose a page in Monotype Poliphilus, place it side by side with the original, and find no difference except in paper. He wrote: 'It was no longer to be doubted that the technical resources available guaranteed a reproduction, faithful to the point of pedantry, of an original, the revival of which had never been attempted.'

But the question arises – which original? Presswork can vary from book to book and from sheet to sheet, and it is not an easy task to determine in what degree the impression of a type upon a page of hand-made paper, which had been dampened for printing, is distorted by the spread of ink or by the stretch of the paper. In 1953 Morison wrote critically of the Poliphilus type, regretting that due care had not been taken to find the best pages of the *Hypnerotomachia* for reproduction. It is not clear whether he includes himself in this criticism, as in his capacity of typographical adviser it might be thought that it was his prime responsibility to obtain the best models; but he was probably pleased at the time to get the pages from Lawrence. Nevertheless, he wrote: 'The error was grave though not catastrophic, as the text of *Four Centuries* demonstrates', but he judged Poliphilus to be a moderate success only.

The *Four Centuries of Fine Printing* (Ernest Benn, 1924), to which he referred, was Morison's first large folio. Cambridge University Press had acquired the Poliphilus type and had used the 16-point size to set this book. A large prospectus was issued, stating that the book contained 'five hundred masterpieces of the roman letter reproduced in the finest collotype'. The first page of the prospectus was hand-lettered with a curious flower pattern in which the initials E.B. and S.M. were intertwined. The centre pages were devoted to a description of the

Paſtore,& quella perſeui,e'Tori ſopra.
Cinti di ferro,et ira dintorno al ſemplice ouile
Di ſdegno ardenti ſtauano i Greci duri.
Ma l'oltraggio rio d'Agamennone,l'ira d'Achille
Quaſi al fondo poſe tutte le genti loro.
Mentre come empio Lupo tra'l timido gregge negleto
Hettore ſquarciando molti de Greci giua.
Stauaſi Achille ſolo temprando l'aspro feroce
Sdegno ardente ſuo con la ſoaue lira.
Tutti feriti i Duci tornar quel giorno dolente
Dentro le tende loro,colmi d'acerbi guai.
Tetide quel giorno con Pallade nulla giouaua,
Nulla Giunon,nulla Gioue giouaua loro.
Furo Macaon iui,& Podalirio l'alta ſalute,
C'hebbero i Greci;ſolo lor uita queſti furo.
Prima co' petti fidi sbatterno li fieri nimici,
Et fecero il giorno proue di chiari Duci.
Poſcia cedendo quei,come Neſtore,Aiace,et Atride,
Stenelo,et Antiloco,con Diomede fero;
Lungo le chiuſe naui con glialtri inſieme ridotti,
Senza ripoſo mai porgere a' membri loro.
Trattiſi l'elmo ſolo,con l'armi in doſſo lucenti,
D'alto ſudor molli,miſero a' feri mano;
Per riſanar l'alte crudeli ferite ch'Enea,
Ch'Hettore,hauendo ſeco Marte animoſo,fece.
O come molti furo gli aspriſſimi colpi feroci,

Page from *Nuova Poesia Toscana*, printed by Antonio Blado in 1539, showing original degree of slope of Arrighi's second italic (facsimile).
This may have been Arrighi's third and last italic, as he used an italic type in four pages of his 'Il Modo' (1523). However, following custom, Arrighi's italics have been referred to in the text as the 'first' and 'second', as being major founts (see page 110, for example). Further research may reveal more about Arrighi's type designs and the identity of the men who cut his italics for him.

work, its format (13 × 18 inches), and the new type in which it was set. The edition was limited to 440 copies at ten guineas each, and ten hand-bound in leather and 'variously embellished', at £40 each, not an insignificant sum in 1924. In the *Handlist* of his writings Morison commented that he had left out all consideration of black-letter because he had no knowledge of the subject.

Deeper research into black-letter was to come, but for some years Morison had been paying attention to the origins of italic type. Aldus Manutius in 1500 planned a series of classical texts in small format books, easy to carry, and at a price suitable for scholars. The roman type, used in larger books, must have seemed inappropriate, and Aldus reverted to the cursive handwriting of about 1420 as a model for a new type. He had cut for him by Francesco da Bologna the first of what are now known as italics, which were independent of roman type and used for a whole book. The use of the type was not so much for space-saving reasons as because of its familiarity to scholars. But there were other writing

hands, less cramped than that copied for Aldus, used, for example, at the papal chancery. Morison realized that these were the basis of the italic types which were cut later than Aldus, and which were no longer used independently but as an auxiliary to roman type, a custom dating from the end of the sixteenth century.

The *Hypnerotomachia Poliphili* had been printed before Aldus had thought of italic, and Morison, faced with the twentieth-century requirement for an accompanying italic, was called upon to recommend a model for Poliphilus. The narrow Aldine italic would obviously not do, and the more formal and generous diplomatic cursive seemed more suitable. In his studies of the writing masters Morison had been impressed by the work of Ludovico degli Arrighi, a writer of apostolic briefs, who also designed italic types. The second of these was used by Antonio Blado, printer to the Holy See, 1515–67, and Morison took it as a basis for an italic to accompany Poliphilus. What was not publicized by Morison was the fact that he altered the slope considerably. As a page from *Nuova Poesia Toscana*, printed by Blado in 1539, shows, the average slope is from five to eight degrees, whereas in Morison's version the slope is twelve degrees, and to meet modern convention the upright capitals were sloped. The type was not called Poliphilus italic, but was named after the printer, Blado. It can be used effectively on its own, the larger sizes being very useful for display.

Broadsheet: the Italic of Antonio Blado.

The successful combination of publisher and printer – Gollancz and Lewis – in getting Poliphilus off to a good start was the beginning of a process which was to flourish in 1925. In the meantime, Morison, acting on behalf of various publishers, often took books up to Cambridge to be printed.

The year 1924 was a key one in Morison's life. In the later summer he made the first of his many visits to the United States, visiting Updike 'as a pilgrim', and meeting Beatrice Warde for the first time. Another important event during the year was the founding of the Double Crown Club, the brain-child of Oliver Simon. Simon discussed the idea of a dining club of people interested in what he called 'the Arts of the Book' with his friend, Hubert Foss, and in July they formed a committee, which met several times to decide on name and constitution, and to make a list of the first or 'original' members. Morison was not a member of this committee, despite his closeness to Simon, but he never was a good committee member, and although selected as one of the original members of the Club, always avoided taking office. Walter Lewis, also an original member, on the other hand, accepted the presidency in 1937, and was prevailed upon to present a paper on one occasion only, when at the ninth dinner in 1926 he spoke on 'The Technique of Machining', which apparently did not enlighten the members very much. Morison, while eschewing office, constantly used the Club as a medium for expressing his ideas and for publicizing his efforts, presenting more papers than any other member.

The Club held its inaugural dinner on 31 October 1924, and then at the second dinner got down to the business of dissecting printing with a discussion on 'Type-faces of Today', a natural subject considering the background of those who formed the Club. Simon presents an amusing word picture of the two rising stars of typography in his autobiography: 'Morison would slowly unwind his figure as if every muscle in his body were in revolt and, while momentarily appearing hesitant and short of words, would soon have his audience especially attentive, imparting criticism, knowledge and original and unusual points of view with a slow, halting, yet concise delivery. No sooner had his black-clad figure sat down than Francis Meynell would rise and enliven the proceedings still further with his wit and carefully turned phrases, delivered with an elegant control of manner.'

THE ITALIC OF ANTONIO BLADO PRINTER TO THE HOLY SEE 1515-1567 AVAILABLE TO USERS OF THE "MONOTYPE" MACHINE

The choice of a suitable italic to accompany the "Monotype" reproduction of the Poliphilus was not made without considerable research as it was only after the passing of a generation or two after the invention of the cursive letter that italic and roman came to be looked upon as two constituents of one fount and designed as such. The present italic is based upon the finest of the letters used by the distinguished craftsman Antonio Blado who occupied the office of printer to the Holy See during the years 1515 to 1567. In all probability this printer's types were designed by the renowned calligrapher Ludovico degli Arrighi, also known as Vicentino de Henricis who held the post of writer of apostolic briefs, and they were probably cut by that famous goldsmith of Perugia, Lautizio de Bartolomeo dei Rotelli mentioned with commendation by Benvenuto Cellini himself. Blado's italic, now made available to users of the "Monotype," possesses a very elegant line and a note of personality which cannot fail to fit it for employment in the finer kinds of advertising and book-work. In conjunction with the Poliphilus roman, printers of to-day possess a series of great character and permanent interest. Extra sorts for use in various kinds of antiquarian printing have been cut and may be incorporated without trouble in the matrix-case

NOTICE

Blado italic, like Poliphilus roman, is ready in three sizes, 16, 13 and 10-point
Ask for the specimen book now in course of composition

ABCDEFGHIJK
LMNOPQRST
UVWXYZ
R
Qu a R
bcde
fghijklm
nopqrstuvwxyz
1 2 3 4 5 6 7 8 9 0

*ABCDEFGHIJ
KLMNOPQR
STUVW
XYZ
Qu a R
bcde
fghijklm
nopqrstuvwxyz
1 2 3 4 5 6 7 8 9 0*

THE LANSTON MONOTYPE CORPORATION, LIMITED
LONDON

These two men, once so close in their younger days, now saw each other only occasionally. Meynell had left the Catholic church and had become an agnostic, which Morison felt strongly about; but, also, as Meynell shrewdly suspected, he was one of the very few friends who had known Morison as a married man – 'a state which I surmise he did not wish to remember'. Indeed, Morison, during a radio programme on Eric Gill, claimed that he had no wife. This was true in the sense that he had not lived with his wife for many years, but from the point of view of the Catholic church he remained married.

Morison was not called upon to give a paper to the Club until the 15th dinner, in 1927, when he chose as his subject one of the smaller, but important, aspects of book production – 'Prelims'. At the 25th dinner, in 1930, he spoke on 'The Newsletters of Ichabod Dawks', the results of some individual researches; and ten dinners later, in 1931, on the 'Old English Newpapers and "The Times" New Roman', reflecting both his preoccupation with newspaper history at the time and the new type designed for *The Times*. With Ellic Howe at the 75th dinner, in 1944, he discussed unusual pieces of printing, and a year later, at the 82nd dinner, he took up the problem 'What is a pamphlet?'.

The range of Morison's enquiring mind is shown in his paper at the 89th dinner, in 1947, when he dealt with modern magazine make-up, which contrasts with that at the 130th dinner, held at King's College, Cambridge, when he discursed on 'Learned Presses'. This was one of the occasions when his habit of excessive correction was remembered by the University Printer (by this time, Brooke Crutchley). The cost of corrections in the Poliphilus number of the *Monotype Recorder*, for example, had exceeded the cost of setting. Ignoring Morison's reputation as 'The Printer's Friend', and to make sure that copies of the paper were ready in time for the dinner the Printer saw to it that no proofs were supplied to Morison.

At the Club's 134th dinner, in 1956, Morison joined with Meynell and Lynton Lamb to speak in memory of the Club's founder, Oliver Simon, who had recently died, and at the 192nd dinner, in 1967, Morison himself was the subject of a memorial meeting.

Morison undoubtedly valued the Double Crown Club, but in his last years he attended dinners infrequently. He had become a great figure in the world of publishing and printing, and not only were there many calls on his time, but he perhaps felt that many of the evenings could be better spent. Morison's view on the Club were given on the occasion of the 176th dinner, held in October 1964, to celebrate the Club's 40th anniversary. A recorded message from Morison was transmitted to the members, in which he said: 'It is difficult for people today to recall or to give the facts about the typographical situation as it was in 1919 immediately after the Armistice. Before 1914 we had no practising typographer in the sense that we have today. There was no designer or free-lance hawking his services about to various printers and publishers. The man who had the greatest influence at the time was Mr Newdigate. He was a typical product of the later arts and crafts movement. He believed very deeply in the standards of Edward Johnston and Emery Walker and Cobden-Sanderson. Behind them, of course, there was the figure of Sidney Cockerell, who was the link with Kelmscott. The standards of Newdigate were to some extent overlaid during the war, when there was no opportunity for practising fine typography. By 1919 new forces came into an influential position. Some younger men began what really became the profession of typographer. They knew about the printing trade. They had some idea of the way things were done in the composing and machine rooms,

but they were mainly concerned with the properties of design. They were not anxious to follow in the footsteps of the American designers, though they were only too glad to make use of their methods and their materials. Some of them clamoured around the machinery manufacturing people to get them to bring out English designs that they themselves favoured.

'While these new younger men, who were in due time to form the nucleus of the Double Crown Club, all wanted to do something, it does not follow that they all wanted to do the same thing. The post-Kelmscott arts and crafts attitude to typography was still historical. The picking up of hints from Geofroy Tory and other French printers of the sixteenth century succeeded the policy of picking up hints from Nicholas Jenson and Venetian printers of the fifteenth century. This idea did not apply to everybody. It did not apply to Mr Newdigate. It did not apply to other people who were very influential and vocal in the Double Crown Club, who believed in the employment of contemporary artists; and I well remember the time when the word "contemporary" became hawked about and talked about. It was about 1922 or '23 that I first became aware that this was a vogue word and considered to be significant in terms of carrying on the great artistic tradition of western civilization and ideas of that sort. Other people had other means.

'The Double Crown Club was a focus of discussion and it is rather a tribute to the even temper of everybody that although these conflicting views were firmly held, the bringing together of publishers, printers, designers (or typographers as they came to be called) in one club for many years was a remarkable achievement. We have managed very easily on the whole to maintain for forty years this equanimity among ourselves while all of us have vigorous and firmly-held differences of opinion.

'As to the historical basis of a good deal of the designing done between 1919 and 1939 there is this to be said. A good many things that have been done in the course of history have been done because they corresponded with human nature and with optical facts. The reason why we have decided to stick to a seriffed form of typography is because we have discovered in the course of centuries that a serif does assist legibility. It is a rational thing to have, and not a superstitious following of the ancients. It is useful to encourage a knowledge of history among typographers so that they emancipate themselves from the possibility of following doctrinaires – instead of rationalists –, ideologues who must have a style that corresponds with what they take to be certain definite trends in the arts, irrespective of whether that trend is a strengthening or weakening of legibility.

'You might say that one of the important things about the Double Crown Club was that it included not only printers and designers, but the publisher. He is, after all, a steward for the reading public, and acts as a moderating influence on the eccentricities and excesses of designers, who left to themselves might easily perpetrate all manner of absurdities; but when they are kept in order, as they are, by intelligent publishers, it is one of the most useful things the Club has done – to bring designers face to face with publishers who themselves have to face the reading public.

'As one of those who assisted in the foundation of the Double Crown Club it would have given me tremendous pleasure if I had been able to be present with you on this occasion when you celebrate the fortieth anniversary. And I would certainly have been there but for the fact that business calls me to Chicago at the very moment when you are meeting. I feel confident that the Club is as useful and healthy an influence today as it was forty years ago; possibly even more so,

in view of the risks that are implicit in some of the radical theories of continental designers whose work makes a great impression on English provincial minds. This is the kind of matter that can be discussed amiably though forcibly in the post-prandial debates of the Double Crown Club.'

This speech clearly outlined the background to the formation of the Double Crown Club, its functions and its future, revealing some of Morison's own prejudices and perhaps a slightly superior attitude, as the phrase 'English provincial minds' indicates; but what was astonishing – and some Club members still cannot make up their minds about the incident – is that Morison, far from being on business in Chicago, was, in fact, dining one floor below in Kettner's restaurant, with a lady. Was this simple absent-mindedness, an example of Morison's rather rough humour, or was it the arrogant gesture of one who felt himself above the minor courtesies?

Though he made much of the amiable discussion on vigorous and firmly-held differences of opinion, Morison did not relish criticism of anything connected too closely with himself. It was perfectly in order for him to criticize his Church, his choice in type-design, or *The Times* newspaper, when he was connected with it, but not for outsiders. From his remarks about the Double Crown Club it might be thought that this was the one place where he would retain his 'equanimity', as he put it. There was one famous occasion when he did not, and it involved, ironically, a young printer, James Shand (elected in 1928), who greatly admired Morison, and who carefully framed his Monotype broadsheets. Shand in 1934 was 29 years old, and was undoubtedly brash with his opinions. At the Club's annual meeting on 17 October he had asked the President, John Johnson, 'to make a reassuring statement on the question of the dreariness of recent papers read before the Club'. The shrewd president countered by asking for suggestions, and the committee, equally shrewdly, at its next meeting asked Shand to oblige with a paper.

This (given at the 45th dinner on 21 November 1934) was eventually entitled 'Typographical Developments, *circa* DCCI–DCCX' (i.e. during the ten years of the Club's life). The honorary secretary, John Carter, wrote: 'Mr Shand's lively and controversial paper provided considerable discussion, much of it irrelevant to the main questions at issue. Too many speakers spent their energies in defending, or condemning with Mr Shand, the layout of *The Listener* and Eric Gill's sans serif type. Mr Foss, however, corrected Mr Shand's alleged idea of the Club as a sort of Sunday school run by the two University Presses, and Mr Lewis observed that photogravure printing was never so clear as type. Mr Morison, unlike all other speakers, said he had not been stimulated at all, and had heard better discussions in Presbyterian chapels. Having thus appeased his conscience in the matter of lower case g for god, as admitted by Mr Shand, he pulled a number of holes in Mr Shand's historical deductions before concluding the discussion.'

Shand had erred sadly; he had criticized Gill sans, a Morison inspiration; had suggested the Club was dominated by the University Presses; and had apparently made a remark about God – all matters which touched Morison, who clearly brought the debate to an end in a magisterial way. The reference to 'Presbyterian chapels' was rhetoric. Presbyterians do not meet in chapels but churches and Morison was not in the habit of attending them. He may have been scoring off Shand's Scottish origin, but more likely could not keep off religion. But that was not all. When asked for his subscription on 4 December 1934, Morison replied: 'Dear John Carter, I shall clear out if there is any more of that Shand-y guff. Stanley Morison', not a very democratic reaction. Carter referred Morison's

message to the Committee, and a very wise body of men resolved: 'Mr Morison's letter of protest at Mr Shand's speech at the 45th dinner was duly noted by the committee.'

One of Shand's most endearing characteristics was his constant endeavour to publish high-class journals of typography, and for the first issue of his new periodical, *Alphabet and Image*, spring 1946, he reprinted an article entitled 'The Numbering of Newspapers' which Morison had written, but which had appeared anonymously in the 50,000th issue of *The Times* on 25 November 1944. Shand added Morison's name to his reprint. Morison waited until the *Handlist* (1950) was published for his rebuke. After the entry (No.136a) he added 'Signed in full (without S.M.'s permission)'.

Morison was a psychological puzzle. A fervent seeker after historical truth, he nevertheless saw the immediate past, in which he was involved, through a very special pair of Morisonian spectacles. His claim to have assisted in the foundation of the Double Crown Club is slight. Why Simon did not ask Morison to be one of the planners, whose names are known and whose meetings are recorded, is open to question. He may have felt that Morison was too often away from London, perhaps Morison's dislike of committees was taken into account, or Simon could have thought he was too much of a controversialist to assist in the delicate task of choosing the first members. Whatever the reason, Morison was not one of the organizers, but one of those invited to attend the inaugural dinner, an honour he shared with thirty-two others.

Cambridge and the end of 'The Fleuron'

Walter Lewis was a key figure in Morison's career. He had recommended Morison to the Monotype Corporation, with important results in the revival of type-faces, and he performed a similar function in getting Morison appointed to the University Press at Cambridge. As a result, the pace of type revival quickened, and from the Press there issued a range of books which contributed to the improvement of book-design.

Lewis left the Cloister Press at the end of 1922 when the change of ownership took place, but lingered on in Manchester as printing adviser to C. W. Hobson, while he looked around for another job. Then the University Printer at Cambridge, J. B. Peace, died suddenly in 1923, and Lewis, recommended by Richard Austen-Leigh, a director of Spottiswoode Ballantyne, was one of the candidates for the vacant position. Although the competition was severe, the Syndics, the governing body of the Press, were impressed by Lewis and appointed him to succeed Peace. Once at the Press Lewis began to implement a programme to improve the standards of printing. The Syndics were not unaware of the need for improvement, since as early as 1917 they had accepted the Bruce Rogers report which, among other matters, had referred to the paucity of good types at the Press. While certain types were introduced, until the composing machine manufacturers took some steps to issue new faces there was little more they could do.

Lewis considered that the typographical improvements suggested by Rogers should be pursued, and that Stanley Morison would be the man to give advice. The idea was put to S. C. Roberts, Secretary to the Syndics, and through him to the Syndics themselves. During an interview Morison was asked by the Chairman: 'I understand you would like to join us?' and Morison replied 'Only if you are interested in good printing'. The appointment was made from the beginning of 1925.

The Monotype Corporation were well aware of the capabilities of the new University Printer, who had printed a *Monotype Recorder* for them at the Cloister Press, a process repeated when they asked him to print at Cambridge the January/February 1924 issue devoted to the Poliphilus type. This was the issue in which S. C. Roberts prophesied that, under the direction of Lewis, the 'Monotype' work of the Press would continue to expand. Moreover, at the Press were two other exceptional men – F. G. Nobbs, a very skilled Monotype operator and later composing room overseer, and J. A. Scott, who ran the Monotype plant. The Monotype Corporation had a very good customer in the University Printer, and had reason to be grateful for advice from Nobbs and Scott on improving the performance of their composing system.

The situation was ripe for the great Morison-Lewis plan. Burch and Morison needed a clear-cut demand for new type-faces. Lewis, to whom the Corporation was beholden, was to provide that demand. The situation developed whereby Morison, as adviser to the Press, would suggest to Lewis that certain typographical

material was desirable, and as adviser to Monotype, assure the Corporation that at least one important customer required it. This, to some extent, took the steam out of the opposition at Monotype. The technique was perhaps somewhat Machiavellian, but judging by the results it was justified.

Morison had a long and happy career with the University Press, broken temporarily between 1945 and 1947, when as editor of *The Times Literary Supplement* he felt that he should not even remotely be connected with a publishing organization. Morison's collaboration with Lewis in the production of the Printer's Christmas books was mutually helpful, and this relationship was to continue with Lewis's successor, Brooke Crutchley. The idea of a Christmas book had begun with Morison's suggestion that a keepsake on the Bell type be issued to favoured customers, but his booklet grew into a full-scale book on John Bell, and the subject had to be dropped as suitable for a small Christmas gift. The general idea, however, was not abandoned, and, instead, a selection of sketches from the *Life and Errors of John Dunton*, entitled *The Tribute of a London Publisher to His Printers*, was issued at Christmas 1930, the first in a tradition which has continued, with various breaks, to the present day.

Morison was fortunate in the craftsmen he found at Cambridge, particularly in Nobbs, the virtuoso of the Monotype keyboard, to whom much of the credit for some of Morison's striking and beautiful broadsheets must go. These were produced for the various type-face revivals which now began to appear. Since reading Updike, Morison had long wanted to revive one of Pierre Simon Fournier's type-faces, and eventually he obtained a decision to proceed with the recutting for machine composition of a roman and italic of this master's earlier period. There was some doubt as to the best model, and two designs were cut – one became series 185 and the other series 178. Morison favoured the latter, but owing to some confusion, while he was abroad, and possibly because the works were still unimpressed by Morison's views, series 185 was approved and cut, being issued as 'Fournier' in 1925. The model used was the St Augustin Ordinaire from Fournier's *Manuel Typographique*, and the result was a light, open face, rather small on the body. There remained series 178, of which only one size of matrices was struck. These were acquired by the Cambridge University Press, where the type was known as Barbou, after one of the members of the French printing family who published works printed in Fournier's types. It was not until 1959 that another size of series 178 was cut, and in 1967 a full composition range of Barbou was made available. In the meantime, this more robust face was used in a number of Cambridge-printed books and, in particular, in the last three volumes of *The Fleuron*.

This publication, badly in need of some financial support, was transferred to the University Press when Morison took over the editorship. Volume 5 appeared in 1926 – a more substantial affair than the earlier issues. This is the volume in which Paul Beaujon's study of the 'Garamond' types appeared. Morison, who with Meynell was among the first to revive printers' flowers, grew rather tired of their use when they were taken up indiscriminately by others, but he was not averse to contemporary designs, such as those of Emil Weiss. The binding and end-papers of Volume 5 were therefore designed by Weiss, and Morison persuaded Lewis to stock up with Weiss ornaments. Updike did not agree with Morison on the value of these ornaments. In the 1937 edition of *Printing Types*, he wrote: 'Mr Morison praises highly (and I think injudiciously) Herr Weiss' decorative material; but his decorative units have a twist about them far away from the easier decorations of Fournier, by which some were inspired. Morison hopes that

Morison's use of ornaments:
specimen issued by Morison in
1925 to show Monotype
Fournier type.

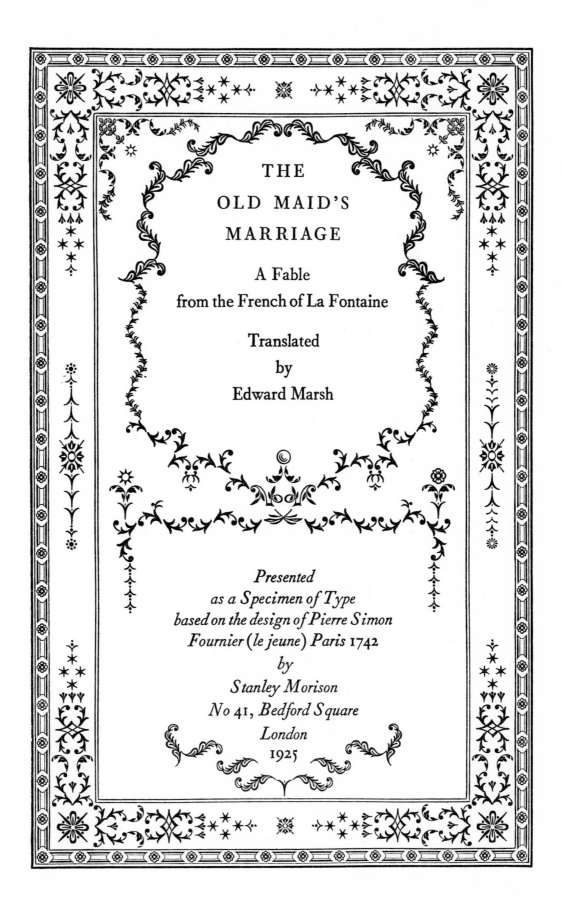

THE
OLD MAID'S
MARRIAGE

A Fable
from the French of La Fontaine

Translated
by
Edward Marsh

*Presented
as a Specimen of Type
based on the design of Pierre Simon
Fournier (le jeune) Paris 1742
by
Stanley Morison
No 41, Bedford Square
London
1925*

the "greater interest taken in German typography by English leaders, will open the way for Weiss' typographical material in England". I hope not.' Updike's view was apparently shared by others at the University Press, where the Weiss ornaments have remained a white elephant.

In Volume 5 of *The Fleuron* Morison continued with his series on type-faces with the article *Towards an Ideal Italic*. He was feeling his way on the question of the nature of italic, and his conclusion called for a 'sloped roman' treatment for those italics issued with roman, and the reservation of the fully cursive for special occasions. Morison was never at his best when theorizing, and in the light of greater experience, when it came to the actual designing of italic types, he felt he had pressed his argument too far. In other words, he abandoned dogma and let the requirements of the human eye take over.

Compared with the binding of No.5 that of Volume 6 was starkly functional, and indicates that Morison's preference for bindings was moving towards great simplicity, although he had already, in his *Penrose* period, experimented in this direction. A major illustrated article in this number, by Albert Windisch, concerned the work of Rudolf Koch, and was the first time the name of Berthold Wolpe, one of Koch's pupils, was mentioned in an English periodical. When Wolpe came to England in 1932, one of the letters of introduction he carried with him was addressed to Morison, who made use of his talents as a type-designer. Paul Beaujon also contributed to this number with *On Decorative Printing in America*, and Morison continued his series with *Decorated Types*.

The last number of *The Fleuron* appeared in 1930. Under 'Acknowledgments' the editor apologized to subscribers, contributors, and advertisers who had waited so patiently for 'this long delayed publication', adding 'other excuse there is none than the reader is here given more "ens" than in any previous issue'. From the pen of Jan van Krimpen came a long article on typography in Holland; Paul Beaujon wrote 'Eric Gill, Sculptor of Letters', and Douglas Cleverdon added a list of books which carried lettering and illustrations by Gill. As an inset there was 'The Passion of Perpetua and Felicity', a new translation by W. H. Shewring, with an engraving by Gill, constituting the first printed specimen of Gill's Perpetua type. Friedrich Ewald described the Officina Bodoni of Hans Mardersteig, while Updike wrote on the work of Thomas Maitland Cleland. Specimens illustrated the use of various types.

The edition is also famous as it included Morison's much-reprinted 'First Principles of Typography'. This essay first appeared under the heading 'Typography' in the twelfth edition of the *Encyclopaedia Britannica* (1929), but Morison re-wrote it for *The Fleuron*. Inspired by the work of Theodore de Vinne, 'First Principles' was described by John Johnson, Printer to the University of Oxford, in his 1933 Dent lecture as 'where the essentials of art meet the essentials of craft in a compendium of ruthlessness such as only Mr Stanley Morison could compile. They are the naked essentials and I would not alter a word of them.' Johnson quoted the beginning of the essay as 'the beginning and end of our own printing lives': 'Typography may be defined as the craft of rightly disposing printing material in accordance with specific purpose; of so arranging the letters, distributing the space, and controlling the type as to aid to the maximum the reader's comprehension of the text. Typography is the efficient means to an essentially utilitarian and only accidentally aesthetic end, for enjoyment of patterns is rarely the reader's chief aim. Therefore, any disposition of printing material which, whatever the intention, has the effect of coming between author and reader is wrong.'

The issue also contained a 'Postscript' from Morison, in which he wrote: 'It has taken nearly eight years to bring *The Fleuron* to its scheduled end. Nobody ever made a penny profit from it. The staff has not at any time been more than two and a secretary; and, as the one member who has contributed an article and reviews to every number, I may be pardoned for congratulating myself upon release from a task which, originally light, made during the last five years heavy demands upon the editorial leisure and means. The increased bulk of numbers 5, 6 and 7, to some extent due to an acceptance of such moral discipline as was necessary to accomplish the job decently, had another cause in the increase of typographical material and activity both here and abroad. New types were being cut; new presses being established; printing became "fine" printing; and printers, publishers, and booksellers between them made typography fashionable. It would be unprofitable to enquire what responsibility, if any, attaches to *The Fleuron* for this development – but some expansion in its pages necessarily resulted. There are signs that, due allowance being made for the speculative section of the book buying classes, the residue of readers able to distinguish good from bad typography is now sufficiently large to exert an influence upon publishers who may consequently be expected to encourage their printers in maintaining a normally high standard of craftsmanship.

'The justification for the 1500 pages in which *The Fleuron* has discussed typography – that admittedly minor technicality of civilized life – is not the elaboration therein of any body of typographical doctrine, and simplification of the elements of arrangement, any precising of the lessons of history, though these have been attempted; but rather its disposition to enquire and its conviction that the teaching and example of its predecessors of the English private press left typography as *The Fleuron* leaves it, matter for further argument.'

Morison, it will be noted, inferred that the seventh volume was the 'scheduled end', whereas at least eight had been envisaged. In reality, he was tired of *The Fleuron*, and now having other fish to fry, had decided to bring it to a close, much to the dismay of some of his friends. It was a piece of Morison's 'ruthlessness'.

One may smile at the complaint about the heaviness of the task not merely because, after all, it was self-imposed, but because it was the editors themselves, in other capacities, who had been responsible for much of the typographical material which expanded *The Fleuron's* pages. Morison had enjoyed not only the editing, but the business side as well, as letters to friends indicate, and had even contemplated a similar annual on calligraphic studies, not to mention monographs on pattern books. As to *The Fleuron* making no money for anybody, this was certainly true of the Curwen Press and of the University Press, each copy in 1928 being sold at a loss. But a deal with the American firm of Doubleday turned the scale, and Morison recalled to Daniel Longwell, of that firm, that the last days of *The Fleuron* were his most affluent.

The relationship with Doubleday arose from the work Morison did for the British publishers, Heinemann. The interested can examine *Devil in Love* (1925) which was produced under Morison's supervision, being set in Baskerville and printed at Cambridge. In about 1927, the American publisher F. H. Doubleday bought a controlling interest in Heinemann's and was introduced to Morison by the London director, Charles Evans. Doubleday invited Morison to work briefly at his Country Life Press on Long Island, without bothering, it seems, to specify any particular duties. Doubleday, typical of most publishers of the day, did not pay a great deal of attention to the design of his books, and left this, advertising, and production to a junior, Daniel Longwell, who, in time, was to become one

of the higher ranking editors of Time Inc. and chairman of the board of editors of *Life* magazine.

Longwell was greatly interested in typography and book-design and as Morison was somewhat at a loss, having no direct assignment, Longwell asked his advice about the design of a jacket for the two-volume edition of *The Life and Letters of Woodrow Wilson*. Morison designed the jackets, using Caslon Old Style. Looking at these jackets one can perhaps see the beginnings of the 'Gollancz' style, although as Longwell pointed out the yellow background was a tint block and not the sort of yellow paper used for the Gollancz jackets. Neither did Morison experiment with the variety of new bold type-faces as he did when he became a director of Gollancz. James Wells, of the Newberry Library, Chicago, thinks that the jackets were a forerunner of the Gollancz style, and since Morison saw his manuscript in which this suggestion was made, and did not contradict it, it may be taken that Morison thought so too. What is particularly noticeable is the *editorial* rather than the *pictorial* treatment which Morison later made famous.

Morison put forward the theory to Longwell that all die-stamping on bindings and such items as title-pages should be from a uniform pattern, so that, as he explained, an office boy could do them. Longwell was intrigued by the idea and Morison helped him to work out a standardized format for the 'Crime Club' series. The savings effected by using standardized dies and title-pages amounted to one cent or more a copy, and Longwell found he had a bigger margin for advertising due to smaller manufacturing costs. He was able to produce a best-seller a month, in consequence.

While at the Country Life Press Morison had shown Doubleday some original wood blocks cut by Eric Gill to illustrate a small volume of the *Stations of the Cross*. Longwell urged publication of a book, mostly to show what Morison could do, and Doubleday agreed. This was a small effort, but, much more important, Morison was able to persuade Doubleday to become the American distributor of *The Fleuron*.

Morison, Longwell recalled, was a very difficult person to Americanize. To him an elevator remained a lift; a street-car a tram; and he did not allow anybody to address him by his first name, shouting: 'Lay off my handle !'. He particularly detested the Long Island Railroad, which he had to use to travel from his New York hotel to the printing plant. When Longwell visited London on one occasion he heard Morison, in exasperation, come as close as so religious a man could come to swearing. His expletives were the names of the stations on the Long Island Railroad. He would shout: 'Floral Park . . . Nassau . . . Boulevard . . . Stewart Manor . . . Country Life Press !! and HEMPSTEAD !!!'.

In order to treat of *The Fleuron* it has been necessary to go ahead in time, but it is now desirable to go back to the period when Morison began to bring his opinions to bear at Monotype, and to lay the foundations for what may be considered his major contribution to typography.

Bridges, Gill, 'Typo Bolshevism'

When the climate of opinion within Monotype and the trade began to change for the better, Morison and the Corporation had to look around for models for new type-faces. Morison had two sources in mind, one ancient and one modern, in the shape of another Aldus type and, if possible, a design from Eric Gill, the sculptor and letter-cutter. These took time to bring to fruition and, in the meantime, suggestions were welcome. In 1926 when Francesco Pastonchi, the Italian poet, wanted a new type-face for an edition of the Italian classics, Monotype were happy to cut a face named after him and designed by Eduardo Cottin, of Turin. A distinctive specimen book for the face was designed and printed by Mardersteig. 'Pastonchi' was not avowedly an interpretation of modern artistic ideas, but was rather a return to classical writing and lettering and, as such, never really became popular among book designers. Oliver Simon did not think it a particularly legible type.

Another source was the United States and the Lanston Monotype Machine Company, of Philadelphia, which had in its employ since 1902 a designer, Sol Hess, who was appointed typographic manager in 1922, and later developed a number of type-face designs of his own. In 1921, however, he had adapted Cochin and its italic for machine composition. This was the Peignot foundry type of 1912, which Morison had introduced at the Pelican Press, and it was therefore a natural choice for the British Monotype repertoire, being added in 1927. Frederick W. Goudy had produced his Goudy Modern for the American Monotype organization in 1918, and this had been an asset to American printers at a time when good type-faces were hard to come by. It was therefore decided to add this face to the British Monotype range.

The roman of Goudy Modern appealed to Morison as a robust rendering of some of the letters used by eighteenth-century French engravers, whereas the italic was of English nineteenth-century inspiration. Morison did not regard Goudy Modern as, strictly speaking, a book type (although it has been used successfully in such limited editions as the Nonesuch *Don Quixote* and the second Nonesuch *Shakespeare*). Morison felt that it was best employed in 'certain kinds of extra-literary compositions as, for example, catalogues and prospectuses', and, in Britain, it made its first appearance in the Cambridge University Press autumn list for 1929, where the 12-point size appeared to advantage. Morison was not uncritical of the type, for he considered that the projectors were excessively long for the smaller sizes and the capitals excessively short, and he regretted reproducing these original 'eccentricities', although, perhaps, at the time he had no option. His general opinion was: 'the type possesses much of the elegance of the fifteenth-century Italian script, the brilliance of eighteenth-century French engraving and the regularity of nineteenth-century English cutting'.

A re-cutting of a type designed by another American, Bruce Rogers, occurred soon afterwards. This was the Centaur, but before recording this incident, perhaps it would be useful to comment on events leading up to it.

Morison was widening his horizons and was beginning to accept the world more easily. Tea shops were giving way to foreign restaurants and the tea to champagne. He was always on the look out for early printed books, particularly those which might provide models from which to reproduce the type. Some of these he obtained from Graham Pollard, a bookseller, of Birrell and Garnett, who also introduced him to the field of bibliography. Their acquaintance, which arose originally when Morison was 'subscribing' the 'Arrighi' book in 1925, developed into a close friendship. They would visit Whitstable for the oyster festival (Morison had the Londoner's taste for oysters and sea food generally) and dine together regularly. Later, Pollard was to call on Morison's typographical knowledge when he and John Carter began their uncovering of T. J. Wise's fabrications.

The 'Arrighi' book was *The Calligraphic Models of Ludovico Degli Arrighi*, a complete facsimile of *La Operina*, 1522, and *Il modo di temperare le penne*, 1523, with an introduction by Morison, who wrote it at the behest of the publisher, Frederick Warde. Soon after his appointment at Monotype, Morison had visited the Officina Bodoni of Hans (Giovanni) Mardersteig, at Montagnola, Switzerland, thus inaugurating a long and friendly relationship between Mardersteig and the Corporation. Mardersteig printed the 'Arrighi' book for Warde, who worked with Morison from a house in Bedford Square. This new situation had arisen because C. W. Hobson, intending to transfer his advertising agency to London, had, in advance of the move, started the Fanfare Press, in March 1925, at 41 Bedford Square, with the general idea that, in addition to setting Hobson advertisements, it should produce some distinguished printing under the supervision of Morison and Warde. The printer at the Fanfare Press was Ernest Ingham, and when Hobson sold the plant to the London Press Exchange the next year he continued in charge and started a programme of his own for a certain amount of quality printing in addition to the commitment in advertisement setting. In this work Morison, as a mark of friendship, helped Ingham, although he remained aloof from any commercial arrangement with the L.P.E. As a director of Gollancz, Morison used the services of the Fanfare Press for printing book jackets.

The story of the revival of the Arrighi italic type (one version called Arrighi and another with standard serifs on the ascenders named Vicenza) is complicated and an attempt has been made to disentangle the various threads by Will Carter, the printer of Cambridge (in a Note at the end of *The Elegies of A Glass Adonis* by C. A. Trypanis, New York, 1967), and he is of the opinion that it was Morison and not Warde who was the moving spirit behind the project to revive Arrighi's italic as a founder's type. However, Warde is generally credited with the 'design' of the Arrighi, based on the first of the two major founts of Arrighi, which was cut by Plumet in Paris in 1925.

A fount of the type was, however, used for another book earlier than *The Calligraphic Models* (1926) and that was for a book of poems by Robert Bridges, the Poet Laureate, who was also an orthographic reformer. Morison had first come across this aspect of Bridges while at *The Imprint* as J. H. Mason had reviewed Bridges's *English Pronunciation* at length in the July 1913 issue. Bridges had concluded that it was possible to write English phonetically on the basis of an old alphabet, both in an aesthetic and legible manner, and took for a basis an eighth-century half uncial. As he had no half-uncial type, he adapted an old Anglo-Saxon fount belonging to the Clarendon Press, having some new letters made. The supply of type for his new alphabet constituted one of Bridges's

A page from the leaflet advertising the Collected Papers of Robert Bridges, showing Bridges's phonetic alphabet and some of the new symbols designed by Morison.

XVI

THE BIBLE

WHAT England wud hav been if the Bible had never become a havsehold book is a hypothetical problem for the moral filosofer; and if we ask hau much we owe tu the literary excellence of aur translation, thatt question is not a wholly literary wun, but it has a very important literary aspect, of which we may ventur tu speek withaut intruding vpon morals or theology or the feeld of esoteric scolarship. For 300 years, and we may almost say from the date of the first dissemination of Tindale's New Testament, the averag Englishman has been svbjected tu an influence of incalculable magnitude, the greiter becavse he has been vnaware of its vnusual caracter; for the Bible that he has red and reveer'd has not only more beuty than eny vther vernacular rendering that eny vther nation has posesst, but it is in its vytal parts more beutiful and intimat than its originals. Here is a cavse of all manner of effects, moral, intellectual, and esthetic. In mere esthetic—that the book which has been present in all aur nvrseries and scoolrooms shud hav been the best conceevable model of simple style and natural beuty, irresistibly influencing for good every development of aur

95

problems, and eventually he turned to Morison for a solution. Ten years elapsed before Morison actually met Bridges, after having noted the distinctive typography of some of his books. Morison wrote to Bridges in 1923 and, when the acquaintance had ripened, Morison put forward the idea that a limited edition of Bridges's poems might well be the first book to be printed in the revived Arrighi italic.

After a very involved set of circumstances, which have been described by Nicolas Barker in *The Printer and the Poet* (Cambridge, privately printed, 1970), *The Tapestry*, by Robert Bridges, was published by Morison in December 1925,

being set in the Arrighi type. The word 'published' is used, for, despite the colophon which gives the impression that Morison and Warde set and printed the book, it was actually composed by the foreman-compositor of the Fanfare Press, and machined on a Harrild proofing press by Ingham and Warde, the ink being an egg-cupful of a special black ink brought by Warde from Paris. The hand proofing press had to be used because the terms of the lease with the Bedford Estates precluded the use of powered machinery in the house; but the proofing press was quite capable of handling the 150 copies involved. Morison corrected the proofs at night in an office or workroom allocated him in the Fanfare Press building. From there he issued various items, such as *The Old Maid's Marriage*, presented as a specimen of type on the design of Pierre Simon Fournier (le jeune), Paris, 1742.

Morison and Bridges continued their partnership, Morison acting as publisher for *The Influence of the Audience*, which was printed at the Country Life Press on Long Island. When it came to Bridges's *Collected Essays and Papers* which required the use of Bridges's phonetic alphabet, it was not the 'Arrighi' italic which was adapted but the Blado (based on Arrighi's second italic, and, as noted, devised for use with Poliphilus) which was chosen, apparently by Bridges. In 1927 the Oxford University Press announced the *Collected Essays and Papers*, to be published in fascicles, printed in the phonetic alphabet invented by Bridges 'in type designed and cut by Mr Stanley Morison and the London [*sic*] Monotype Corporation'. The type was hardly cut by Morison, but the copywriter probably had little knowledge of what was involved. The announcement continued: 'New symbols are introduced in successive numbers, as the reader may be able to bear them, and these are explained in the preliminary pages.' Morison was responsible for the design of most of these characters, including some which were not used. Blado lower-case, when augmented with the special characters, was known as 'R.B.'s Chilswell fount' ('Chilswell' after the village in which he lived), which was designed to combine with Blado italic and Poliphilus capitals. The first fascicle shows only four added characters, but by number four the alphabet had been expanded to thirty-nine characters, and a further fifteen were added later.

Before Bridges's death in April 1930, Morison co-operated with him in the publication of the special edition of *The Testament of Beauty*, regarded as Bridges's masterpiece (although the republican Morison could not have approved of its dedication to King George V). The book was composed in the large composition size of Bembo, a type-face which, in its turn, many regard as Morison's finest achievement, and to which a separate chapter will be devoted.

Arrighi's first italic enters the picture again when Bruce Rogers's Centaur type is considered. Before 1914 Rogers had acquired a copy of Jenson's *Eusebius* of 1470 and had been struck by the crispness of the type. He had a page enlarged to five times that of the original and worked over the letters with pen and brush and then had them photographed. The photographs served as models for the first cutting of a type called Centaur, in 1914, by Robert Wiebking, of Barnhart Brothers and Spindler, of Chicago, who modified some of the designs in an effort to improve them. The type was for the use of the Metropolitan Museum, New York, and was therefore private property. In the 1920's Rogers, because by then he was satisfied with the system of casting on Monotype machines, offered the composing machine rights of Centaur to Monotype. Morison considered Rogers's version of Jenson's face a freehand emphasis to the calligraphic basis of the original, and virtually an independent design. The great folio Oxford Bible, mechanically composed in 22-point Centaur, 'provides the most monumental

impression ever given to a Monotype face', wrote Morison in 1953.

The followers of the Morris doctrines on Jenson had been at a loss when it came to an italic to suit their Jensonian faces, since Jenson gave them no guidance. Rogers in 1914 ignored the problem, but for his Monotype Centaur in 1929 he persuaded Frederick Warde to design a modified version of the founder's type he had copied from Arrighi of 1524. In the re-cutting, the capitals were inclined, whereas in the original they are upright as convention required before the mid-sixteenth century. The result, wrote Morison, was a rendering 'as free and as calligraphic as Rogers's roman, of one of the finest of that category of italic nowadays called "chancery cursives"', adding: 'The acceptance by Rogers and others of the Roman instead of the Venetian type of cursive as the basis for the italics of Centaur (and Bembo and Polifilo) is one of the more significant factors in the 1922–3 period.'

In a letter to Alfred Fairbank on 6 June 1957, Beatrice Warde wrote: 'Centaur italic was designed by my late husband, Frederic Warde, at the suggestion of Mr Morison, and in consultation with the late Bruce Rogers, designer of Centaur. It was first of all intended that this Centaur italic should have its own separate name (on the analogy of Blado which is, of course, the italic of Poliphilus); this was found too confusing. Mr Morison had previously put in hand with the late Charles Malin, the great Parisian hand-punch cutter, a cutting of an Arrighi italic, which was produced under Mr Warde's supervision. That hand-set Arrighi was used in Robert Bridges's "The Tapestry" and in Douglas Cleverdon's edition of "The Ancient Mariner", illustrated by David Jones.'

As both Carter and Barker show, it was Warde who put the cutting of the Arrighi italic in hand with Charles Plumet and not with Charles Malin, and even after thirty years it might be thought that Mrs Warde would get the facts right about her husband's activities. However, she saw little of him and they separated soon afterwards; and she may not have known the precise details. In any case, the error could be excused if she was guided by Morison's comment after entry No.34 in the 1949 *Handlist*, where, referring to the book *Calligraphic Models*, he writes '. . . first modern use of Arrighi italic, re-cut, at the instance of S.M., by the punch-cutter Charles Malin of the Rue Didot, to whom he had been introduced by F. Thibaudeau of G. Peignot & Fils, typefounders'.

Additionally interesting is Mrs Warde's suggestion that the separate name for the italic was found to be too confusing. Was this really so? Reference works obligingly refer to Centaur italic *or* Arrighi, but typographers, in general, refer to Arrighi and mean the Monotype version not the founders' italic type.

The work of another American typographer also appealed to Morison – that of Joseph Blumenthal, who had founded the Spiral Press in New York in 1926. For his own use he had designed the Spiral type, which, in 1930, was cast by the Bauer typefoundry in Frankfurt, from hand-cut punches by Louis Hoell. Matrices were re-cut mechanically by Monotype in 1935 and the type was issued to the trade as 'Emerson'. When it was shown in *Signature*, Reynolds Stone commended it on the grounds that it 'avoided the rigidity of a modern face and preserved some of the virtues of the classic renaissance types'.

Morison, however, wanted Monotype to be the sponsor of original typographical material, using, if possible, the work of modern artists. At the same time, he felt that no original from a drawing board could be as satisfactory as a design adapted from existing type, and he was looking for the engraved quality found in the work of a Griffo or a Fournier. An orthodox calligrapher might produce one of those designs which Morison had already noted fell between two

stools – being neither script nor type. It followed that he would get the best result from a practitioner in lettering who was an engraver either in metal or stone. An old friend, Eric Gill, seemed to fit the role perfectly, but there were difficulties.

Morison had known Gill since his days at Burns and Oates, and in 1924 had approached him to write an article for *The Fleuron*. Gill politely refused, saying 'Typography is not my line of country'. This was a set-back for Morison, but there was a more fundamental objection to type-designing, than a mere lack of interest in typography, for Gill was opposed to modern industrial society, and supported the ideas of those who wanted to return to a largely mythical golden age of handicrafts. It followed therefore that he could not allow his letters to be turned into type by an industrial process, and then be printed from by machines. Morison took a different view, and argued that the monks in *scriptoria*, turning out as many copies of the gospel as they could by hand, would have welcomed a machine to have helped in the multiplication.

Both men were Catholics, and from early 1925 Morison began an argument on Thomistic lines, which would appeal to Gill, to bring the artist to his way of thinking. It took some years of wily persuasion to meet Gill's objections, and these were not really resolved, when, to please Morison, he drew two alphabets, such as he would normally cut on stone, and handed them to Morison without any interest in what process would be used to turn them into type-faces.

What Morison wanted was a man who hardly existed, an artist punch-cutter, one who both designed a type-face and was capable of cutting the punches for it. He would have to combine the work of a letter-designer with that of a craftsman punch-cutter, and therefore reasoned that if Gill's letters were to be successfully translated into type it would be best to commission a punch-cutter to engrave trial punches. This would meet his own requirement for the production of a really satisfactory type, and, in the process, perhaps interest Gill in the way in which handicraft and industrial techniques could be allied to produce something worth while. Accordingly, Morison took Gill's alphabets to Paris and arranged for a series of hand-cut punches from Charles Malin, by this time one of the last of the skilled artisan punch-cutters. The punches were made in 1926, and trial matrices struck, and then type cast. Corrections were carried out, and then all the punches were brought to England and used to assist in the processes of reproduction by the Corporation's engineers.

The first size of the upper- and lower-case roman was completed in August 1928, and was first shown in a private printing of an English translation of *The Passion of Perpetua and Felicity* (martyred in the year 203). The roman was therefore named Perpetua and the italic, which was cut later, Felicity, although, for some reason, unlike other italics with their own names this does not seem to have stuck. Perpetua was first used commercially for the composition of Gill's *Art-Nonsense*, published by Cassell in December 1929. As the italic had not then completed, the author's emphasis is expressed by underlining.

When the italic appeared it was slightly less monumental than had been anticipated, and was the result of a number of compromises. Morison's theory of a 'sloped roman' may have had some influence, but Gill had been drawing italic letters of this sort since the early 1900's, and had published a very similar design in 1909. Many of the letters differ from the roman only in being sloped to the right but the Perpetua italic, unlike later 'sloped roman' experiments, just retains, in the lower-case f and g for example, a vestige of the calligraphic origins of italic.

Morison prophesied that the titling capitals (series 258) 'will be esteemed as long as the Latin alphabet remains the basis of western recorded civilization', but

he was less certain about the quality of the composition sizes. 'While the relations of the thicks and thins and the serifs are perfectly judged, and all the essentials are present in correct balance, certain departures from the norm, set up by the centuries, distract and therefore estrange the reader, although only to a slight extent . . . This is a welcome innovation in the large sizes, but the same variations repeated, few though they are, in the small sizes, suffice to render the design "peculiar".' His final judgement was that in the small sizes Perpetua 'achieved the object of providing a distinguished form for a distinguished text; and in the larger sizes, a noble, monumental appearance'.

Not surprisingly, in the circumstances, the titling capitals of Perpetua, as shown on the Monotype specimen sheets, have been in great demand by architects, and for that purpose, in a sense, need not have been translated into metal type at all. However, Perpetua can be used in books to produce, as Morison said, 'a noble, monumental appearance' and this is exhibited clearly in the service books, which Morison designed for the 1937 and 1953 Coronations.

Gill's interest in typography was now aroused, and the man whose line of country was not typography went on to design more type-faces, not always for Morison or Monotype; to write a manual on the subject; and to set up as a commercial printer, not, be it noted, as a private printer, as some people have mistakenly thought, but one who used printing machines, not hand-presses. This may have amused Morison secretly, but he probably recalled Gill's enthusiasms for any cause to which he had been converted. The full irony of the situation was appreciated in 1936, when Gill was one of the first Royal Designers for Industry to be elected. Morison declined the honour, as his principles, at the time, would not allow him to accept any distinction containing the word 'Royal'. Gill, the anti-industrialist, swallowed the word 'Industry' long before Morison, the republican, could swallow 'Royal'. Not until 1960, when he had sufficiently mellowed, did Morison allow himself to be elected an R.D.I.

In 1930 Gill drew a type for himself and had it cut by the Caslon typefoundry. With characteristic pugnacity he proclaimed that his Joanna type 'was not designed to facilitate machine punch-cutting. Not at all. Machines can do practically anything. The question isn't what they can do but what they should. It is clear that machine products are best when they are plain . . . Joanna is an attempt to design a book face free from all fancy business.' At first Joanna was reserved for use by Gill's own printing firm, Hague and Gill, but J. M. Dent, the publishers, were then allowed to use it and they later arranged for it to be cut by the Monotype Corporation for their exclusive use. It was released for general use in the printing trade in 1958.

Gill was called on by Morison to provide a completely different kind of type-face from Perpetua, which was eventually known as Gill sans. To understand its origin it is necessary to turn back to 1925 when Morison and Gill first began their discussions on type. In that year, while still an undergraduate, Douglas Cleverdon had decided to make bookselling a career and had sent out his first catalogue, a copy going to Morison. Morison was surprised at such precosity, but was pleased to see Cleverdon when he turned up at 41 Bedford Square. Cleverdon came down from Oxford in 1926 and opened a bookshop in Bristol. His friendship with Morison flourished, so much so that Morison designed 'in about three minutes' the cover of Cleverdon's third catalogue, dated 1927, using the old favourite Moreau-le-jeune type to set the bookseller's name – an appropriately 'engraved' face complementing neatly a copper-engraving by J. E. Laboureur, whom both Morison and Cleverdon admired. Morison also

ANNUAL * MEETING ¶ FEDERATION OF MASTER PRINTERS

BLACKPOOL

PUBLICITY AND SELLING CONGRESS

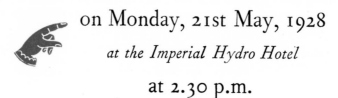 on Monday, 21st May, 1928

at the Imperial Hydro Hotel

at 2.30 p.m.

FIFTEENTH COST CONGRESS
OF THE FEDERATION OF MASTER
PRINTERS AND ALLIED TRADES OF
THE UNITED KINGDOM OF GREAT
BRITAIN AND IRELAND

IMPERIAL HOTEL, BLACKPOOL
MONDAY, 21st MAY
1928

The reduced reproduction, right, shows a programme cover by George W. Jones originally printed by him with the initial outlined in gold and coloured in red upon a background partly coloured in green. The contrast between this cover and Morison's design reproduced at the left in its original size will help to explain the shock experienced by many of the master printers present at Blackpool in 1928.

supervised the printing of Cleverdon's publication *The Beaux Stratagem* at the Doubleday printing works, but Cleverdon thought it an unsatisfactory piece of production.

Cleverdon also knew Gill. During an attack of influenza which kept Gill house-bound in Bristol, he agreed to sketch letters in a book as models for the young bookseller to follow for labels and placards. Among the alphabets was one of 'block letters', and when Cleverdon asked Gill to paint the facia of his shop, Gill used these block or sans serif letters. This facia, destroyed in 1940, has entered typographical history as being the origin of the famous Gill sans type family, but Gill's interest in 'block' letters went as far back as 1915 at least, when his master, Edward Johnston, designed a sans serif for use by the London Underground railway, to which Gill sans owes something of its origin. Another of Johnston's pupils produced a sans serif – Harold Curwen, who first designed one for a letterheading in 1912, printing from line blocks. The capitals were cut as type in 1928, and one size of the lower-case in 1931. The characteristic of these Johnston-derived sans serifs is that they are based on the Roman model and do not have either the crude appearance of nineteenth-century grotesques or the mechanical, rule and compass look of the twentieth-century German productions.

Gill had continued in the Johnston spirit when he experimented with block letters for the Army and Navy stores and for sign boards for the Gill home in Wales. By October 1926 he began painting Cleverdon's facia, and it was as a consequence of seeing this that Morison asked Gill to supply an alphabet for type-cutting. Such a type-face was highly desirable at this point, as the Monotype Corporation had introduced its Super Caster, and Morison had become responsible for suggesting suitable display as well as text types. There was also competition from the German typefoundries, which were issuing sans serif types and making an impact on the protagonists of the 'new typography' and among supporters of the Bauhaus school of thought.

Morison was delighted to find a sans serif to hand and Gill readily supplied the necessary alphabets, agreeing, with some amusement, to Morison's suggestion

that the new type should be called Gill sans. With the help of Monotype's type drawing office the first trial to be cut was a titling face (series 231), and it was this type which was used – together with the first version of Gill's printers' fist – on the front of the programme for a 'Publicity and Selling' Congress, organized by the British Federation of Master Printers at Blackpool in May 1928. Morison was asked to give an address, which he entitled 'Robbing the Printer', in which he warned printers that they were losing business to the advertising and publicity agents.

It was not Morison's talk which stirred the greatest interest, but the programme which he had designed and had printed rather hurriedly in a 'cock robin' shop in time for the Congress. Following Morison's speech, W. Howard Hazell asked him to point out the beauty in the programme – 'the programme with the red hand'. Morison said he could not answer the question as what was beautiful was debatable. He added: 'I think my programme has its uses. I saw Mr Hazell kill a fly with his copy.' Morison and Hazell were at cross-purposes. The programme was not meant to be beautiful, but attention-catching, in which it fully succeeded. Hazell had to admit that it was so designed, and that it was original, but this did not satisfy those printers who were very conscious of the George W. Jones school of 'beautiful' printing. J. R. Riddell, by now principal of the London School of Printing, had written: 'The circular relating to the Selling Congress should be withdrawn if at all possible. In this, there is an example of "how not to do it" and one which technical instructors have been concentrating their best efforts to eliminate from the ordinary work of the printer. To my mind, it is an abomination that ought never to have seen the light of day . . .'. Bertram Evans got up to say that they must recognize that this driving after effect, which was so blatant in so many circles of activity in addition to that in which Mr Morison functioned, was bound to come to an end sooner than they imagined. Accusations of 'typographical bolshevism' were thrown about, and the modest little programme must have been one of the most controversial items ever to have come before a printers' meeting.

Morison then prepared a 'manifesto', composed and printed at short notice, to distribute at the annual conference of the master printers, which followed in June. Entitled 'The 2 Kinds of Effectiveness', it is described by Morison in the *Handlist* as 'The rejection of the protest of an ignorant and truculent section of the British Federation of Master Printers, which had refused acceptance of a programme of the proceedings, at the 'Selling' section of its annual conference. This, designed by S.M. and printed gratuitously, as the first use of Eric Gill's sans-serif, had been denounced as "typographical bolshevism". The trade journals of the day abound in reference to S.M. as alternatively, a "bolshevik" and a "high-priest".'

In 'The 2 Kinds of Effectiveness' Morison tried to explain the difference between fine book-typography and the modern 'attention appeal' publicity, which was deliberately planned to catch attention and hold interest. He wrote: 'Not only does everybody advertise in order to expand nowadays, but every progressive firm *must* advertise in order not to lose money to a livelier competitor. The result is that competition for attention has reached a point where the explosive, arresting force of *novelty* must be used as never before.'

This doctrine does not seem very remarkable today, but in 1928 it was unpalatable. Morison answered Riddell's criticism with: 'We have no other answer than that it is the proper business of effective business printing to include provocation among its constituent virtues. To say that the style of our folder

Morison's 'manifesto' distributed at the 1928 annual conference of the British Federation of Master Printers (reduced).

THE 2 KINDS OF EFFECTIVENESS

The conventions of fine book-typography have been developed, accepted and obeyed for centuries. When a book is legible, pleasing to the eye, and above all unobtrusive, we say it is "effectively" printed.

But there is another kind of printing—historically a very recent kind, inevitably arising out of the industrialisation of our life and gathering greater and greater volume with the increasingly intense business competition of the present day—to which the familiar canons of fine book-typography cannot possibly be applied. An unobtrusive advertisement, a catalogue page, which only a connoisseur can distinguish from a piece of "classic" printing, might have caught the eye of the casual reader in the days when any advertisement was something of a novelty. Now it is elbowed out of sight by displayed printing which is deliberately planned to catch attention and hold interest. It would be unthinkable to impose this calculated "attention appeal" upon book-printing. But it is no less dangerous to base all sales-promotion matter on the temperate conventions of classic printing.

Not only does everybody advertise in order to expand nowadays, but every progressive firm *must* advertise in order not to lose money to a livelier competitor. The result is that competition for attention has reached a point where the explosive, arresting force of *novelty* must be used as never before. The printer is a collaborator, and here is his opportunity. It is his task to express his customers' copy with the utmost force. "Old-fashioned" is a word that never troubles the book printer. But it is a fatal word to the job printer who necessarily works in an atmosphere of high and increasing tension, and who, if he wants to maintain his position, must learn to *appeal to the present day in the terms of the present day.*

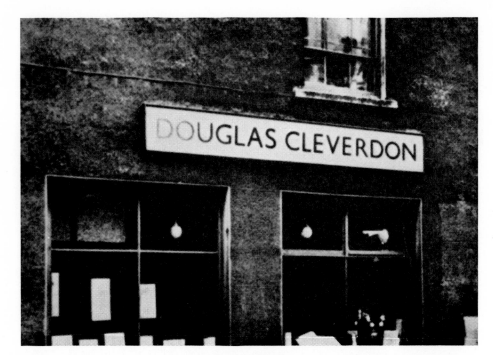

Facia board, 1926 (since destroyed), in letters later developed as Gill Sans.

represents the only way of being effective is as idle as to say that all job printing ought to conform to the dignified predilections of book designers. To be effective you must surprise – *startle*. Here is no one criterion but individuality and novelty. Tempering and controlling these with logic, the progressive printer will create fresh rules for each fresh case.'

Despite the adverse reaction of some members of the Congress, Gill sans, as such, got off to a good start. In due course, C. C. G. Dandridge, newly-appointed Publicity Manager of the London and North Eastern Railway, was attracted by the type's simplicity and decided to use it as a standard type for the L. & N.E.R.'s signs, time-tables, and other printed matter. Once accepted, some ninety printing establishments under contract to the L. & N.E.R. had to install Gill sans. As the standardization process continued, the Gill sans family grew to meet the various demands, and Gill cheerfully welcomed each successive test of the adaptability of his basic design. By the end of 1935 Gill sans comprised the largest related series of types for modern composition and display ever based on a single design.

Morison's 'two kinds of effectiveness' were apparent when he came to advise the newly formed firm of Victor Gollancz Ltd. Morison and Gollancz had known each other for some years, although Morison was not fond of Gollancz's back-slapping approach and unauthorized use of his first name. While Gollancz had been at Ernest Benn Ltd, some very distinctive books by Morison had been published including not only *Four Centuries of Fine Printing* (1924), but also *Modern Fine Printing* (1925) and *The Art of the Printer* (1925). Morison supervised the typography of Benn's Julian editions, particularly an important limited edition of *The Works of P. B. Shelley*, which ran to ten volumes. When Gollancz left to found his own firm in 1928 Morison became one of its directors, and for ten years advised on design and production. The only book of Morison's published by Gollancz was the large folio *German Incunabula in the British Museum*. Morison had continued to pursue his studies of black-letter, and this book was his first attempt to explain the type's emergence.

Morison's connexion with the Gollancz firm is best known for the famous yellow jackets which he devised from 1929 onwards. Following the line of

The Post Office telegram form before and after it was re-designed by Morison in about 1935. Morison cut down the wording and reduced it to essentials. The setting is in various weights and sizes of Gill Sans.

argument he developed at the printers' congress, he suggested that a book jacket must startle the potential buyer. This was not accepted by everybody at Gollancz, but the publisher himself decided that Morison's ideas should be given a trial to see if they would work. The potential reader, according to Morison, should first be compelled to look at a jacket and then induced to start reading at once. This combination demanded typographical audacity – a mixture of both eye-catching display and more sober editorial setting. Morison began a discussion of the book's contents on the front of the jacket with the intention of making the reader turn to the flap and then to the book itself. To make sure that the jacket would stand out from others, black, red, and magenta printing on a special bright yellow paper (Morgan's Yellow Radiant) was used. Gill sans was a valuable weapon in

this battle of the bookstalls, as a glance at the jacket of Joad's *Guide to Philosophy* recalls, but Morison used all the display faces he could lay hands on, particularly the new bold faces being issued by German typefounders. These jackets were not welcomed by the book trade – publishers and booksellers – who thought they were unfair.

The doctrine that a jacket is not just for protection but is an integral part of the selling apparatus has since been accepted, and it can be seen that Morison was a pioneer in this respect. Furthermore, since the binding was not required to catch the eye, it could be extremely simple. Gollancz books thereupon assumed a dress of black cloth, undecorated except for title and publisher's and author's name on spine. This simplicity must have saved Gollancz money as it had once done at Doubleday's. After a time Morison designed no more Gollancz jackets, but in the hands of Ernest Ingham, of the Fanfare Press, and his compositors the style continued.

Morison was also a critic of advertising and considered most copy and layout were too 'literary'. This will probably surprise the average advertising man, but in an article on 'Advertisement Settings' in *Signature* (No.3, July 1936) he demanded exactly the opposite of that which is required in book-work – more space after full points, less decoration, typographical diversions, and (never mind the printer) the treatment of type as if it were made of rubber. It is an article which could still be read with profit in advertising agencies.

Gollancz and Morison were both socialists with pacifist tendencies, but Morison ceased to be a director of Victor Gollancz Ltd in 1938, and the reason is not difficult to find if the political situation of the time is recalled. The Spanish civil war was raging and feelings ran high. The well-known journalist Allen Hutt had come into the Morison circle, and his connection with newspaper typography and that aspect of Morison's career will be discussed in an appropriate chapter. Hutt had the additional attraction for Morison of holding strong political views. The fact is that while Morison was always willing to discuss typography, he also liked talking about philosophy, religion, and politics. Morison was disturbed, as a Catholic, at the activities of the left-wing in the Spanish war, and was conducting a debate with both Gill and Hutt. Gill, despite his Catholicism, seemed to be on the side of the anarchists (about whose activities Morison seemed surprisingly well informed). Morison and Hutt conducted their debate by letter, but had numerous verbal exchanges, which tended to grow heated; so much so that on one occasion in the old Monotype offices in Fetter Lane Hutt lost patience and exclaimed – to the open-mouthed astonishment of Beatrice Warde and John Tarr, who were in the room – 'Uncle Stan, stop talking through your big black hat!'.

No lightning struck at this example of *lèse-majesté*, and Hutt continued to enjoy a valuable relationship with Morison, despite a slight cooling off when Hutt criticized not Morison's religion, but something far more serious – *The Times* newspaper, for which, as will be explained later, Morison came to have an almost religious regard.

There is no reason to believe that Morison did not equally enjoy arguing with Victor Gollancz, but as Gollancz's Left Book Club was not only solidly anti-Franco but was actively helping the Spanish Republican forces, Morison must have found the atmosphere at Gollancz's Henrietta Street offices uncongenial, and his relationship with the Left Book Club, although at one remove, a positive embarrassment in Catholic circles.

'The Times' & newspapers

An aspect of printing which absorbed Morison was newspaper production and journalism. In time he was to become a great authority on newspaper history and an influential figure in the newspaper world, initially as typographical adviser to *The Times*, but eventually as 'the most active backroom boy in Printing House Square', to quote *The Times* leader on his death. How this came about is possibly one of the most remarkable stories in Morison's remarkable career.

The man who set the whole process in motion in the early summer of 1929 was Edmund Hopkinson, later an advertisement manager at *The Times*. When another printing supplement was planned Hopkinson asked the Monotype Corporation if it would take a full-page advertisement as it had done in 1912. Before making a decision Burch asked for Morison's opinion. Morison startled Hopkinson by saying quite bluntly that he would rather pay *The Times* £1000 to keep their hands off a Monotype advertisement. He continued by giving Hopkinson a lecture on the bad printing and out-of-date typography of his newspaper. A compromise was reached whereby the Corporation would take advertisement space but would set up its own announcement.

Hopkinson went away a wiser man, but being also an intelligent one, he reported Morison's strictures to William Lints-Smith, the Manager of *The Times*. Lints-Smith did not leave the matter there but met Morison on 1 August, and having heard his criticisms, asked what Morison would do. Morison suggested a complete reform of the typography of the newspaper.

Lints-Smith was impressed by Morison's case, and suggested that Morison might like to take an advisory job on the newspaper. According to his own account, Morison held off for a time, and said finally: 'If you take the full point out after the paper's name I will come.' The full point was omitted after 13 August, and Morison accepted the appointment as typographic adviser, which Lints-Smith had secured. It must be appreciated that the Manager of *The Times* was a much more important and influential figure than his comparatively modest title would suggest. While the day of the high-sounding, but ineffective rank on newspapers had yet to come, even then 'Manager' would not have been thought adequate in Fleet Street, except at *The Times*, for the heavy responsibility involved. He was, in fact, the agent of the proprietors in all matters except the editorial contents of the newspaper. This concentration of power in one man made a great deal of difference to Morison's career at *The Times*.

The Manager arranged a small party at the Devonshire Club for Morison to meet some of the senior staff. Among those present was F. P. Bishop (later Sir Patrick), who recalled how astonished they were at the freedom and violence of Morison's criticisms. After lunch, Lints-Smith remarked: 'Well, Morison, I hope that when you come to know us better, you will like us a little more.'

In the meantime there was the special printing supplement, of 29 October 1929, to prepare, and Morison was asked to contribute to it. His article was headed

MEMORANDUM

ON A PROPOSAL TO REVISE

THE TYPOGRAPHY OF

The Times

1930

'Newspaper Types', with two sub-titles, 'English Modern Face' and 'A Study of *The Times*'. Readers learned that in 1785 *The Times*, under its original name, *The Daily Universal Register*, had been set in an 'old face', but that a bookseller, John Bell, inspired by the work of Parisian designers had established his own foundry to produce a 'modern' face. His punch-cutter was Richard Austin, and together they produced the first English 'modern' face, which was eventually used in Bell's newspaper, *The Oracle*. John Walter, of *The Times*, did not approve of Bell, but *The Times*, nevertheless, went 'modern' in 1799, using a Caslon version of this class of type. Foundries quickly followed Austin's example, and in 1809 William Miller set up in Edinburgh the first foundry to be devoted to 'modern' face. 'It is from this foundry', wrote Morison, 'that the present *Times* founts derive, and it is at least possible that they were designed by Richard Austin, for he worked also for this foundry.' Morison concluded: 'The question of an ideal type is, indeed, one of the greatest difficulty, complexity, and risk for any newspaper, and whatever the final result of recently conducted experiments, the type of this present Printing Number remains that of its predecessor of 17 years ago.'

The experiments to which Morison referred included the setting of trial pages of *The Times* in various type-faces, including Baskerville, Plantin, Imprint, and Ionic. An experimental re-cutting of Perpetua, with shortened ascenders and descenders, was also tried. The object was to determine the behaviour of various type-faces when printed from a curved stereotyped plate by rotary printing.

So that the Chief Proprietor, Major John Astor (later Lord Astor of Hever) should have some idea of the historical background to the typography of his newspaper, Morison, early in 1930, prepared *The Typography of The Times*, which was illustrated with upwards of forty plates from originals between 1 January 1785 and 16 June 1930. This was a large folio with setting in 24-point Bembo, the matrices having been specially cut for the purpose. The edition consisted of one copy, which was presented to the Chief Proprietor by the staff of the newspaper. This was, possibly, an expensive gesture, but Major Astor could be in no doubt as to the calibre of his new adviser.

As the result of the experiments Morison decided that a completely new type-face was needed, and he put this view forward at a conference on 24 October 1930. The Manager thereupon appointed a committee to consider: 'The desirability of making an alteration in the present editorial and heading founts.' Among members of the committee was the Assistant Editor, R. M. Barrington-Ward, a supporter of the change. Geoffrey Dawson, the Editor, was a little detached and preferred to leave details to others. Another member was Harold Child, a journalist and fellow-member of Morison in the Double Crown Club and an enthusiast for good printing. Sir Patrick Bishop, who also served on the committee, recalled that it contributed very little, since Morison was the mainspring of the whole operation from its inception to its final conclusion. Nevertheless, Morison could not have achieved much without the support of a number of influential figures, including the Manager and particularly the Assistant Editor.

For the committee's guidance Morison prepared a thirty-four-page memorandum, which was presented on 26 November 1930. This is not so rare a publication as the one-copy edition given to the Chief Proprietor, but must be nearly so. Twenty-five copies of the *Memorandum on a Proposal to Revise the Typography of The Times* were printed, eleven of which were circulated and the rest pulped years later by an over-zealous warehouseman. The Memorandum was

exhaustive and subjected the committee members to what was, in effect, a short course in typography. At one point Morison interpolated: 'But more (alas for the Committee!) of this later', as if suspecting that it might all be too much for them. The historical portion was taken from his own 'Type Designs of Past and Present' (the *Monotype Recorder*, September/December 1925, published in book form by The Fleuron Ltd, the following year).

Morison began by defining the nature of typography and the readership of *The Times*, going on to describe the printing trade of the day and the lack of correspondence between the book and newspaper sections. The reasons for the low standards of newspapers were explored, and the desirability of reforms stressed. There followed a discussion on the question of legibility and a summary of considerations raised by any proposals to change the typography of *The Times*. The object was to prove a clear case for the revision of that typography. '*The Times* will not be recommended to introduce anything resembling the aesthetic faces on the private press movement of the nineteenth century, nor one of the mass production faces which American newspaper men have recently brought out', wrote Morison, but rather '. . . by articulating the problem of a new type with relevant detail of past and present practice, to assist the Committee towards the adoption of a fount which shall be English in its basic tradition, new, though free from conscious archaism or conscious art, losing no scintilla of that "legibility", which rests upon fundamental ocular laws, or of that "readability", which rests upon age-long customs of the eyes'.

A minor, but interesting, point occurs in Morison's discussion of 'the present typography of *The Times*', where he explains that the constant cutting and re-cutting had reduced the design of the editorial type to 'the feeble thing it is today'. In a comment on the 20-point size used for 'departmental headings' he says: 'the heading "Points from Letters", for example, displays a broken-backed lower case "f" which had to be seen to be believed. It is impossible to imagine any London publisher of the present day using such types for even his cheapest novels.' Morison was to remember this 'broken-backed' 'f' when, in 1933, he was asked for advice by Graham Pollard and John Carter in the Wise investigations. Perhaps a publisher of 1930 would not have used such a letter, but T. J. Wise did so, unwittingly, and this led to his unmasking.

Morison waited to let the implications of his memorandum sink in before beginning a subtle campaign to alter what was thought to be the traditional 'gothick' title-piece of the newspaper. He particularly disliked this, calling it 'paste-and-watery', and issued a 'Supplement' to his memorandum to persuade the management 'not to attempt the task of faking a new gothic but, by following the clear logic of the nature of the paper, to range a well-cut, correctly drawn Royal Device between the title set in disciplined roman capitals of the utmost simplicity'.

Fortunately for Morison's case the first issue of the re-named *The Times* (1 January 1788) had carried a title in roman lettering, which therefore could be considered as 'traditional'. The adoption of the 'trick gothick' had merely been to keep up with fashion. Morison had his way, after a lot of heart-searching by the directors, and the newly designed newspaper carried a title in roman lettering. He was not so successful with the Royal Arms.

The Times had no warrant for the use of these arms, but it seems they were carried originally from 1 January 1785 as an indication of the paper's politics ('Court-Tory'). They were therefore the arms of George III, of five quarterings – England, Scotland, France, Ireland, and Hanover, and, while poorly drawn, had

the minor merit that the lion and unicorn were at least supporting the shield. By 19 May 1787 they had become 'couchant', and had remained in that posture ever since.

Morison pointed out that other newspapers carried the Royal Arms without the slightest authority, including *The Era*, an entertainment industry journal, 'in which the features of the lion supporting the shield closely resemble those of Mr James Maxton'. Morison's suggestion that 'the publication by *The Times* of the "Royal Edition" (on rag paper, price 4d) would be regarded by Authority as sufficient ground for the issuance of a Royal Warrant' is unlikely to have been taken seriously as it would have been thought undesirable for a particular newspaper, no matter how eminent, to have even so slight an official connexion with the Crown. But even if this had been granted, the arms would have been those of George V and not of George III.

Morison had good advice, as on the foreign staff of *The Times* was the founder of the Society of Genealogists, Harry Pirie-Gordon, a son-in-law of G. E. Buckle, Editor of *The Times*, 1884–1912, and a literary collaborator, in his youth, with Frederick William Rolfe ('Baron Corvo'). Pirie-Gordon and a Captain Shaw pointed out the heraldic errors in the arms being used, and new versions were commissioned. A vigorous design by Harold Stabler was shown in the 'Supplement', but was rejected in favour, not of the existing version, in which the lion and unicorn looked as if they were made of putty, or of the original of 1785, but of a degraded specimen of 1792, with a winsome, wide-eyed lion and a unicorn looking like a country bumpkin. Mr Stabler's supporters were fierce and noble creatures, but they were also conspicuously 'armed' in a place which may have decided the board against them. Morison may have claimed that '*The Times*, with its new titling, its new device, and its new text types, possesses, from the headline on the front page to the tail imprint on the back, a visual unity' (*Printing The Times*, 1932), but it began its new career with a distinctly old version of the Royal Arms, proclaiming the King of Great Britain also King of France and Hanover.

Despite Morison's rhetoric about English tradition, archaism, conscious art, and scintillas, the committee were not much wiser about the type they were being called on to recommend, but for the meeting of 28 January 1931 Morison prepared two possible designs, one based on Perpetua and the other a 'modernised Plantin'. The committee indicated a preference for the latter, and this may have been the genesis of the type-face which was eventually known as Times New Roman (to differentiate it from the previously-used 'Times Old Roman'). Twenty years later, in *Printing the Times since 1785* (London, 1953) Morison declared that his intention was to sharpen up the even lines and blunt serifs of Plantin to give it greater contrast of line and sharper serifs.

The steps which led to the first drawing of Times New Roman are obscure, and some odd theories have been produced as to its origins, including American suggestions that it was based on De Vinne Roman, or that Eric Gill had a hand in it. Morison did not help by writing in 1953 that he had pencilled a set of drawings and handed them to the late Victor Lardent, of *The Times* publicity department, and that Lardent made a first-class set of finished drawings out of the pencilled patterns. This is doubtful, as Morison could sketch a layout but was no draughtsman. Thirty-seven years were to pass before Lardent was questioned for publication about the origins of the type (in January 1968 by the author), and he was unable to remember in detail what had happened. He was clear, however, that Morison did not give him any patterns, and that the production of the basic

alphabet was a much lengthier process than that suggested by Morison.

Lardent said that initially Morison handed him a photographic copy of a page from a book printed by Plantin to use as a basis. He was not sure about the exact book, but Plantin was the name which had remained in his mind. Hugh Williamson, in his *Methods of Book Design* (London, 1956) wrote briefly of Times New Roman: 'In structure the design closely resembles Monotype Plantin', but went no further at the time to analyse this resemblance. He has now told the author that it was the illustrations in Peggy Lang's article in *Alphabet and Image* (No.2, 1946) which led him to this conclusion. He writes: 'One of the details was the way in which the mainstroke of lower-case b ends short of the line and swings straight into the bowl without a foot-serif. I noticed a similar detail in Plantin, together with other details, and then saw the similarity of proportion between the two designs. From then on I always supposed Plantin and Times to be father and son, like Caslon and Imprint.'

Allen Hutt, in an article 'Times Roman: A Re-assessment' (*Journal of Typographic Research*, Volume IV, Summer 1970, Cleveland, Ohio), writes: 'But all commentators, including myself, have hitherto missed the simple fact that Times Roman is a sharpened-up, tighter, re-proportioned version of Monotype Plantin, 110, with an increased x-height and some letters modified – the splayed M, for instance, and the crossed W. This is scarcely surprising, since the late Victor Lardent, the artist in the publicity department of *The Times* who drew the alphabets for the new design under Morison's direction, recalled that Morison initially handed him a photo-copy of a page from a book printed by Plantin. Morison might just as well have handed Lardent some specimen sheets of 110, the first (1913) and still one of the greatest of the Monotype recuttings of the classics.'

The type in a book literally printed by Plantin would not have the characteristics of the modern 'Plantin' type, but the page could have been photographed from the 1905 Plantin-Moretus specimen (the origin of Monotype's face), to which Morison could have had access. Morison, as Hutt suggests, could have handed Lardent specimen sheets, or, it could be postulated, even proofs of settings of Monotype Plantin, but taking what evidence there is, it looks as if the *Index Characterum*, 1905, was the inspiration for Times New Roman.

In a record of the changes introduced in *The Times*, from the issue of 3 October 1932, entitled *Printing The Times*, Morison wrote: 'The new designs, controlled by the specific requirements of the case, differ from the text and heading founts of every other press, or newspaper, or book printer in the world. "The Times New Roman" (as it is called) *is* new; but while it is an innovation, it is also something of a reaction. The "Modern" type characteristic of the British newspaper is, as has been said, a version of the design which, invented between 1780 and 1790, came to a full development between 1800 and 1820. By the time Queen Victoria ascended the throne it had completely supplanted, whether in books or in newspapers, the early Georgian "old face", cut by William Caslon, and used in *The Times* until November 1799. Caslon's design stems directly through Garamond to a roman first used by Aldus in 1495. "The Times New Roman" possesses many structural features to be found in this distinguished archetype. Nevertheless, it is not exactly an "old face", for its sharp serifs are tokens of "modern face". It is a newspaper type – and hardly a book type – for it is strictly appointed for use in short lines – i.e. in columns. A modified design will be cut for book-work. Typographical pundits will probably classify the design as a "modernised old face". Ordinary readers, for whom a type is what it does, will

The first issue of *The Times* to be set in the Times New Roman type was published on 3 October 1932. Reproduced in reduced size is a page from the issue of 2 December 1932 which shows the first-ever double-column heading to be used in the editorial portion of the newspaper.

BRITISH NOTE TO AMERICA

DISASTROUS RECORD OF WAR-DEBT PAYMENTS

LAUSANNE SETTLEMENT IN DANGER

SUSPENSION NEEDED FOR WORLD REVIVAL

The following is a full Summary of the British Note of December 1, 1932, in regard to the British War Debt to the United States Government. The full text is published on page 7.

The British Note begins by saying that His Majesty's Government warmly welcome that part of the reply of the United States Government in which they express their willingness to facilitate discussions with a view to the adjustment of the British War Debt. Since the United States Government state that it does not appear to them that sufficient reasons have been given for their request for the suspension of the December instalment, the present Note sets out in greater detail the reasons of His Majesty's Government for the view that a resumption of War Debt payments would intensify the world depression.

1. Reparations and War Debts in Relation to the Economic Crisis

The causes of the depression may be manifold, but it has been generally recognized that War Debts and Reparations have been one of the major causes. While in some respects it may be difficult for Governments to remedy the troubles of the world, there are certain steps which it is clearly within their powers and their responsibility to take.

The vast requirements for War purposes far exceeded any normal means of payment and could only be financed by means of loans from the producing countries. The loans raised, whether they were market loans or Government loans, were taken, not in the form of money, but in the form of goods.

The United States made loans to the Allies (including the United Kingdom) totalling approximately £2,055,000,000; the United Kingdom made loans to its European Allies amounting to £1,600,000,000; the French Government had made similar loans equivalent (at par) to £460,000,000. In the aggregate these loans reached the colossal total of over £4,000,000,000. (Throughout this Summary dollars are translated into sterling at par.)

BURSTING OF THE STORM

If the course of commerce were deflected to the extent required to repay these War-time Debts, it would entail a radical alteration in the economy both of the debtor and of the creditor countries. For a time the payment of Reparations and War Debts was rendered possible by the flow of investment capital from the United States of America to Continental Europe. But the prosperity of the period from 1923 to 1929 was to a large extent illusory. Almost before the ink had dried on the agreements embodying the Young Plan for the final settlement of Reparations drawn up in the summer of 1929, the storm which had not then been visible had burst upon the world. Startled and alarmed, the lenders who had for five years so liberally poured their capital into Continental Europe withdrew such funds as were immediately recoverable. Towards the middle of 1931 something like a panic prevailed. Since then the world has been living under the stress of continued pressure, which have completely undermined the confidence on which the system of private investment depended. Currencies are threatened with instability, if not with collapse, and the controls and restrictions intended to remedy the trouble have merely aggravated it. Everywhere taxation has been ruthlessly increased and expenditure drastically curtailed, and yet Budgets are in deficit or are balanced with ever increasing difficulty. The world cannot even begin to consider how to restore the monetary mechanism, without which the modern world cannot effectively conduct its daily life, until the causes which undermine confidence have been removed. One of the most important of these is the system of inter-Governmental debts.

EXPENDITURE ON DESTRUCTION

These inter-Governmental debts are radically different from the commercial loans raised by foreign Governments on the markets for productive purposes. Such market loans have converted whole territories from desolate swamps or uninhabited plains to flourishing provinces teeming with human life and producing great additions to the real wealth of the world. Such productive loans are self-liquidating. But Reparations and War Debts represent expenditure on destruction. Like the shells on which they were largely spent, these War loans were blown to pieces and have produced nothing to repay them. In the long run, international debts can only be paid in the form of goods or services.

The creditors, in so far as they have adopted a commercial policy which precludes payment in goods, have compelled their debtors to pay in gold. This has led to a drain on the gold standard with world-wide results. It has driven debtor countries off the gold standard; has forced down the price of commodities in terms of gold currencies, causing widespread ruin to producers in debtor and creditor countries alike. This process has seriously increased the burden of commercial debts; but it has rendered intolerable the peculiar burden of unproductive War Debts.

Difficulties first became acute in Germany. The withdrawal of credits from Germany and the consequent movements of capital forced the United Kingdom to abandon the Gold Standard with world-wide results. Thus the baneful effects of these unnatural transfers in respect of Reparations and War Debts have gravely accentuated the difficulties of all free Continents. Confidence and credit cannot revive until an end has been put to these attempts to force the stream of capital to flow uphill.

2. The "Capacity to Pay" and the "Capacity to Receive"

The Secretary of the United States Treasury in his Annual Report for 1924-

25 stated that a debtor Government must " be permitted to preserve and improve its economic position to bring its Budget into balance, and to place its finances and currency on a sound basis, and to maintain and, if possible, to improve the standard of living of its citizens." A resumption of War Debt payments in the present circumstances appears altogether inconsistent with the principles here laid down.

Experience has, in fact, shown that when dealing with international transfers of the character and of the unprecedented magnitude of Reparations and War Debts, the principle of " the capacity to pay" of the debtor—even if thus applied—can only be regarded as of secondary importance compared with an even wider principle, viz., that of the capacity of the world to endure the economic and financial consequences which those transfers would involve.

3. The Fiscal Sacrifice and the National Gain

Any remission of War Debts may be criticized as merely transferring the liability from the taxpayer in the borrowing country to the taxpayer in the lending country, and in this respect the taxpayers in the United Kingdom and in the United States of America are in much the same position. Before the Hoover Moratorium all the Reparation and War Debts receipts of the United Kingdom were required to cover the current payments due on its own War debt to the United States Government, and the United Kingdom taxpayer had each year to find from his own resources the amount of over £80,000,000 a year required for the interest on the internal loans out of which the advances (£1,600,000,000) were made by the United Kingdom to the Allies. In the case of the United States of America, the amount due from foreign Governments in respect of War Debts is now £55,000,000 a year, and if this is not received it would increase by that amount the burden on the American taxpayer, who also, of course, has to pay interest on the internal loans from which the advances by the United States Government to the European Allies were made. The interests of the two countries looked at from this standpoint are the same. But it would be taking altogether too narrow a view to regard those interests as being limited to securing payment of these War Debts from the borrowing Governments. Even a partial recovery of business activity in the creditor countries would result in additional receipts from taxation on the existing scale which would compensate the Exchequers of the creditor countries many times over for the loss of revenue involved in the revision of the War Debt settlements. It will not profit a creditor country to collect a few million pounds or dollars if it thereby perpetuates world disorder; and a War Debt settlement, however generous it may seem, would be repaid again and again by the contribution which it would make to world revival.

It is in the power of the Governments of the world, and particularly of the United States of America and of the United Kingdom as the two greatest creditor nations, if they unite in cooperation, to make the first and essential step towards averting disaster, financial, economic, and political.

4. The Past Record of the United Kingdom

Apart from these general considerations, H.M. Government hold the sincere conviction that this request for a re-examination of War Debts is fully justified on the grounds of the past record of the United Kingdom in the matter of inter-Governmental debts, and of their present position.

The total British War expenditure in the United States of America amounted to approximately £2,400,000,000. Of this total only about one-third was financed by borrowing from the United States Government. Approximately £600,000,000 was obtained by the sale of gold and securities. In addition H.M. Government raised commercial loans on the United States market before the entry of the United States into the War to the amount of about £304,000,000.

Of these market borrowings £275,000,000 have been repaid, and in respect of indebtedness to the United States Government payments have been made both before and after the Funding Agreement amounting to £354,000,000, or £629,000,000 in all.

Meanwhile the advances made by this country amounted to £1,600,000,000 and had increased subsequently by the addition of unpaid interest to capital. Shortly after the War his Majesty's Government offered to join in any equitable arrangement for the reduction or cancellation of inter-Allied debts provided it was of an all-round character. That proposal was not accepted and his Majesty's Government were called upon to fund their debt to the United States of America.

RECEIPTS AND PAYMENTS

They then announced that they would limit their demands on their own debtors to the amount that they were themselves required to pay to their creditor. But in fact receipts of his Majesty's Government from their debtors have amounted to less than half their payments to their creditor. The relative position is that the United States of America made loans amounting to £2,055,000,000 and the United Kingdom made similar loans amounting to £1,600,000,000; the United States of America have received for the benefit of their taxpayers £434,000,000 and the United Kingdom have received for the benefit of their taxpayers nothing, have passed on all their receipts to the United States of America, and have paid out of the pockets of their taxpayers £134,000,000. In fact, after interest has been taken into account, some £200,000,000 has been found by the British taxpayer. While the British share of the total indebtedness to the United States of America is only 40 per cent., of the total debt payments made to the United States of America 80 per cent. has come from Great Britain. The

efforts which this has involved to the British nation, coming as they did after the losses resulting from the War, constitute, in the view of his Majesty's Government, a strong claim to consideration on the part of the United States Government.

5. The Increase in the Burden

His Majesty's Government also call attention to the changes of circumstances which have increased the burden of their obligations.

In the first place the British debt is expressed in terms of gold, but the burden on the British people is measured in terms of sterling. The payment due on December 15 is owing to this circumstance increased from £19,750,000 to approximately £30,000,000.

In the second place the average wholesale price index in the United States of America during the period when the debt was incurred was 189, and is now under 94 (taking 1913 as a basis in each case). The debt therefore represents to-day in terms of goods not less than twice the amount which was borrowed.

In the third place the effect of the American Tariff has been to restrict the import of the manufactured goods which the United Kingdom produces. In 1923 when the British War Debt was funded, the War Debt annuity amounted to £33,000,000, or approximately half the value of the British domestic exports to the United States (£60,000,000). From 1933 onwards the annuity in respect of the War Debt would amount at present rates of exchange to approximately £60,000,000, whereas the British domestic exports to the United States of America this year are not likely to exceed £16,000,000. The imports into the United Kingdom from the United States show an equally remarkable fall from £211,000,000 in 1923 to £59,000,000 in the first nine months of 1932. The total trade between the two countries from the time of the Funding Agreement has fallen from about £300,000,000 a year to £100,000,000.

6. Economic Reactions of Resuming War Debt Payments

The United Kingdom has up to the present generally been the best customer of the United States, but, if War Debt payments had to be resumed, the very heavy adverse balance of visible trade between the United Kingdom and the United States of America (£78,000,000 in 1931) would have to be reduced by adopting measures which would further restrict British purchases of American goods. To the extent, therefore, that payments were resumed to the United States Treasury a definite loss must follow to the United States producer.

Moreover, his Majesty's Government would also have to guard against the effects which would follow if the unique facilities offered by the British market to the world's goods were used by the other debtors of America to obtain sterling which they would then sell across the exchange in order to meet their obligations to the United States Government.

7. The Lausanne Settlement

His Majesty's Government take it for granted that preferential treatment will never be claimed for the War Debts due to the United States of America as compared with those due to this country; and a situation in which this country was required to continue War Debt payments while forgoing the War Debt payments due to it would be admitted at once to be unthinkable. Thus, if the payment of the sums due in respect of the British War debt to the United States Government were to be resumed his Majesty's Government would be obliged to reopen the question of payments from their own debtors—France, Italy, Portugal, Yugoslavia, Rumania, and Greece, and also the British Dominions, which have been suspended since the Lausanne Conference. The debtor countries would, in turn, have to demand the payment by Germany of her obligations under the Young Plan, and the United Kingdom would have to do likewise. Without a readjustment of War Debt obligations the Lausanne Agreement could not be ratified; the question of Reparations would remain unsettled; the improvement in conditions which followed the Lausanne Agreements would be undone; and fatal results might well be found to have accrued to the solution of many grave political, as well as financial, problems now under discussion.

8. The Payment due on December 15 in Relation to the Subsequent Discussions

His Majesty's Government emphasize their conviction that their proposal for a suspension of the December payment, a proposal which would in no way affect any ultimate settlement, is necessary in order to create the condition favourable to a successful issue of the subsequent conversations in regard to the revision of the existing Debt obligations. The difficulties of making the transfer in present circumstances are so great and would involve such far-reaching reactions, both financial and political, that the resulting doubts and anxieties in regard to the immediate situation would distract the attention of the Governments and peoples when the chief need was an effective and systematic approach to the problem to be solved.

9. The Transfer Difficulties

The reserves of his Majesty's Government in gold and in foreign exchange, though adequate for the purpose of mitigating exchange fluctuations for which they were designed, were not intended and would not suffice to cover, as well, the payment of £95,500,000 due on December 15. The exchange difficulty would remain even if the device were adopted of payment in sterling to a blocked account; for the existence of a large sum awaiting transfer would affect the market almost as seriously as an actual purchase of exchange.

The only remaining alternative would be payment in gold. Such a method of payment would involve the sacrifice of a considerable part of the gold reserves of the Bank of England, which are widely regarded as no more than sufficient for the responsibilities of London as a financial centre.

10. Conclusion

In conclusion his Majesty's Government state that they trust that the full statement of their views which they have now made will demonstrate clearly the ground upon which their request was based—namely, their own profound conviction that a resumption of War Debt payments as they existed before the Hoover Moratorium would inevitably deepen the depression in world trade and would lead to further falls in commodity prices with disastrous consequences from which no good results can be expected.

They believe that a discussion between the United States Government and themselves upon these matters might bear fruitful issue for the revival of world prosperity. They are convinced that the prospects of success would be materially improved by the postponement of the December instalment, and they are prepared to consider with the Government of the United States of America in any manner in which that postponement might be most conveniently arranged.

WASHINGTON VIEWS

DISCUSSIONS AT WHITE HOUSE

THE EFFECT ON CONGRESS

FROM OUR OWN CORRESPONDENT

WASHINGTON, DEC. 1

A copy of the second British Note was sent at 8.30 this morning to the residence of Mr. Stimson and by him was at once taken to President Hoover at the White House. Mr. Mills, Secretary of the Treasury, was summoned into conference there and the Note was discussed at length. Later in the morning Mr. Stimson went to the State Department, where he was joined by the British Ambassador. It was then announced that the text of the Note would be given to the Press soon after the Stock Exchange was closed for the day.

There is no reason to doubt that Mr. Stimson was able to convey to Sir Ronald Lindsay the conclusions which Mr. Hoover had reached and to indicate in general the nature of the President's recommendations to Congress next week, as these may have been affected by the arguments of the British Government. It is common knowledge that, independently of their presentation by London, these arguments are in a large sense found convincing not only by Mr. Hoover, but by all those whose executive position here gives them a knowledge of and a concern in the world situation. What effect the British Note, the recommendations Mr. Hoover will make, and the growing mass of opinion favourable to friendly adjustment will have upon Congress is still doubtful almost to the point of despair.

AGRICULTURISTS' VIEWS

It is true that some hold to the belief that a deeper impression was made upon those members of the Senate Finance and House Ways and Means committees who were called in by the President some time ago than could decently appear in the statement of views issued by Mr. Hoover soon after they had left him. If this is so these gentlemen have signally failed to make this evident. It is true also that the agricultural interests, for the relief of whose depression the President-Elect is now trying to devise means, are occasionally vocal on the debt question. The Houston Cotton Exchange, for instance, has passed a resolution calling upon the Government to "confer at once with foreign Governments with the view of finding a rearrangement of debts that can in fact be carried out without destruction of foreign buying power, on which our farmers' survival depends." If the example of the Houston exchange were more generally followed Congress would be a thousand times more likely to give heed than it will be when it reads Mr. Hoover.

Perhaps the willingness of members of the Senate and the House to discuss privately the possibilities of separate treatment of the British debt is a sign of a change of heart, for this willingness is perceptibly growing. Their reasons, however, are as dangerous as their conversion is partial. They appear, in fact, to be moved less by anxiety about the economic effect of British difficulties than by their determination that France shall not escape one cent of the payment either of the December annuity or of later instalments and by the hope that an Anglo-American compromise at this time would have the double effect of tending to isolate France and of persuading Japan to modify its Manchurian policy.

"POLICY OF DISUNION"

They might with advantage read Mr. Walter Lippmann's contribution to the New York Herald Tribune this morning, for, as he says, they are crying out "for a policy to divide, to disunite, or to disorganize the common action of the most advanced nations." How, he asks, "do they expect peace to return to this troubled earth if the British, French and American democracies get into a brawl over the immediate payment of a few dollars?" And, "What is the good of talking about disarmament and world economic conferences, and the maintenance of treaties in Asia, if at the very heart of Western civilization the democracies have not the sympathy, intelligence, and self-restraint to sit down like gentlemen and discuss a debt?" It is, he says, a "spectacle for the ironic gods."

The few Americans who have had the opportunity of reading the British Note and with whom there has been an opportunity of speech before this dispatch was written have been unhesitating in the expression of their admiration for its cogency and good temper. This notwithstanding, they find explosive possibilities in the statement that its "initiative in devising a settlement of reparations was taken by the creditor Governments at Lausanne with the cognizance and approval of the United States Government." They may be right, but events are moving with such rapidity that even the Democrats, who desire to charge Mr. Hoover with the making of a "deal" to the disadvantage of the American people, may not get an inference favourable.

A message from our Paris Correspondent referring to the French reply to the United States, which was despatched last night, appears on the preceding page.

M. DOUMERGUE IN LONDON

M. Doumergue, former President of the French Republic, and Mme. Doumergue arrived at Victoria Station at 3.40 yesterday on a visit to London. They were received by the French Ambassador, Lord Derby, President of the United Association of Great Britain and France, M. Bernheim, President of the French Colony in London, and other distinguished French people.

M. Doumergue's speech last night at a dinner given by the United Associations of Great Britain and France is reported on page 16.

DEATH OF DAME ELIZABETH WORDSWORTH

We regret to announce that DAME ELIZABETH WORDSWORTH, D.C.L., the first Principal of Lady Margaret Hall, Oxford, died at her home in Oxford on Wednesday night at the age of 92.

A memoir will be found on page 20.

RENT CONTROL

CHANGES IN NEW BILL

RIGHTS OF TENANT AND LANDLORD

From Our Parliamentary Correspondent

Important changes in the present law of rent restriction and control are contained in the Government's new Rent and Mortgage Interest Restrictions (Amendment) Bill, the text of which will be issued to-day. The text of the Bill is expected to be ready during the Christmas recess.

The Bill carries out the main recommendations of the report of the Departmental Committee which sat during the life of the Labour Government under the chairmanship of Lord Marley. It recognizes that private enterprise has now caught up with the demand for the best type of houses which were controlled under the original legislation. It rapidly catching-up with the second type of house, for the better-class artisan, but it has not yet solved the problem of providing cheap houses for the lowest-paid sections of the community. Where houses of this type are decontrolled the rent may jump up to 80 per cent. above the pre-War figure, and the Government recognize that for these houses full control must continue.

PLAN FOR FIVE YEARS

The Bill accordingly proposes that there shall be immediate decontrol of houses with a rateable value which in 1931 was more than £45 in the Metropolitan Police District, £35 in the rest of England and Wales, and £45 in Scotland. A period of six months will elapse before mortgages on these houses are decontrolled. Houses with a rateable value between £20 and £45 in the Metropolitan Police District, £13 and £35 in the rest of England and Wales and £26 5s. and £45 in Scotland will still be subject to decontrol when they become vacant. Houses with a rateable value below these figures will cease to be decontrolled when they become vacant, but houses which are already decontrolled will remain decontrolled. A register will be kept by local authorities of houses falling within these limits which are already decontrolled, and if a landlord does not register a house within a specified time it will be treated as controlled. The Bill will remain operative for five years, and if it is not renewed rent restriction will then come to an end.

It is hoped to deal with excessive charges by protected tenants sub-letting by a clause in the new Bill which sets out that the tenant must inform his landlord of any sub-letting, with particulars of accommodation and the rent charged. If the landlord considers the rent excessive he can apply to the local County Court for the ejection of the tenant, and if the Court grants the Order, from which there is no appeal except on a point of law, it will fix the proper rent payable by the sub-tenant, who will then become the direct tenant of the landlord. In such circumstances the house does not become decontrolled on the change of tenants. Where a Court has at any time fixed the rent, a protected tenant who attempts to charge his sub-tenant more will be liable to a fine of £100.

RECOVERING POSSESSION

Amendments will be made in the law as to recovery of possession. At present a landlord who has owned a house since 1924, and who requires possession for his own occupation or that of members of his own family, may apply for it on the ground of "greater hardship" without proof of alternative accommodation. This right will now be extended to any landlord who bought his house at any time before July 11, 1931, when the Marley Committee reported, and the onus of proving hardship will be transferred from the landlord to the tenant. In any case where a landlord desires possession he can obtain it on proving to the County Court that suitable accommodation is available for the tenant, whatever may be the reason of the landlord for requiring possession. Alternative accommodation includes a council house or a privately-owned house (neither controlled or with like security of tenure) which is similar as regards extent and rental to a council house or is otherwise reasonably suitable to the needs and means of the tenant. It has now provided for the first time that a landlord can obtain possession if the tenant has been guilty of overcrowding.

MISCHIEF MAKERS IN COTTON DISPUTE

MONEY FROM "DOUBTFUL QUARTERS"

The Blackburn Weavers' Association report that over £64,000 was paid in members' benefit in the last quarter in connexion with the recent cotton trade dispute.

The committee state that "there are persons bent on creating disunity in our ranks and furthering the cause of an avowed insurrectionary movement financed from doubtful quarters."

BELGIAN NEUTRALITY

FROM OUR OWN CORRESPONDENT

BERLIN, DEC. 1

I learn that the London message recently published in the German Press, in which a vital passage in Major-General His George Aston's recent letter to The Times was misreflated in such a way as to suggest that the British General Staff before the War had advocated a British violation of the neutrality of Belgium, whereas the original memorandum quoted in that letter strongly opposed either a British or a French invasion of Belgium, did not emanate from the London office of the semi-official Wolff Agency.

As no indication was given of the source of this message in the German newspapers which published it beyond a date-line, "London," its origin must remain a mystery; but its statement that Great Britain contemplated an invasion of Belgium remains in the minds of German newspaper readers.

THE GIMCRACK DINNER

Speaking at the annual Gimcrack Club dinner at York last night Sir Alfred Butt, who won the Gimcrack Stakes in August with Young Lover, said that the totalisator had so far failed in any way to help racing. The latest stage of the development of the totalisator was what is known as Tote Clubs, which, Sir Alfred said, are most harmful and injurious to the community. Sir Alfred also made several suggestions to the Jockey Club for the benefit of racing generally.

A report of Sir Alfred Butt's speech will be found on page 4.

THE FIRST TEST MATCH

WOODFULL OUT

SYDNEY, Dec. 2.—Australia won the toss in the first Test Match here to-day and decided to bat. The teams are:—

AUSTRALIA.—W. M. Woodfull (Victoria) (captain), S. J. McCabe (New South Wales), A. F. Kippax (New South Wales), T. W. Wall (South Australia), W. H. Ponsford (Victoria), J. H. Fingleton (New South Wales), C. V. Grimmett (South Australia), L. Nagel (Victoria), W. A. Oldfield (New South Wales), W. J. O'Reilly (New South Wales), V. Y. Richardson (South Australia), with S. Hird (New South Wales) as twelfth man.

ENGLAND.—D. R. Jardine (Surrey) (captain), G. O. Allen (Middlesex), R. E. S. Wyatt (Warwickshire), The Nawab of Pataudi (Worcestershire), H. Sutcliffe (Yorkshire), M. Leyland (Yorkshire), H. Larwood (Nottinghamshire), W. Hammond (Gloucestershire), L. Ames (Kent), W. Voce (Nottinghamshire), H. Verity (Yorkshire), with E. Paynter (Lancashire) as twelfth man.

The Sydney ground is celebrating its jubilee this year, the first Test having been played at Sydney in 1882. A quarter of an hour before the start there were probably 30,000 people present. The weather was fine and invigorating. Thousands of fashionably-dressed women thronged into the Ladies' Enclosure and gave the ground an Ascot-like appearance.

Woodfull and Ponsford came out to bat first. Larwood opened the bowling to Woodfull, who made the first run off Larwood's second ball. Ponsford then made another single.

Voce took the other end, opposite the pavilion, and bowled a maiden over to Ponsford. Then Larwood followed with a maiden over. One of his balls struck Ponsford on the hip, and the crowd showed its displeasure.

Although neither team had then been chosen, it was announced yesterday that the doctors had declared D. Bradman to be unfit to play. It was stated late last night that he had been ordered a fortnight's rest. The doctors had said that he was thoroughly run down.

SLOW SCORING

Both batsmen were playing carefully, and Larwood and Voce were bowling well. In bowling the fourth ball of his fourth over Voce slipped on the hard wicket and fell heavily to the ground on his back. He got up rubbing the knee that he injured on board the Orontes, but continued to bowl, apparently not affected by his spill.

Jardine made his first change when 10 had been scored, Allen coming on for Larwood, who had bowled four overs for four runs. Play continued to be very slow, and the first half-hour yielded only a dozen runs.

The third ball of Voce's fifth over clean bowled Ponsford—but it was a no-ball. Then, after batting 38 minutes for seven runs, Woodfull fell into Voce's leg trap. He swung at a high ball, but only snicked it and it sailed over his shoulder to Ames, who held a fine catch.

Fingleton, who came in next, had scored two runs when he cut a ball from Voce and ran. Ponsford, however, sent him back. Allen quickly threw the ball in and Ames broke the wicket. There was a confident appeal, but it was not successful. Fingleton only just saved his wicket.

Voce had been bowling splendidly, but at 28 he was given 4 rest in favour of Hammond. Voce had one wicket for 12 runs in seven overs.

Jardine only gave his fast bowlers a few overs at a time, and when the score reached 30 he brought Larwood back and gave Allen a rest. Allen had bowled four overs for eight runs.

The first boundary came at 42, a leg-bye off Hammond. Twenty-one more runs were added before the luncheon interval.

Lunch score :—

AUSTRALIA—First Innings		
Woodfull, c. Ames, b. Voce		7
Ponsford, not out		32
Fingleton, not out		13
Extras		11
Total (1 wkt.)		**63**

—Reuter.

COLONEL OF SCOTS GUARDS

THE DUKE OF YORK'S APPOINTMENT

The King has been pleased to approve the appointment of Major-General His Royal Highness The Duke of York, Earl of Inverness, K.G., K.T., G.C.M.G., G.C.V.O., Colonel-in-Chief 11th Hussars (Prince Albert's Own), The Somerset Light Infantry (Prince Albert's), The East Yorkshire Regiment, Royal Army Ordnance Corps, and The Leicestershire Yeomanry (Prince Albert's Own), Personal Aide-de-Camp to The King, to be Colonel, Scots Guards, in succession to the late Field-Marshal Lord Methuen.

INVALIDS

Sir Austen Chamberlain was reported last night to be much better.

The condition of Mr. J. C. Stobart, of the B.B.C., who is ill at his London home in diabetes, was stated yesterday to be about the same.

The Hon. Mrs. French, wife of Major the Hon. Edward Gerald French, who was knocked down by a car in Cromwell Road, Kensington, a few days ago, was stated yesterday to be progressing as well as could be expected in view of her serious injuries.

COMPANY MEETINGS

Reports of the following meetings appear in our City pages:—

London and Rhodesian Mining and Land.
Madeley Collieries.
New Zealand Loan and Mercantile Agency.
North Ashanti Mining Company.
Peruvian Corporation.
Rover Company.
Tobacco Securities Trust.

TRANSPORT BILL

SLOW PROGRESS IN THE COMMONS

LORDS AND SPEED LIMIT

WESTMINSTER, THURSDAY

The House of Commons made very slow progress with the London Passenger Transport Bill to-day, the efforts of Ministers to place opposition offering merely new occasions for obstruction.

The first Government amendment enlisted the Labour Party among the critics, for it proposed to take from the Minister of Transport the power to appoint members of the Control Board of the amalgamated London transport and vest it in appointment trustees. Mr. Pybus claimed that the change would free the machinery set up by the Bill from political interference, but Mr. Attlee bitterly attacked him for removing the last vestige of public control of a monopoly. The personnel of the trustees who gave endless opportunities for amendments to secure representatives of special interests, and it seemed as though the Government will have to take expeditory measures if the Bill is to go through.

In the Lords, Lord Buckmaster returned to the attack upon "speed fiends" with a motion, which was agreed to, that all vehicles subject to a speed limit should be fitted with accurate speedometers. He was particularly severe upon omnibuses and lorries which drove too fast and upon employers who forced their drivers to break the law under pain of dismissal. He suggested the installation of instruments recording the speed at which vehicles travelled throughout a run, and that no licences should be issued unless they had at least a speedometer.

CARDINAL BOURNE ILL

ATTACK OF INFLUENZA IN ROME

FROM OUR OWN CORRESPONDENT

ROME, DEC. 1

Cardinal Bourne is lying seriously ill here with a bronchial cold and gastric influenza.

His Eminence arrived in Rome at 2.30 on Monday, and was then feeling so poorly that instead of staying as usual with the Redemptionist Fathers in the Via Merulana he went to the hospital of the English Sisters at Santo Stefano Rotondo, and took to his bed. At first his Eminence seemed to be holding his own, but yesterday Dr. Sabatucci became uneasy at his temperature remaining so persistently at 101 and at the quickness of his pulse. Dr. Bastianelli was therefore also called in, and the latest bulletin declares that, although the Cardinal's condition is serious, as yet there is no trace of pneumonia. I understand that his Eminence is in excellent spirits.

BOOKS OF THE WEEK

Another of the series of articles on Christmas Books, summarizing the successes of the season ; and reviews of "War Debts and World Prosperity," by H. G. Moulton and L. Pasvolsky ; "Philip II. of Spain," by David Loth ; "Days of Endeavour," by Captain J. W. Harris ; "Reminiscences of a Specialist," by Dr. Greville MacDonald ; "The Story of the Borgias," by L. Collison-Morley ; "The History of Piracy," by Philip Gosse ; and of four recent volumes on fishing ; together with other notices of new books, will be found on pages 8, 9, and 10.

ENTERTAINMENTS INDEX

be pleased to leave them to analyse the spirit of the letter. If "The Times New Roman" is successful it is because the designers regarded their task as a problem in proportion and legibility.'

Morison referred to the 'designers' in the plural, and well he might, as it is apparent that Lardent's drawings and his own corrections were not sufficient to ensure the creation of a type-face which would meet his own requirements. Although Lardent remained embittered to the end of his life because he considered he had never received proper recognition for his contribution to a highly publicized type-face, he was not a specialist type-designer, and worked at least at two removes from the finished job – through Morison's alterations and those made by the anonymous draughtsmen and craftsmen of the Monotype Corporation, whose skill was necessarily involved.

Morison made use of his connexion with Monotype so that the type could be manufactured. Here was a customer, *The Times*, requiring a type of its own, a situation Monotype had faced before, and for which it was therefore willing to make its services available. A laborious and costly process ensued. Since the concept was a novel one for *The Times* board of directors, they could have had no idea of how much money was involved, and since the Corporation, on this occasion, was not adopting suggestions from its typographical adviser, but taking orders from him, they would not have queried the cost. Whether, if the Corporation had been launching a face itself it would have accepted the extraordinary large number of re-made punches is doubtful.

There is some confusion about the total number of punches cut. In *The Times* house journal article (reprinted in the *Monotype Recorder* of September/October 1932) the figure is given as 5973; in *The Times* history as 7048, and in *A Tally of Types* as 'above 14,750'; but there seems to be no confusion about the number which had to be re-cut – 1075. This is reported as if the fact that this large number had to be corrected in one detail of design or another was an achievement, but any type manufacturer would regard such a figure – whole alphabets must have been involved – as an admission of incompetence on the part of the designer, and as an indication of uncertainty about the original design. The Monotype Corporation was in no position to object, even if it wanted to, and considering the country was, by this point, in the middle of an economic slump, it was probably quite pleased that so much work was being made available.

Morison's references in *Printing The Times* to 'typographical pundits' suggest that he was not particularly concerned with what specialists thought were the origins of the type, but was content for it to be judged on its performance, which was a fair enough attitude. But since Times Roman was a type 'family' from the first, and has been increased since, particularly with special-purpose founts, it is difficult and unreasonable to judge the design as a whole.

'Popularity' is not necessarily a good guide, as fashion, the degree of promotion, and availability in size, weights, and widths can affect the adoption of a type-face. The widespread use of a face such as Cheltenham has often puzzled commentators, but one answer probably lies in its unusual range of variations in weight and style. A text face, such as Bembo, might well have conquered book-designers whatever the degree of promotion, since it is so legible, readable, and good-looking whatever paper and printing process is used.

The Times Roman family certainly received great publicity, and Morison himself made sure it was used. At times he was too assiduous in promoting it, as on the occasion when a book was withdrawn from Cambridge because the publisher disliked Morison's insistence that it be set in Times New Roman.

Meynell's Nonesuch Press *Minnow among Tritons* (1934) was the first book to be set in the type, and Updike was the first to adopt it in America. The Crowell-Collier Publishing Co., of New York, in 1943, embraced the standard version as 'a heaven-sent medium for any periodical', and after Morison met Henry Luce on a Mediterranean cruise with William Benton, of the *Encyclopaedia Britannica*, Times New Roman began to make its appearance in the Luce Periodicals, *Time*, *Life*, and *Fortune*.

Times New Roman was also widely available. For a year it was the exclusive property of *The Times*, although by special permission of the proprietors the September/October 1932 issue of the *Monotype Recorder* had been composed in the type; and then in 1933 it was freed from control and could be composed on the Linotype, Intertype, and Monotype machines and from foundry type.

To assess the precise weight of each factor in the adoption of Times New Roman would be an impossible task, but the fact is, while it was not the all-purpose type which some printers pray for, it was welcomed as a basic 'bread and butter' face over a wide area. As time passed, however, the 'pundits' began to look more closely at Morison's type-face, a process culminating in Allen Hutt's reassessment in the summer of 1970. Hutt prophesied that Times Roman would not survive the decade as a major news-text, 'at any rate in hot-metal form for rotary letterpress-printing' – for which it had originally been designed. Hutt's qualification was made because the situation might be quite different in a world of photo-composition and web-offset lithographic printing. Hutt makes the point that Times New Roman had been designed for a newspaper in a class of its own, with impeccable press work and a high-grade paper, but that rough presswork and common newsprint gave the face little chance. 'Times Roman, in short', he adds, 'was designed for production conditions which have ceased to exist.'

Under close scrutiny the Times Roman family of type does show signs of a lack of total control and imperfect conception, but in 1929 Morison, despite what may have been thought later, had little experience of letter design as such. Lardent's experience, though no doubt greater in the publicity field, was not that of the highly specialized type-designer, a rare breed. Why Morison chose his method of designing a type-face is not known, but there may have been a combination of reasons. He probably wanted the type for Britain's premier class-newspaper, *The Times*, to be of completely British origin, and may have also felt the time had come when he should have a direct hand in its creation. Since the few type-designers in the world were almost all outside Britain, and since Morison was not capable of drawing letters, he used Lardent as the instrument to give shape to his ideas – not always an ideal arrangement.

Nevertheless, in the three smallest sizes series 327 (the basic face) is a good text type, and the capitals, though perhaps a little too heavy, are well designed, as is the italic. Above 12 point the proportions of some of the letters make for an uneasy partnership. It is ironical that 327, which Morison said was 'hardly a book type', is the one used most for book-work, and not Times New Roman Wide, the modification produced for book printing. The faulty design of some of the letters were repeated in the Wide version (427) and 627 (427 with long ascenders), but were corrected in 421, Times Roman semi-bold, initially produced for the Cambridge University Press for a new Bible, which up to 10 point is excellent in prayer books and Bibles.

Morison was not unaware of the difficulties which could arise from the use of different kinds of paper. Times New Roman was at its best on the paper used by the newspaper at the time of the type's conception, but when in the early 1950's

a more highly finished variety was adopted, the type looked less satisfactory, becoming more feeble in appearance. Morison made various experiments to overcome this, but without much effect. Increases in the edition run and the printing at high speed on a lower quality of newsprint from 1966 onwards have meant that the original strong colour of the type has given way to a grey look.

Times bold (334) is a separately designed letter with an over-heavy and narrow appearance, as the thickening has been carried out inside the letter. The italic, on the other hand, is a thickened-up version of that of 327, and as the roman is not so derived, the two faces do not work well together. When it came to titling faces Morison was on firmer ground and the Extended Titling (339) constitutes a splendid set of letters, and it may be regretted that it was not used as the model for the other display faces. Hutt claims that it is one of the finest capital alphabets in the roman letter at the disposal of printers, and much superior to Times bold. The Heavy Titling (328) is striking, but the Bold Titling (332) is not quite so good. The curious Hever Titling, which was used only in certain parts of *The Times*, seems to have a Bembo provenance, and does not fit in with the rest of the family, which, taken as a whole, is a fairly odd collection. The so-called Times New Roman Book (627) cannot be used at the same time as Times bold, and the Semi-bold (421) does not align with either 327 or 427, and cannot therefore be used as a companion bold face, but perhaps this is as well as it is a superior design to the two others – at least in sizes up to 10 point.

What of the future of Times Roman as a photo-composed face, printed by offset-lithography? Hutt maintains that the effect is agreeable, and queries only the retention of the face on grounds of style and taste. He asks '. . . is the elegance and urbanity of Times the most apt typographical vehicle for a popular newspaper in the last third of the twentieth century?' Only time will tell. The general feeling among the 'pundits' is one of regret that Morison was not able, for one reason or another, to pay closer attention to the work of producing the Times Roman family, and to improve it in the light of increasing knowledge and experience.

Morison, however, soon took on duties other than that of the typographical adviser of *The Times*. He became the newspaper's historian, and adviser on much wider issues than typography. Morison gained the confidence of the Chief Proprietor and the board of directors as a source of ideas; his great strength, from their point of view, was an ability to crystallize a solution to a problem while others were groping, and a completely ruthless approach which allowed of no ambiguity. He became the main author of the five-volume *History of The Times*, which he planned and edited, in the process writing copiously about Alfred Harmsworth, Lord Northcliffe, Chief Proprietor from 1908 to 1922, and in so doing offending members of the Harmsworth family. Morison immersed himself in the work, becoming fascinated not only in the way the newspaper was run, but in the power it wielded. This added spice to the taste of power which Morison always enjoyed. His old friend T. F. Burns, editor of *The Tablet*, summed up Morison very wittily: 'He was, in fact, always interested in the corridors of power, and not least when they led to the dining room'; and *The Times* had a good dining room.

While Morison is often thought of in the role of *éminence grise*, he was not uninterested in emerging from the background and wielding power directly. An attempt to persuade Burch to get him appointed to the Monotype board had failed. The shrewd managing director knew that the other directors would not take kindly to a man of Morison's views and personality at their meetings, and frankly he did not fit in with the concept of what a director of the Corporation

should represent. He was given a splendid consolation prize in the shape of a well-paid life appointment as typographical consultant. Another temporary consolation was his directorship of Victor Gollancz Ltd, but this did not carry much influence and ceased in 1938. It was at *The Times* that he found satisfaction, and defended the paper with almost religious fervour. Poor Canon Vance once tentatively suggested to Morison and Francis Mathew (Manager at the time) that *The Times* should put news on the front page (as ultimately it did). Vance commented: 'Francis Mathew might have considered it. To S.M. it was sheer blasphemy. He charged back with scornful arguments suggesting in no uncertain way that 'You, Guvnor, don't know what you are talking about''.'

Attitudes towards Morison's activities at *The Times* are naturally coloured by personal and political viewpoints. They range from those who thought Morison was 'power-mad' to others who felt his influence was enormously beneficial. A man who lost his job as the result of Morison's influence was not likely to agree that his dismissal was disinterested, and those of a politically conservative outlook would not welcome what was thought to be a left-wing influence on editorial policy. The whole question of the use of power is difficult, but it is probable that Morison, who had his human failings, was little different to other men, in that he used power for what he thought were good ends, but could not resist occasionally the temptations which power offers, among which are the identification of the personal with the public good, and the justification of means by ends.

Morison was very helpful to R. M. Barrington-Ward, his early supporter, when Barrington-Ward succeeded Geoffrey Dawson as Editor in October 1941. Barrington-Ward had been Deputy Editor since 1934 and had not been happy with the policy of Neville Chamberlain in relation to the emergence of Nazi Germany. Dawson, on the other hand, was a close confidant of Chamberlain, and supported his policies. In 1941 Dawson was 67 years old, and had only three more years to live. He had seen the collapse of Chamberlain's policies, and could not have been very comfortable in the editorial chair, particularly after Germany had attacked Russia in June 1941. Those who felt that Barrington-Ward leaned too heavily on Morison considered that the stop-gap editor who followed was even more dependent on him. It was thus that Morison's influence was greatest between the death of Barrington-Ward in February 1948 and the appointment of Sir William Haley as Editor in 1952. Morison tended to captivate educated members of the upper and middle classes, a fascination which did not always extend to those of less privileged upbringing. It is thought that Haley and Morison had too much in common to get on together. Both were self-educated men of comparatively humble origin, with keen minds, and not to put too fine a point on it, with an authoritative outlook. Haley did not require advice on the editorial side; but owing to the peculiar managerial system at *The Times* Morison still managed to wield a certain amount of influence until his retirement in 1960.

During Morison's 'supreme moment', as one observer called it, he increasingly advised on appointments in *The Times* organization, and this produced at least one surprising result. In 1936 he had redesigned the *Times Literary Supplement*, giving it a more popular appearance, but by 1945 he had become critical of editorial policy. When the Editor resigned it was thought that the best way of meeting Morison's criticisms was to assign him the task of finding the right solutions. Morison caused a certain amount of surprise by taking on the job of Editor himself, continuing until 1947. While Morison, the critic, could not very well shirk the task offered him, he, in fact, relished the job – his first in real journalism, with which he had been fascinated for years – and he certainly

improved the paper's standing. By his decision to abandon insularity and to notice books from other than English-speaking parts of the world; by raising the standards of reviewing; by utilizing the services of well-known scholars; by dropping obituaries and the crossword puzzle; and by reinstating the major front-page article, he began the process of making the *T.L.S.* internationally eminent.

The connexion with *The Times* strengthened Morison's deep interest in newspapers, which was already apparent in his comments on John Bell in the 1929 Printing Supplement. Working in the Bibliothèque Nationale in 1926, Morison had discovered, by chance, an announcement of May 1788, by John Bell, 'Of the British Library, Strand, London', to the effect that he had opened a new printing letter foundry, and presenting a specimen of the first set of types 'which have been completed under his directions By William Coleman, Regulator, And Richard Austin, Punch-Cutter'. Morison recognized the type as one used in America by Updike, among others, and of which there was a small fount at Cambridge called 'Georgian'. Bell's 'British Type Foundry' had been dissolved in 1797, and apparently what Morison called the first English 'modern' face had almost been forgotten, although punches and matrices had descended to Stephenson Blake & Company. In 1864 a set of Bell's types cast from these original matrices was taken to America, and at the Riverside Press was known as 'Brimmer', after a well-known writer. Updike admired 'Brimmer' and obtained strikes from Britain for his own casting, naming his new fount Mountjoye.

Bill poster (reduced from 30 × 20 in.) for *The Times Literary Supplement.*

After discovering the true origin of Brimmer, Mountjoye, and Georgian, Morison traced the punches to Stephenson Blake and began to take an interest in John Bell, bookseller, printer, publisher, typefounder and journalist (all careers which, in the modern sense, even if for a short time only, Morison managed to encompass himself). The result of his studies may be seen in *John Bell*, which had started life as the modest keepsake, but had developed into a full-scale book, published by Cambridge in 1930.

The book, and the exhibition put on by the First Edition Club, brought recognition to Bell and his type-face, cut for him by Richard Austin, which had hardly been used in England except in Bell's newspaper, *The Oracle*, described by Morison as 'the most elegant sheet ever published'. While inspired by Firmin Didot's 1784 'modern' design, Austin's type, as Updike and Williamson have pointed out, retains some old face characteristics (a reason for its readability), and should perhaps be classed as a transitional type-face. Austin, in fact, criticized, in an 1810 specimen of his own Imperial Letter Foundry, the unworkable quality of type with too delicate hair lines, showing an awareness of the decadent fate which awaited the ideas of Fournier, Bodoni, and Didot, when carried too far.

Morison found a more enduring memorial for Bell than the transitory exhibition and the limited edition of his book. A Monotype facsimile of the original type was made in collaboration with Stephenson Blake, the first size of the composing machine version being ready in 1931. The printing trade was presented with a compact, legible, beautiful type, of which Morison wrote: 'For sheer brilliance of cutting, that is to say fineness of serif, it is comparable only with Eric Gill's Perpetua.' Monotype Bell was first used, appropriately, for Morison's *The English Newspaper* (Cambridge, 1932), an extended version of the Sandars lectures in bibliography, which Morison had delivered in 1931-2.

Morison was adept at rediscovering both documents and types which had been forgotten for generations. He found the diary of Ichabod Dawks, lost since the eighteenth century, and he traced the original matrices for the script type

THE ⟨crest⟩ TIMES
LITERARY SUPPLEMENT
REVIEWS THIS WEEK

THE ACHIEVEMENT OF THE
NONESUCH PRESS

FRIDAY THREEPENCE

Printed by The Times Publishing Company, Limited, Printing House Square, London, E.C.4.

invented for the composition of Dawks's news-letter. He and Pollard attempted to find Dawks's grave, but were unsuccessful. At the Double Crown Club dinner of 20 March 1930 Morison spoke on the subject of Dawks and his news-letter, and the menu and accompanying matter were set in the original script type. This was followed the next year by Morison's book *Ichabod Dawks and his News-letter*, which included a facsimile of the news-letter for 3 August 1699, set in types cast from the original matrices which had come down to Stephenson Blake from the foundry of Thomas and John Grover, 1674–1728.

Captain Edward Topham (1751–1820), conductor of *The World and Fashionable Advertiser*, was the subject of one of the University Printer's presentation books (New Year, 1931), and Thomas Barnes, Editor of *The Times*, 1817–41, of that of New Year's Day, 1935. Immersed in the history of the press, Morison wrote a brief typographical history for the *Jewish Chronicle* when it went over to Times New Roman on 12 November 1937.

Not unconnected with Morison's enthusiasm, newspaper typography was now being scrutinized for the first time in any depth, and the spring 1936 issue of the *Monotype Recorder* was devoted to the theme 'The Changing Newspaper' (set, naturally, in Times New Roman). In the issue Morison dealt with 'The Editorial Text: Standardization and the text type', and readers were able to compare specimens of Times New Roman, Monotype 'Modern', and 'Ionic'. Not only did the Times New Roman give seventy-two words to the sixty-eight of 'Modern' and the fifty-five of 'Ionic', but was also, in the circumstances, more legible. 'The Problems of Editorial Display' were dealt with by Monotype's newspaper adviser, Allen Hutt, who had successfully revised the typography of *Reynolds News* where the Monotype Super Caster provided 'the largest repertory of possible faces extant together with all the rule, border, and spacing material in unending supply'.

Hutt followed Morison's typographical teaching and Morison took a benevolent interest in the various stages of Hutt's book, *Newspaper Design*, in which, when it was finally published in 1960, Hutt wrote: 'This book has a long history; in the course of that history its first debt has been to Mr Stanley Morison from whom I have learned so much in the past twenty-five years, and who vetted an initial synopsis of mine as long ago as 1947.'

During 1933 Morison had been able to assist Graham Pollard and John Carter in their investigations of dubious publications, which resulted in their book *An Enquiry into the Nature of Certain XIXth Century Pamphlets*, the dullness of the title to some extent disguising the sensational contents, which led to the revelation that a distinguished bibliographer, T. J. Wise, was a fabricator of fraudulent first editions (among other misdemeanours). The investigators had come to the conclusion that *Sonnets from the Portuguese*, by E.B.B., was a fabrication, and the statement that it was printed in 1847 false. There was no copy of the book in public ownership which could be examined, and so, at the investigators' request, Morison, when in New York in January 1933, examined the copy in the Morgan Library. In a cable he drew attention to three characters which seemed out of place – the f, j, and question mark.

For years the fragile projections of kerned types had irritated printers, and at some time between 1880 and 1883 the printer Richard Clay, disturbed by the breaking of the projection of the lower case 'f' and 'j' in a modern fount, had tried to make his own kernless versions. Not succeeding, he approached the typefounders P. M. Shanks to do it for him. The result was a broken-backed or buttonhook 'f' and a similar kind of 'j'. The idea spread and modern founts

Another bill poster (reduced from 30×20 in.) for *The Times Literary Supplement* of 14 May 1938 – setting in the Times Roman family except for three lines in Perpetua and two lines in italic.

THE TIMES

LITERARY SUPPLEMENT

EL GRAN TURCO

from

EARLY ITALIAN ENGRAVING

BY ARTHUR M. HIND

FRIDAY *Reviewed in this Issue* **THREEPENCE**

began to include these unlovely but efficient kernless designs, as Morison had discovered when criticizing *The Times* editorial founts in his Memorandum.

The question mark was in a different category. It had not been planned as being more efficient, but was more likely to have been the result of an accident. When Clay's lost or broke the matrix for the correct Long Primer question mark, somebody supplied the deficiency by casting an italic question mark of the next smaller size (bourgeois) upright on a long Primer body. John Tarr, former head of the Monotype drawing office, believes that he was the first to recognise this peculiarity, but does not recall Morison ever crediting him with this discovery.

Morison drew Pollard and Carter's attention to the kernless 'f' and 'j' in the *Sonnets* and to the fact that the question mark was obviously not part of the regular fount. The same 'f', 'j', and odd question mark were found in a publication which Clay had printed for T. J. Wise in 1893. It was discovered that the paper used in the *Sonnets* could not have been made in 1847, that the kernless founts were not added until the 1890's and the odd question mark must have been restricted to one printer only. It was clear, therefore, that Wise must have had some connexion with the fabriction of the spurious pamphlet. The investigators continued in their efforts, and the final, but delayed result was the unmasking of Wise.

Ten creative years

The type-face Bembo has been mentioned fleetingly and it is now appropriate to deal with this, perhaps the most popular of all Morison's revivals – the favourite of British book designers. Bembo, which appeared in 1929, derives from the first roman type used by Aldus Manutius in the dialogue *De Aetna* by Pietro Bembo (scholar, poet, and cardinal, 1470–1546), printed in Venice in 1495, and the first type to which the name 'old face' can be given. Aldus's romans were thought to be of a much lower level than those of Jenson by Morris, and Updike, while he did not think the *De Aetna* type successful, was prepared to praise that of the *Hypnerotomachia*. Aldus's talents as a printer had, indeed, not been rated very highly by connoisseurs, but, as Morison pointed out, much opinion was formed on the basis of bad facsimiles.

The connoisseurs, up to and including Bruce Rogers, thought that the roman types of Jenson were the best model to follow. Little was known about italic types, and it was hardly appreciated that Claude Garamond had taken as a model not Jenson's types, but those of the punch-cutter Francesco Griffo, who worked for Aldus. It was left to Stanley Morison to see the excellent quality of the type first used by Aldus in *De Aetna*, which, he said, had to be studied page by page, and which, he concluded, letter for letter was in certain respects superior to the *Hypnerotomachia*, although the types were varieties of the same design.

Griffo's roman types evolved gradually from the earliest Venetians, until they reached their finest form in *De Aetna*. He gradually freed himself from the influence of the scribal letter and was the first to emphasize the effect of the punch-cutter's engraving tool. Griffo could be described as the first modern type-designer in the sense that he devised types for the mechanical craft of printing and not for an alternative to the handwritten manuscript. This accounts for the wide acceptance of the machine-made version of Griffo's type for which Morison was responsible. It was a compromise between handwriting and the brilliant sharp type products of the engraver's punch, which, in time, led to the decadence of 'modern' type-faces.

It has not gone unnoticed that the characters which ultimately formed the model for Monotype Bembo were printed before those used as a model for Poliphilus, and various theories have been put forward as to why the 1499 letter (and hence Poliphilus) is rugged and irregular and suitable for specialized and careful use only, whereas the earlier Bembo letter in its modern form can be, and is, used widely. One suggestion is that the type for the *Hypnerotomachia* was a re-cutting of the *De Aetna* type strengthened to harmonize with the heavy woodcuts which are so prominent a feature of the book. But Mardersteig, who has devoted much time to the study of Griffo and his work, points out that many defects in casting can be seen in the *De Aetna* type, and he feels that the technique of typecasting had not been sufficiently developed at the time to cope with the fine serifs of Griffo's letters. It follows, perhaps, that these elegant forms were abandoned after a few years and replaced by the sturdier letters which appeared

in three works before they were used in the *Polifilo*, which rather puts paid to the idea that they were specially re-cut for that book. Mardersteig also makes the point that over-inking is noticeable, and even when a page is enlarged photographically it is by no means clear whether some letters are intentional variations or whether they have been deformed by casting or the printing.

Morison was not sufficiently experienced in 1923 when Poliphilus was cut, but once he appreciated the virtues of the type in *De Aetna* he saw to it that modern techniques were used to regularize the final design of the type. Mardersteig himself produced Griffo type (cut by Charles Malin), basing it more closely on the *De Aetna*, with its numerous variations, and in his modern edition of the tract, printed in 1969, he set the Latin text in Griffo and the English text in Bembo, from which it can be seen that the Monotype treatment has produced a more regular version, acceptable to present-day taste. Not all the oddities were erased at first, including the eccentric capital roman M and a question mark the same size as the colon. The more normal M with two serifs was marketed from the beginning and has been allowed to take over, and a few years after Bembo was first issued the University Press, Cambridge asked for a more normal-sized question mark, which is now available, with the smaller one as an alternative sort.

The wide use of the Bembo type provides ample testimony to this remarkable design. Morison has ascribed its success to the fact that 'it was inspired not by writing but by engraving; not script but sculpture'. It was the prototype of the types of Garamond, Granjon, Van Dijck, and Caslon.

Despite the success of the Blado italic (which Morison prophesied would outlive the Poliphilus roman), and despite all Morison's researches into the nature of italic, much hesitation was felt in 1928 when the question of an italic for Bembo was discussed. From *A Tally of Types* one gets the impression that Alfred Fairbank, the distinguished calligrapher, was asked to design an italic for Bembo. These are Morison's words: 'The first endeavour was to create a new chancery cursive based upon the hand of the most accomplished living English scribe available for the purpose, Alfred Fairbank. This italic was duly commissioned and cut.' But, in the columns of the *Journal of the Society of Italic Handwriting*, in 1963, Fairbank gives a different account. He explained that in 1927, when he had begun to write a 'Horace' for the late St John Hornby in a set italic script, it occurred to him that there might be a place for an italic type of modern design to be used in its own right, in the same way as the first italic printing types of Aldus. He began to make drawings, although his ignorance of printing at that time was such that he had to borrow a solitary piece of type to see what it was like. He was, however, advised, that as a design for an italic in its own right, his work had no prospect of succeeding. He was told that the design could be used as an italic in association with a roman type then in production by the Monotype Corporation, and was shown a specimen of Bembo, which he liked. Fairbank sold his drawings to Monotype and these were adapted by shortening the ascenders and descenders and widening some of the letters and in Fairbank's words, changing the g 'to a letter with an unrelated incidence of shading, thus reducing the sense of unity I was so anxious to achieve'.

It was then found that the Fairbank italic looked happier on its own than in association with Bembo roman, which was Fairbank's original intention. It is surprising that Morison, after all his researches, was not struck at once by the fact that Fairbank's italic was in the independent, intimate, and economic tradition of the first italics, rather than that of those developed as auxiliaries to the roman.

On the greatest and most useful of all inventions, the invention of alphabetical writing, Plato did not look with much complacency. He seems to have thought that the use of letters had operated on the human mind as the use of the go-cart in learning to walk, or of corks in learning

Three lines from 'Sorts Trial No.1', dated 27 November 1928, of 'Bembo Italic' (i.e. Fairbank Italic) showing the lower case 'g' as Alfred Fairbank intended it to be.

Fairbank continued in his article: 'The type, adapted from my design, was first used in 1929 as Bembo italic, but was soon replaced by the existing Bembo Italic, a product of the Monotype Corporation. Subsequently it was called Narrow Bembo Italic and now Condensed Bembo Italic. Condensed from what? The statement has been made in several books that I was asked to design an Italic for the Bembo Roman. This was not so. Had this request been made, the Italic type produced would have been different.'

It is understandable that Fairbank did not become an admirer of Morison, whom he considered unreliable, prejudiced, and rather arrogant. When he designed an alphabet of capitals at Morison's request, he was neither paid, nor was his drawing returned. When he drew Morison's attention to the fact that he had not been paid he received a rude reply.

Fairbank's italic was not credited to him for many years, and Paul Standard, the American calligrapher, admonished Morison to his face for his 'suppression' of the type. However, it began to permeate through to type lovers. When Fairbank was in the National Library of Wales he asked to see the types obtained from the Gregynog Press, but was told that they did not have 'Narrow Bembo Italic'. When he found the type in a drawer, the printer said: 'That's Fairbank italic'.

Another italic, possessing less personality, was sought to accompany Bembo. The model was found in a publication of the writing master Giovanniantonio Tagliente, who practised in Venice in 1624. For the Monotype version the italic had to be severely revised. The ascenders were seriffed, and the roman capitals mechanically slanted. 'While not disagreeable, it is insipid', Morison wrote, and he considered the Blado italic a much superior achievement.

One of the world's small band of contemporary type-designers was Jan van Krimpen, to whom Morison turned when further type-faces were thought to be desirable. Morison had first come into contact with Van Krimpen in 1926 when he had written to thank him for a review of *The Fleuron* in a Dutch publication. As a result, Van Krimpen, a superb calligrapher, was asked to design the binding of the special edition of *The Fleuron*, No.7. Van Krimpen's experience in type design went back to 1923 when he had been asked by the typefoundry Enschedé en Zonen, of Haarlem, to design a type for them. By 1925 one size was ready to be used for a book on the Dutch exhibit at the Paris exhibition of that year (the type was named Lutetia after the Latin name for Paris). Morison wrote to say how much he liked it, and two years later the Monotype Corporation began cutting it for machine composition.

Morison was unstinting in his praise for Lutetia. In the catalogue for the Enschedé exhibition held in London in 1929, he wrote: 'Nevertheless, the Lutetia is so handsomely proportioned and finely fashioned, possesses so happily that combination of originality and familiarity necessary to reading (lacking in the ninety-and-nine other original types at hand) that it may be fairly described as the

best independent type design made for a score of years. The italic deserves special praise since it is the first fount designed on the Continent to depart from the tradition of Aldus, Garamond and Caslon, and to follow Arrighi and Blado in its adoption of that easy and uniform slope which makes it comfortable reading, not merely in extract but in mass.'

However, Morison's liking for the Arrighi-style italic was not followed when Van Krimpen designed Romulus, cut by Monotype in 1936. Its italic applied Morison's theoretical ideas in his essay *Towards an Ideal Italic*, where he had urged that the only function of the italic was to support the main roman letter. Romulus italic was therefore a sloped roman, but the result was not a happy one for the reader, as A. F. Johnson observed in a review in *Signature* (No.13, 1940) where he stated of the 'sloped roman': 'This may be logical, but results in a stiff and monotonous letter.' Both Morison and Van Krimpen later considered the experiment to be wrong in principle, but they discussed a script type for the Romulus family, and out of this came Van Krimpen's exquisite Cancelleresca Bastarda.

The name, Romulus, was suggested by Beatrice Warde, and the family, as planned by Van Krimpen, is perhaps one of the most original ever designed for book-work, in that it includes three kinds of text roman – the standard (with its 'sloped roman' italic), a semi-bold, and a bold condensed; and four mated sans serifs to align with the others. These are known as Light, Normal, Semi-bold, and Bold, the second and third to match in weight with Romulus roman and semi-bold. The ornamental italic, Cancelleresca Bastarda, although often used alone, will align with other founts of appropriate size if they are leaded. However, only the standard roman (458) and the semi-bold (520) were cut for machine composition. The others were cut as foundry type by Enschedé, and are on Didot bodies.

Van Krimpen developed into one of the most distinguished of world type-designers, and became, with the highly experienced punch-cutter P. H. Rädisch, at the Enschedé foundry, a valuable asset to Morison. After designing his Open Roman capitals in 1928, Van Krimpen went on to consider specimens and punches owned by Enschedé which were attributed to Christoffel van Dijck, of Amsterdam, the leading typefounder of the middle of the seventeenth century. Van Krimpen designed a roman, Romanée, to accompany what was considered to be Van Dijck's only surviving italic, and was then asked by Monotype to oversee the production for machine composition of a 'Van Dijck' type-face. Punches of a large italic fount which survived were identified as those of characters appearing on a specimen sheet which were thought to be Van Dijck's work. The Monotype type was to be based on the italic and roman in this specimen, but Van Krimpen came to doubt whether either italic or roman were cut by Van Dijck. He kept to the design of the italic, however, and discovered a roman which he considered was its mate in a translation of Ovid's *Metamorphoses* (Amsterdam, 1671).

Morison, remembering the lesson of Poliphilus, did not have the roman copied direct from the book, but to establish the precise weight of line of the original design had Rädisch cut six trial punches, under the eye of Van Krimpen. These punches were sent to the Monotype works, where they served as the basis to settle decisions when the complete founts of Monotype Van Dijck were cut. The series was produced in 1935.

As has been recalled in connexion with Gill sans, Morison had the dual responsibility of proposing types suitable for mechanical composition and for

display casting on the Monotype Super Caster. Morison's early work at the Pelican and Cloister Presses had brought him into contact with rich collections of display types from mainly American and European sources, and Bruce Rogers had designed a poster type for Pelican. Morison's controversial initial use of Gill sans and the design of the Gollancz jackets are evidence of his personal interest in the manipulation of display types, but his efforts to inspire the design of new ones were not very successful. Morison did not have much of an eye for letter-forms outside the classical shapes, and he was called upon to advise in a period when display faces were greatly influenced by fashion and the desire to attract attention, which Morison fully understood, but which sometimes gave rise to bizarre designs.

During the early 1930's advertising designers, in particular, demanded heavy, so-called 'Egyptian' display faces, and German and American foundries and composing machine manufacturers hastened to supply them. Monotype could not afford to be left behind, and without any personal enthusiasm from Morison, such faces as Rockwell and Figaro were cut.

Morison had one success when he decided that an advertising designer was perhaps the best man to produce advertising display faces. The talented Ashley Havinden was commissioned to provide two varieties of a new design, and Ashley Crawford (plain and outline) was in tune with the times, although it has now passed out of fashion. After the war, Ashley Script was made on Morison's suggestion, thereby making available in typographical form an elegant brush script, which had caught the public's fancy when used for advertisements and for the written signs in Simpson's of Piccadilly. But, in general, Morison's attempts to satisfy the whims of fashion were a failure and he commissioned some very curious designs such as Grock and Braggadocio. He called on the designer of scripts, Imre Reiner, and Reiner's Matura (1938) was followed by Mercurius and Pepita in the post-war period. Reiner's designs have enjoyed greater popularity on the Continent, while Havinden's had more success in Britain.

While Morison remained in the 'corridors of power' at *The Times*, display types in the editorial columns were kept under close control. Cochin was permitted for headings on the women's page, but elsewhere the only departure from the bespoke set of Times Roman founts was Perpetua. Cochin was an old Morison favourite, and he remained unshaken in his belief that the display sizes of Perpetua were unique in being assured of a lasting place in public esteem.

The hard work put into persuading Gill to design type-faces had paid off handsomely, and Morison had a further stroke of good fortune when, in 1932, Berthold Wolpe, a distinguished pupil of Rudolf Koch at the Arts and Crafts School of Offenbach, came to England with a letter of introduction to Morison. Morison was familiar with Wolpe's work as an inscriptional engraver, particularly in metal, from reproductions in various articles. Wolpe specialized in inscriptions in bronze and stone and this fact assumed some importance when Morison commissioned a new titling face. When Wolpe's Albertus appeared in one size in 1936 it was seen to be a distinguished face derived from letters which were cut rather than drawn. Albertus became embarrassingly popular, being used by lettering artists outside the printing trade without acknowledgement. Issued in 1937 with a lower-case and in a range of sizes, it was followed by Albertus Bold titling and Albertus Light in 1940. As was to be expected Morison, with his special interest in black-letter, took the opportunity of commissioning such a face from Wolpe, a leading exponent in this type of design. The result was an excellent condensed face in sizes from 14 to 72 point, and it looks from the display

in the spring 1937 *Monotype Recorder* as if no name had been decided at that point, but only a series number – 457. However, in the text there are examples called 'Bismarck Schrift', presumably so named with an eye on the German market. This was dropped, and the type was later named Sachsenwald, after Bismarck's estate. The *Monotype Recorder* in question contained Morison's 'Black-letter: its origin and current use', a preliminary statement of his later, 1942, work. Wolpe also designed a roman type, Pegasus, which was issued in 16 point only.

Morison had a great affection for Germany and respect for its scholars and printers; in their turn such men as Julius Rodenberg, the leading bibliographer of modern German printing, and Carl Ernst Poeschel, a world-famous printer, from the vantage point of Leipzig, once the centre of Germany's book trade, did much to make Morison known in Germany. During his German researches Morison had become aware of the rise of Leipzig as a centre of the book trade in the seventeenth century, a trend not unconnected with the increase of composition in German over that in Latin. A natural result was the development of a native school of typefounding and the emergence of 'Fraktur', a descendant of the Gothic 'Textura', as the dominant type. Fraktur, as Morison has pointed out, is legible and space-saving both in width and depth. The roman types developed in Leipzig were also relatively dark, narrow, and close-fitting to compete successfully with Fraktur.

A specimen issued by Wolfgang Dietrich Ehrhardt, a Leipzig typefounder, in about 1720 shows a graded series of fourteen sizes of a roman type, and for some reason these were mistakenly attributed to Anton Janson, a Dutchman and former owner of the Ehrhardt foundry between approximately 1668 and 1687. Harry Carter, however, has shown that there is little doubt that they were cut by the Dutch-trained Hungarian Nicholas Kis, who left a set of his matrices for sale in Leipzig in 1689 on his way back to his homeland.

At Morison's suggestion in 1938 Monotype produced a regularized version of one of the romans in the Ehrhardt specimen and named it after the foundry. It is a narrow and closely fitting letter, rather dark and fairly large on the body, so that it saves space without any loss of legibility. Its first showing was in the fifth annual Book Number of the *Monotype Recorder* (Volume 37, No.2, 1938), and it proved to be a popular face with book designers; indeed, in the opinion of some, it is Morison's finest revival.

Another German type-face which was cut for mechanical composition arose from Oliver Simon's enthusiasm for it – the type originally cut between 1803 and 1828 by J. E. Walbaum, of Goslar and Weimar, from a design based on Firmin Didot. While editing *The Fleuron* several books printed in Walbaum by Poeschel and Trepte, of Leipzig, had come to Simon's notice, and in 1925 the Curwen Press bought a complete range from the Berlin foundry of Berthold, which held the original punches and matrices. Not to everybody's taste, Walbaum nevertheless has elegance and crispness, and Simon found that it had two special advantages for the Curwen Press. By chance the type was for many years exclusive to the Curwen Press in Britain, and they were able to obtain many clients among type-conscious print buyers, even becoming known as a 'Walbaum' house. Secondly, the unusual difference in the emphasis of weight between the larger sizes and the small was such that they could use the larger sizes for display purposes in a variety of jobbing work. Morison was never attracted by Walbaum's types, but he realized that they were in favour in Germany, and Simon's use of them had showed there was a demand in Britain. The Corporation was therefore advised to cut Walbaum for mechanical composition in 1933.

Broadside (original size 23½ × 15¼ in.) of Berthold Wolpe's Albertus capitals commissioned by Morison and first issued in the 72 point size in 1936.

·ALBERTUS CAPITALS·

ABCDEFGHIJKLMNOPQ
CUT IN SEVEN SIZES
RSTUVWXYZ!?&MW&
FROM 14 TO 72 POINT
EXCLUSIVELY WITH
MONOTYPE* MACHINES

"MONOTYPE" SERIES 324

TRADE MONOTYPE MARK

LONDON
THE MONOTYPE CORPORATION LTD
43 & 44 FETTER LANE E.C.4

On his 50th birthday, 6 May 1939, Morison dined with Ellic Howe, the printing trade historian. Two years earlier Morison had persuaded Howe to edit a collection of trade documents which Morison had bought in 1929. Morison wanted to do the job himself but had been held up by the work involved in *The Times* history. The result of Howe's work was *The London Compositor*, published by the Bibliographical Society in 1947. Howe, with Morison, Harry Carter, A. F. Johnson, and Graham Pollard, was interested in indexing every type specimen sheet they could find, and in *The Library* (March 1942) they published a list of specimens issued before 1800. The intention was that they should collaborate in publishing the type specimens with commentaries, but Morison was never a good committee man and his interest languished until shortly after the war when John Dreyfus stimulated it again. Morison once told Howe: 'The only reason for writing anything is to answer one's own questions. In the process of finding the answers, however incomplete or provisional, you might answer someone else's questions', and it was as a result of Dreyfus's revival of the type specimen project that Morison sat down to write, and in trying to find answers to his own questions produced a long essay summarizing a life-time's study of typography.

The year 1940 was commonly regarded as marking the fifth centenary of the invention of printing, and when the war brought to a halt the preparations for exhibitions planned in various European cities, Brooke Crutchley decided to arrange one at the Fitzwilliam Museum, Cambridge. Despite war conditions, plans went ahead, both Morison and Howe lending books and specimens. Among the lenders, headed by the King, was a name then known to a select few as a book collector – 'Ian L. Fleming Esq.', who years later was to achieve fame as the creator of James Bond. The exhibition was designed to portray the uses to which printing from movable type had been put since Gutenberg had invented it 500 years before. Scheduled to last from 6 May to 23 June 1940, it was closed after only ten days because of the deterioration in the war situation, but the catalogue, containing as it did a wealth of information, not easily obtained elsewhere, was in such demand that a reprint was issued in the July. Morison contributed the notes for the section entitled 'The Progress of Journalism', the exhibits for which ranged from a *Mercury* of 1606 to a *Sunday Pictorial* of 1915. Morison was keenly interested in this attempt to show the finished results of man's use of type, and kept it at the back of his mind until the time might again be ripe for a similar exhibition. More than twenty years were to pass before this became possible.

The war brought a halt to Monotype's type-cutting activities, but Morison was as busy as ever, particularly at *The Times*. A special number of the *Monotype Recorder* (September 1940) celebrated the fifth centennial of the invention of typography; this was the work of Morison, Beatrice Warde, and S. H. Steinberg. Beatrice Warde as editor of the *Recorder* felt it was a good occasion to call on Steinberg, sometime Reader at Leipzig University, for a summary of what really happened as the result of the invention of type and the press. Fifteen years later Steinberg's essay was expanded into a book *Five Hundred Years of Printing*, and has since established itself as a standard work. A revised edition was published in paper-back form, and reprints continue to appear. It has been translated into German and Italian.

Morison was naturally involved in many arguments about the war. While he had opposed the first world war he was in favour of the second. He refused, however, to be subjected to anti-German hysteria, as he was an old friend of

Germany, though not of its totalitarian government. He kept in touch with his German friends to the last moment. In a letter to Wolpe, dated 8 September 1939, he wrote: 'Today I had a nice letter from Leipzig – from C. E. Poeschel – dated 31 8 39: "We understand each other perfectly . . . for ever yours C.E.P.".' Only the year before Morison had been collaborating with Poeschel in the printing of a facsimile of a fifteenth-century manuscript, dedicated to Karl Klingspor, 'a friend of twenty years standing' on the occasion of his 70th birthday. In the English edition of 1940 Morison made his position clear when he wrote: 'we are at war essentially with the Nazi party . . .'.

He kept up correspondence with those at home, such as Hutt and Gill, if he thought he could learn something about the war and attitudes towards it. Paradoxically, Gill, one-time volunteer in the Queen's Westminster Rifles and an army driver in 1918, had turned pacifist, and Morison, the former conscientious objector, was now a supporter of the war.

Many of Morison's papers were destroyed in the great air raid of 9–10 May 1941, and it was thought that his correspondence with Gill on type design had been lost; but it survives in the Clark Library of California. Beatrice Warde had intended to go to California and use the letters as the basis of a paper on Morison's influence on Gill, but death intervened. In the air raid Morison's rooms and library at 22 Park Crescent, Regent's Park were destroyed, and papers, including a typescript of selected calligraphical and typographic studies ready for publication by Harvard University Press, with them. He was, however, able to rescue from the burning work table a paper on black-letter and another on early humanistic script. Morison was persuaded by Ellic Howe to publish the former, and accordingly it was printed for him by Cambridge University Press in an edition of 100 copies in 1942. The preface, describing the air raid, provides a vivid account of the effect of warfare on civilians. The paper on humanistic script found its way into *The Library* (June/September 1943).

Morison was occupied with liturgical subjects during the war. He was approached by Burns and Oates to produce a Roman breviary in four volumes, a very big job, which, because of shortage of staff at the University Press, had to be machined outside and did not appear until the war's end. The design is Morison at his best, and his choice of Reynolds Stone to produce the wood engravings, which embellish the Breviary, was a sound one. The opening pages with heraldic decoration are among the finest of Stone's work.

Cambridge was also asked to carry out the printing for the service of opening of the new Anglican cathedral at Liverpool, and although Morison was a Catholic he designed *Solemn Entrance in Time of War*, the special edition of which is among the most admired of his liturgical printing design.

During the discussions he came into contact with the Dean of Liverpool, Dr J. W. Dwelly, who disclosed to Morison that he had been planning a series of books on problems of worship. Morison was drawn into the plan, and arising from it came his work *English Prayer Books*, the only book in the projected series. Those who have handled this small-looking book have been surprised at the number of words it includes – a brilliant example of planning a book to meet particular economic conditions. Morison distilled into this book all the knowledge he had acquired sitting at the feet of the liturgical masters, and in *English Prayer Books* he acknowledged his debt to them. The book met with criticism, but was recognized as a work of considerable erudition.

The last two decades

At the war's end Morison was 57 with twenty more years of life before him, and although he began to shed some of the work at the Monotype Corporation and at the University Press on to his successor, John Dreyfus, during that period, he still undertook a diverse amount of activity, involving new projects and the making of new acquaintances.

Some of his oldest friends, such as Poeschel and Updike, had died during the war, but others were very much alive. He had heard that Van Krimpen was well in 1943 through the Red Cross, and further news reached him in 1945 through John Dreyfus, who was serving with the army near Haarlem. When Dreyfus came to England on leave he brought Morison smoke proofs of a new type Van Krimpen had been working on during the war. It had originally been designed for a Bible to be published by the Spectrum publishing house in Utrecht but the plan had been dropped, and Van Krimpen was eager for the type to be cut for general use. After consultations between Enschedé and Monotype, the type was jointly manufactured by the two firms under the name of Spectrum. The first fount was cut by Monotype in 1952 and the series released in 1955. The upright italic retains the chancery style for which Van Krimpen became famous.

Contact with Europe again opened up further possibilities for Morison. In Verona, Giovanni Mardersteig had long been at work on a new type named Dante. Morison had known Mardersteig since the early twenties when they had discussed Aldus together, and Morison had been in touch with Mardersteig during his stay in Glasgow, where he had been invited in 1935 to advise the Collins Cleartype Press. On finding that there was no such thing as a 'clear type' at the press, Mardersteig had designed Fontana (after the fountain device in the firm's mark), and based on a fount cut by Alexander Wilson of the Glasgow Letter Foundry c.1760. The type was cut by Monotype for the exclusive use of Collins in 1936, and was released for general use twenty-five years later.

Dante was an original design and had resulted from a long and happy collaboration between Mardersteig and the French punch-cutter Charles Malin. The type was re-cut by Monotype in 1957 and it rapidly became popular far beyond Verona. After Malin's death it was decided by Monotype that a semi-bold should be made for this design. Some trial punches were cut by Matthew Carter (Harry Carter's son) in accordance with Mardersteig's sketches, and these were used as the basis for the complete semi-bold founts subsequently manufactured by Monotype.

Whereas Morison was not responsible for the names given to either Spectrum or Dante, the same is not true of Sabon, the last new text type to be made with his co-operation before his death. The type was the result of a demand made in Germany for an economical text face to be manufactured in identical form for composition on Monotype and Linotype machines and with founders' type. Jan Tschichold provided the drawings, but the name was suggested by Morison. Sabon had been a typefounder in Frankfurt, where Tschichold's design was

manufactured, and as Sabon had also acquired founts of Garamond's types, upon which Tschichold based his roman design, the name seemed appropriate. The type was used for the text of the 1968 *Penrose Annual*.

Morison was also able to resume his visits to the United States, where he began to make important connexions. Among the Americans he had met in London during the 1920's had been Pierce Butler, first custodian of the Newberry Library's Wing Foundation, which contains a remarkable collection of writing books. Another American collector, C. L. Ricketts, asked Morison to visit him and use his library, an invitation which Morison accepted, using the resources of both the Ricketts and Newberry Library, which acquired the Ricketts collection in 1941. Resulting from his studies was the Calligraphy entry for the fourteenth edition of the *Encyclopaedia Britannica* (1929) to which Morison also contributed the sections on Printing Type and Typography.

From 1948 to 1962 Morison paid almost annual visits to Chicago as a Newberry Fellow. At the time, the Fellowship was simply a research grant for readers who wished to work in the library collections, and not the present one-year period of residence. After 1962, although he continued to visit the Library, he had become a member of the *Encyclopaedia Britannica* Board of Editors and visited Chicago on business two or three times a year. From his Fellowships resulted articles on Italian and American *calligraphica*, published in the *Newberry Library Bulletin*; an edition of *Verini's Luminario* (1947) (with A. F. Johnson), and a monograph on *Byzantine Elements in Humanistic Script*. In the autumn of 1959 the Library honoured Morison by mounting an exhibition of his work in printing, typography, palaeography, calligraphy, design, liturgiology, and history.

Morison also visited the countries of Europe regularly – Italy, Switzerland, France, Holland, and, particularly, Germany, where he had many friends. It is not generally known, but in the 1930's he had also visited Russia, possibly in connexion with the desire of *Pravda* and *Izvestia* to use a Monotype Super Caster (one was ordered and delivered, together with special Cyrillic founts). While in Leningrad he took the opportunity of attending Mass at a church in the Nevsky Prospekt.

To mark Morison's 60th birthday in 1949, *A Handlist of the Writings of Stanley Morison* was compiled by John Carter, with indexes by Graham Pollard. It was printed for private distribution by Brooke Crutchley, Printer to the University, Cambridge, and contained 141 entries. This useful record of Morison's works, including notes by himself, some of which have been quoted, was supplemented ten years later by Miss P. M. Handover in the periodical *Motif*, when the opportunity was taken of including additions and corrections, bringing the total of items up to 172.

Morison was respected in Europe as an authority in what is called 'Press science'. A major factor was his work, the *History of The Times*, an account of the editorial, business, and political processes by which the newspaper achieved a position of power and prestige; but in 1953 a major work on the physical development of the paper was published under the title *Printing The Times since 1785*. This was to some extent to meet the critics who had complained that this aspect had been excluded from the *History*. Produced in Morison's favourite 'large folio' size, *Printing The Times* was planned, edited, and, for the most part, written by him. The Times Roman, 24 point, in which it was set was keyboarded and cast on Monotype machines, and the volume was profusely illustrated in collotype, letterpress, and gravure. As usual, Morison was well served by his collaborators. All except one of the distinctive initial letters or factotums were

designed by Alec Campbell of *The Times* studio, who was also responsible for the drawing of the Applegath and Cowper press of 1828. Lettering on a map was engraved by H. K. Wolfenden, and in the text there were shown the Royal arms designed for the title-piece in 1951 by Reynolds Stone.

The other important work of Morison's to appear in 1953 was *A Tally of Types*, the Cambridge University Printer's Christmas book. Elegantly produced, with wood-engravings and binding design by Reynolds Stone, and designed by John Dreyfus, it contains a preface and postscript by Brooke Crutchley, but consists mainly of Morison's own notes on those Monotype faces which were introduced at the University Press, and, as such, is a key document in the consideration of Morison's contribution to typography. It has been referred to already, and while much of the content is unexceptionable, other parts pose historical problems, which may never be answered fully.

Morison was not much of a lecturer, as disappointed students at the Royal College of Art (where he was senior Fellow) discovered. Neither did he like appearing on public platforms. But to oblige a very old friend, Turner Berry, Librarian of the St Bride Institute, he agreed to give his first public lecture in Britain for twenty-five years on 5 October 1954, as part of a series entitled 'The Press'. Morison's talk was called 'The Origins of the Newspaper' and although he was inaudible to part of the audience and had some difficulty with his slides, Morison presented a detailed history of the newspaper. He could not agree, on typographical grounds, that the earliest known coranto published in English with an Amsterdam imprint was really printed in London in 1620; supporting the *Corante, or, newes from Italy, Germany, Hungarie, Spaine and France* as the first newspaper printed in London. (The imprint of this coranto indicates that it was printed for 'N.B.' on 24 September 1621. The initials could apply equally to Nicholas Bourne or Nathaniel Butter, both of whom were associated with the first series of numbered and dated news-books, which appeared during the next two years.) Morison also maintained that the *Daily Courant*, published next door to the King's Arms Tavern, Fleet Street by Edward Mallet in 1702, should be regarded as the first dated and serially numbered British daily newspaper, with which view few authorities would disagree, but he went on to say that it was followed by the *Daily Oracle* of 1715, which is not mentioned by others, who give credit to the *Daily Post* (1719).

At the time of Morison's lecture, the first annual Newspaper Design contest was being judged. The three judges, Brooke Crutchley, W. Turner Berry, and J. M. Richards, after long and careful deliberation decided to nominate *The Times* for the award of the best-designed newspaper of the year 1954. This was both because of its then excellence and also in view of all that it had done in 'recent years' in the cause of good design and of the lead it had set in typographical matters. The judges felt quite sure that all competitors (there were 203 in number) would agree with them that the tribute was well deserved.

The award, a plaque presented by Linotype & Machinery Ltd, for 'the newspaper judged by an independent panel to be the best in typography, layout and the use and reproduction of illustration', was justly presented to Morison by the chairman of Linotype, Victor Walker, at a presentation lunch at the Savoy Hotel. It had been noticeable that in some of the provincial papers, in particular, the profusion of advertisements did not assist the design of the page, and Morison, in his speech, emphasized the need for future judges to take notice of the relationship between displayed advertisements and text matter.

Relieved of the more detailed work at the Monotype Corporation by John

Dreyfus, Morison began to write more on religious matters – *Kingship and Christianity* was the title of a paper delivered in 1956; *The Portraiture of Thomas More* was published in a limited edition in 1958, and later issued as a popular edition. He was able to turn his thoughts to wider aspects of calligraphy and palaeography, although he retained his interest in all that was going on in book and newspaper typography. He informed Hutt in 1960: 'My mind is engrossed with the political, ideological interpretation of the Carolingian Minuscule; rather a distance from Ionic.' Dreyfus succeeded him as Typographical Adviser at Monotype, although Morison still held a life-appointment; and then he retired from the University Press, Cambridge in 1959, being succeeded there also by Dreyfus; and from *The Times* in 1960. He began to devote much of his time to the affairs of the *Encyclopaedia Britannica*, the editorial board of which he had joined in 1961. But his health was not good. Though suffering from a painful spinal condition, which laid him low for four months, he had taken the chair at the first lecture in the series 'Printing in London', given by his colleague at *The Times*, Miss P. M. Handover, at the St Bride Institute during 1958.

Morison also pursued what some of his friends felt was a strange addiction for tycoons, the outstanding example being Lord Beaverbrook. They could not understand this particular friendship in a man of such firmly held principles. Beaverbrook was, after all, an arch-priest of private enterprise and Empire, royalist supporter and Presbyterian; Morison was a socialist, republican, and a Catholic. Beatrice Warde was not at all happy about the relationship, and some members of Beaverbrook's family and immediate circle disliked his friendship with Morison. When she heard that Morison had turned down an invitation to a party on the grounds that he never attended such gatherings, Beatrice Warde exclaimed 'He'd go if he knew Beaverbrook was going to be there!'; and Beaverbrook's circle was fearful in case Morison should influence him politically.

But it really does not take a psychologist to explain the attraction these two men had for each other, or for Morison's pleasure in going on yachting cruises, staying in the Bahamas, and generally indulging in the life of the very rich. His early life had been deprived as he saw it, he had been poor as a young man, and it had taken a little time to obtain the pre-war comforts of the professional classes, and, having savoured them, what was more natural than to want to experience 'life at the top' in his last years, no matter how distasteful this might be to his mainly Fabian-oriented, middle-class friends, who, he thought (perhaps inaccurately), had had a better start in life than himself. The attraction of such men as Beaverbrook, Senator Benton, and Henry Luce, was, however, not merely because of their wealth, but because, in one way or another, they were also powerful, and Morison, to put it in the mildest terms, was not unattracted by power.

Beaverbrook and Morison met on board the *Queen Mary* in June 1948. Beaverbrook was curious to meet the man who looked like 'a clergyman'; Morison to meet a press lord, who had known Northcliffe, about whom he was writing in *The Times* history. Formal notes were exchanged, and Morison met Beaverbrook for his first talk on the sun deck. Apart from the mutual attraction which arose they found a basis for collaboration in their writing of recent history. Morison wanted to learn more from the Lloyd George papers, which Beaverbrook eventually bought; Beaverbrook more about Northcliffe's ownership of *The Times* and other matters, including the attitude of *The Times* towards King Edward's abdication.

The next year Morison wrote to Beaverbrook with some queries, with the

reminder that he was the 'clergyman' with whom Beaverbrook had discussed Northcliffe's letters on the *Queen Mary*. From then on the friendship grew, and with it their correspondence; the salutations of the letters which on Morison's part had begun with the very formal 'My Lord', and on Beaverbrook's with 'Dear Mr Morison', progressed to 'Dear Beaverbrook' (or even 'Dear B.') and 'Dear Morison'. When the Presbyterian Beaverbrook changed to 'Dear Friend', Morison replied in the old trade union style with 'Dear Brother'. That did not last long, and finally it was 'Dear Max' and 'Dear Stanley'. Whatever lesser mortals were allowed to do, the Canadian peer was permitted to use Morison's 'handle'.

Beaverbrook used *The Times* history as the basis of two talks, the first being on television on 14 May 1952, when he said: 'The responsible writer is Mr Stanley Morison. He is 63 years of age. He is an authority on Karl Marx, on John Calvin, and he thinks he knows something about John Knox, but he does not. I asked him to show me the grave of Karl Marx, in Highgate Cemetery. I took the precaution, of course, of having a cameraman there. And here is the picture. But he is no hero worshipper of Marx or Calvin or Knox. He was converted to the Roman Catholic faith at the age of 22. From atheism not Presbyterianism. He likes to be called a papist. He dresses like a Jesuit; always in black and wears a black clerical hat half a size too small for his head. You would like Morison. His laugh is infectious. Ringing out loudly at his neighbour's jokes, and also his own. He does not make the mistake of pouring old wine into new bottles. If the wine is old and really good, he has another use for it. Morison's fame will grow.'

The picture of Morison at Karl Marx's grave caused some slight embarrassment, as Beaverbrook wanted to use it in an advertisement for the History, but *The Times* felt it was not quite the thing. Most of Beaverbrook's talk was devoted to Northcliffe, for which Morison had checked the script. The second talk was on sound radio on 25 May 1952, and was much more controversial. Part of it was devoted to the role of the then editor of *The Times*, Geoffrey Dawson, in the abdication of Edward VIII, and Beaverbrook used Morison's history to back up his interpretation. Next day Beaverbrook was attacked on two scores – that it was inopportune to revive memories of the Abdication and that his account was inaccurate.

On the first, Beaverbrook, reasonably enough, said he was reviewing Volume IV of *The Times* history and it was this book, not he, which in twenty-two pages had dealt with the subject. As to the second charge, he wrote and had set up in type a pamphlet *Lord Beaverbrook on the Abdication*, where, side by side, he printed statements from his broadcast and evidence to back them from the *History*. For some reason the pamphlet was never published. It has been stated that the pamphlet was critical of Morison. This was not so. Indeed, the two men became very close, Morison reading the proofs of Beaverbrook's books, and visiting him in the West Indies. Much of their talk was on history and, in particular, on Northcliffe and the first world war; but also on religion. Beaverbrook, as a Presbyterian, sometimes tried to get his staff interested in the affairs of this denomination, but without much success. Morison, on the other hand, as a student of religious variations, was genuinely interested in Presbyterian forms of worship, which are distinctly non-liturgical, and was able to discuss them intelligently with Beaverbrook.

Beaverbrook, according to his own words, accepted Morison's knowledge of most religious matters, but not on the subject of John Knox. He appreciated Morison's work on St Thomas More, and there were vague plans, which came

ARN... Mr... ...know, ...by/
...ondon 1957, or anyo... ...ing/having known
... whereabouts, please contact ...retherton, Turpin &
Pell, Solicitors, Rugby.
MAX B.—In this week's anniversary of the domestic
occurrence, in a small Canadian Manse, 85 years
ago, which was destined to affect world events of his-
toric significance, this friend grateful for years of merry
companionship desires for you at this present, fully enjoy-
ment and lasting happiness, and for the future, abundance
of health and strength of vigour.—S. M.
WELLINGTONIANS, London dinner. Apothecaries'
Hall, 6.30, June 1. Tickets £5 including drinks and
tips from Pike, 16, ...rs Lane.
GLYNDEBOUR' ...hes ...
. 11

Morison's *cri de cœur* 'agony column' announcement in *The Times* of 25 May 1964, at a time when he had ceased to be an intimate of the Beaverbrook circle.

to nothing, that the Beaverbrook Foundation might publish a book, if the source material were given to the University of New Brunswick, of which Morison became an honorary Ph.D. in 1959. Rumours that Morison was to write a life of Beaverbrook were firmly scotched by Morison.

The two men found each other's company congenial, and Morison had clearly found a companion unlike any other in his long and varied life, as is witnessed by his 'agony column' announcement in *The Times*, of 25 May 1964: 'Max B. – In this week's anniversary of the domestic occurrence, in a small Canadian Manse, 85 years ago, which was destined to affect world events of historic significance, this friend grateful for years of merry companionship desires for you at this present, fully enjoyment and lasting happiness, and for the future, abundance of health and strength of vigour. – S.M.'

Beaverbrook died on 9 June 1964 and Morison did not survive him long. One of his last ventures into the outside world before his death was to attend the opening of the Beaverbrook Library in St Bride's Street, London, on 25 May (Beaverbrook's birthday) 1967. Almost blind and confined to a wheelchair, he had insisted on attending, and was very moved by the ceremony.

As printing techniques moved slowly away from the use of metal type towards composition on film, it might be thought that Morison would lose interest in 'typography', if it were continued to be called that. This was not so, as he took a keen interest in the development of photo-composition, even if he called it 'a new fangled' process. He kept in close touch with George Westover, who had been with the Monotype Corporation (and was to return to it), as Westover had invented the Rotofoto. In 1955 Morison considerably extended and re-wrote a work called *The Geneva Bible*, originally published in 1954, and allowed the text to be used for a pamphlet composed on the Rotofoto, and printed at the London School of Printing and Graphic Arts. On his own copy of this work he underlined the word 'Rotofoto' and wrote against it 'i.e. Westover's invention'. Subsequently he arranged for the Cambridge edition of his *First Principles of Typography* to be set on a 'Monophoto' machine in Bembo 12 point. Photo-composition was much discussed in the late fifties, and was taken as his subject when Morison addressed the Art Workers Guild in May 1958. The members must have been surprised at this choice but nevertheless Morison brought it within their purview, as much of the paper was devoted to the idea that a book could not be considered a work of art unless the type was the product of the hand-cut punch. Agreement or otherwise with Morison's view depends on what is meant by 'work of art', but one might just as well say that an oil painting was a work of art only if the pigment had been ground by hand. Apart from this unusual reservation Morison did not see much difference between composition in metal or on film, maintaining that there could be virtue in photo-composition if governed by order and consistency.

Morison's 70th birthday was noticed more abroad than in Britain, causing

Hans Schmoller and S. H. Steinberg to comment in their article in *Der Druckspiegel* (June 1959), entitled *Stanley Morison, 'Nonpareil' der Typographie und Schriftkunde:* 'He celebrated his seventieth birthday in May of this year. If he were a German, a large "Festschrift" would have already been devoted to him ten or even twenty years ago. But this idea is almost foreign to the cautious English. His 50th birthday passed with little attention paid to it; on his sixtieth there appeared a bibliography of his written works (142 in number!), privately printed by the Cambridge University Press in modest paper boards, as well as an eight sided, very witty description of his career (in the original: *Prolegomena ad curriculum vitae*) which ends with a quotation from Walter Scott: "On, Stanley, on!" and a little wood-cut of a mounted racehorse.'

An important event in Morison's last years was the great show, 'Printing and the Mind of Man', which accompanied the exhibition of printing machinery (IPEX) held at Olympia, London, in 1963. Morison used his extensive influence to ensure that 'Printing and the Mind of Man' was one of the finest displays ever to show the results of printing in communicating man's ideas. He had never forgotten the promise of the Cambridge exhibition of 1940, and he saw an opportunity of doing things on a grand scale. Two years of preparation produced an immensely impressive collection of books and equipment. Morison was fortunate that the president of the sponsoring body was Jack Matson, managing director of the Monotype Corporation, who was not only enthusiastic about the exhibit, but conveyed his enthusiasm to his associates in the printing machinery field. The expense was formidable, but nothing was spared to make the exhibition a success, and, as a result, it gave a great fillip to British prestige. It was widely regretted that 'Printing and the Mind of Man' could not be permanent, but this was not possible as exhibits had come from all over the world. Headed by the Queen, the list of lenders included Ian Fleming, who lent more books than any other private individual as his collection had been carefully built up over the years to include first editions of those works which had had an impact on the mind of man. The catalogue of the exhibition will long be cherished as a booksellers' and collectors' guide; and a larger and more distinguished volume, *Printing and the Mind of Man*, edited by John Carter and Percy H. Muir, will outlast the memories of those fortunate enough to visit the actual exhibition.

The year of 'Printing and the Mind of Man' also saw the results of another project. John Dreyfus, after the war, had persuaded the type-specimen group to consider the possibility of publication. With their encouragement he assumed the duties of general editor, and in 1963 the first fifteen facsimiles were published with commentaries. For this publication Morison wrote a 34,000 word essay 'On the Classification of Typographical Variations', on which comment is reserved to the last chapter of this book.

Morison saw his last great work, the book on Dr Fell and his types, just before he died, but he had hoped to be present at the launching which took place the day after his death, 12 October 1967. Beatrice Warde told a New York lecture audience on the 19th, of Morison's last days. Mrs Warde, who had partially retired from Monotype in 1960, continued to make lecture tours, mostly in the United States, and had promised Dr Robert Leslie, of New York, that she and Morison would hold a discussion on their forty-year collaboration as one of the Paul Bennett Memorial lectures, for which Dr Leslie was responsible. Morison had agreed, but in the spring of 1967 had sent her a cable in San Francisco saying he had had a sharp attack of bronchial trouble. This was an understatement, as he was in an oxygen tent with double pneumonia.

Morison recovered sufficiently to attend the opening of the Beaverbrook Library in May and in June when Beatrice Warde returned to London he got up and dressed to meet her. She raised the question of the 'cross-talk' they were to hold in New York, and asked whether the autumn would do. 'Very well', Morison replied, 'but not before the twelfth of October. That's the publication-date of the Fell book, and I must be at the party they're giving for it.'

To most people Dr Fell is known only by one malicious epigram, attributed to Tom Brown, beginning 'I do not love you Dr Fell . . .', but John Fell (1625–86), Dean of Christ Church and Bishop of Oxford, is the father of the corporately owned printing house of Oxford University, and the provenance of the type-faces he obtained from Holland were for long a matter of interest. Morison had first learned of the types in the 1912 Printing Supplement of *The Times*; and he and Meynell were among the few who had actually used them outside the University Press. He therefore undertook in 1925 to investigate the origins of the types, although there was a slight difficulty in relation to working with Oxford at the time. Lewis was paying Morison for his typographic services at Cambridge, and was rather jealous if Morison gave advice, even of the gratuitous kind, elsewhere, particularly to the Oxford University Press. It is understandable, therefore, that the Fell type project was not speedily undertaken. The first printed result appeared in 1930 – five broadsheet specimens, with explanatory text. Morison demonstrated that some of the smaller types, for which matrices had been purchased in Holland in 1670–2, in fact, reproduced punches cut by French masters in the sixteenth century.

Morison's notes were destroyed in the air raid of 1941, and the whole project lagged until in 1953 he visited the Plantin-Moretus Museum in Antwerp and decided that a thorough investigation of the punches, matrices, account books, and inventories there would shed light on the origins of some of the Fell types. The examination was carried out by Harry Carter, and at Oxford punches for the larger types were sorted out and examined by Carter and J. S. G. Simmons. Their conclusion that these were cut for Fell at Oxford by Peter de Walpergen was accepted by Morison.

Writing of the book began in 1956 and the complete manuscript was delivered to the printers in 1960. Experts in several branches of learning criticized it, some rewriting continued until 1964, and late in that year the copy reached the composing room. In Fell's honour the entire book was set in type cast in the typefoundry with the matrices he had bought. This meant setting by hand, using and re-using a fount of type which was enough for forty pages only. As soon as proofs were passed the formes for five sheets of the book were sent to machine. The printing, reminiscent of methods in Fell's day, began in 1965 and was finished in June 1967.

An exhibition in London celebrating the publication of *John Fell, the University Press and the 'Fell' Types*, by Stanley Morison, was planned, as Morison had known, for 12 October 1967. As the visitors gathered they learned that Morison had died the night before, and the exhibition became, in the words of Sir Francis Meynell who opened it, a monument to both Morison and Bishop Fell.

Morison planned his own funeral carefully. One of his oldest friends was Professor H. P. R. Finberg. They had first met when Morison was advising Ernest Benn, and Finberg worked with a subsidiary firm. Finberg went on to become a printer and publisher, and then a professor at Leicester University. As a printer he was a customer of the Monotype Corporation and he corresponded regularly with Morison. They met often and held an annual celebration luncheon

on 6 May, Morison's birthday and the feast day of St John *ante portam Latinam*, patron saint of scribes and printers. They even founded a guild of Catholic printers, but it languished. Morison extracted a promise from Finberg that he would make sure to enlighten those people attending his funeral as to what was going on, as many would not be Catholics. Eventually the Catholic church decided to use the vernacular so that when Finberg saw Morison on his death-bed he was able to tell him that he had translated the Requiem Mass from Latin into English to meet his wish that everybody should understand.

Morison made his plans with Bernard Dunne, of Burns and Oates, there being no kinsman living. These at first involved some highly unorthodox suggestions, including either Morison's recorded voice greeting the assembled congregation in a jovial way, or that at every stage of the ceremony a cleric should provide a running commentary over a loud speaker. These ideas were dropped, and for the Solemn Mass of Requiem in Westminster Cathedral on 18 October 1967, Dunne saw through the press a booklet which contained the liturgies in both Latin and English (provided by Finberg), and was printed by the University Press, Cambridge. However, at a suitable point Canon F. J. Bartlett explained the service to those who were not fully aware of its significance. 'Our custom at a Mass of Requiem is to preach either a panegyric at the end of the Mass or a homily after the reading of the Gospel. Stanley Morison was concerned that at his Requiem the nature of the service should be in some way explained. As a liturgiologist he would surely prefer the homily to the panegyric. He was pre-eminently a man of letters, yet he has been quoted as saying, "I am not interested in literature: I want information".'

The large, but very mixed congregation were given information, but it is doubtful if many, apart from the Catholics and High Anglicans present, fully appreciated what was going on. The large agnostic element was puzzled and curious; the nonconformists were relieved that the Cathedral surroundings were so simple, as they had envisaged the wildest excesses of the baroque, and were reassured by the English accents of the priests. Some of Morison's associates did not attend as they disapproved of his religion. The funeral brought out the diverse nature of Morison's interests and of his friends, whom he tended to keep in water-tight compartments, and who met only at his death.

Later, on 29 November, Morison's fellow-members of the Double Crown Club met for dinner at Kettner's restaurant and heard his voice once more – the recorded talk he had made for the dinner three years before when he was supposed to be in Chicago. For the occasion, Beatrice Warde was invited to attend, the first time a woman had invaded the hitherto all-male dining club. She was one of six official speakers, each of whom dealt with some aspect of Morison's life – the others were Sir Francis Meynell ('The Early Days'); Ellic Howe ('Morison's writings'); John Carter ('The Wise Affair; Printing and the Mind of Man'); Charles Batey ('Beginnings of the Fell Book'), and Harry Carter ('Collaborating with Morison'). Beatrice Warde, however, spoke about Morison and Gill, bringing out clearly Morison's major role – that of master organizer and persuader. He was more than this, it is true, and an attempt will be made to assess Morison's significance in the final chapter.

Morison, the historical figure

Canon Vance was convinced that there were many Morisons, and all the evidence goes to prove that this was so. This multiplication of Morisons, on the other hand, makes the task of evaluating his contribution to the progress of mankind much more difficult than say that of a simple artist-craftsman. This final chapter will try to find its way through the maze and conclude with a summary of what are felt to be Morison's greatest achievements.

Two extensive projects provide a clue to the way in which Morison's mind was working in the 1950's, when he was seeking a rational explanation for the way in which alphabetic characters, lettering, and, hence, type-faces had developed. Since he was also deeply absorbed in religion it was not unnatural that he should have seen a close relationship between lettering and ideology, which, however, it may be thought, on consideration, Morison carried too far.

The first was Morison's long introductory essay, for *Type Specimen Facsimiles* (1963), entitled 'On the Classification of Typographical Variations', running to some 40,000 words and covering the period 1467 to the date of publication. Its object was to trace the steps by which knowledge of typographical variations, and the reasons for them, and the terminology applied in the past and present to them, had been accumulated; and how, ultimately, this knowledge became sufficiently organized to justify inclusion within the general science of bibliography.

The essay makes valuable reading, and as Harry Carter (in *The Library*, June 1969) describes it, 'It is the digest of a lifetime's reading, of a life spent largely in reading and building-up an unequalled erudition in its subject, an encyclopaedic article, retailing other people's discoveries and opinions.' Few could have equalled Morison's tracing of typographic documents through the centuries and evaluating the work of scholars, and if the work had been left at that it would still have been a major contribution; but Morison also wanted to establish a 'science' of typographical variations, and put forward the requirement for documentation 'on the development of type-design consciously viewed as a means of reducing the real space occupied by the letters while maintaining their apparent size'; and for a study of the competition, expressed in terms of type-design, in the Bible trade of the sixteenth and seventeenth centuries.

The essay was reprinted, with another, in a book entitled *Letter forms typographic and scriptorial* (London, 1968), which was reviewed by Harry Carter in *The Library*. Carter doubted Morison's requirements, writing: 'The problem of legibility is much more complicated and to a great extent subjective: it has resisted all attempts at measurement; and Morison's own practice of reviving old types for the Monotype Corporation conflicts with a belief that there has been a development of type-design with the passage of time or towards any kind of letters', and, 'This thesis can be explained, I think, as one part of Morison tilting at another. The imagined adversary was the artist or anyone who took pleasure of an artistic kind in variation of letters due to human exuberance or liking for the

continual slight novelty, including part of himself and the likely buyers of the facsimiles that he was introducing. He was known to commission artists to design types. He sought in this essay (or part of it) to do for type-design what he had done for printing-design in his *First principles of typography*, to impose rational principles on a human activity. It is wholesome up to a point . . .'

Morison's difficulty was that design of letters has not been a 'rational' activity. Nobody sat down and deliberately designed an alphabet. The way in which it developed can be studied, but much remains obscure, and the way in which alphabetic letters were represented varied according to the tools used and the material on which they were imposed, and to the background, temperament, and particular whims of a scribe or artist. The design of type has been subjected to many kinds of influence, not excluding the attempt at rationalization by Louis XIV's advisers, but even that, in the long run, was watered down by the punch-cutters. The oddities of fashion, much of which is still inexplicable, temporary economic factors, and the sheer, basic truculent desire of groups of people to be different from others, which governments, priests, and educationists have tried, largely unsuccessfully, to curb, precludes any real possibility of the scientific development (in the sense which Morison required) of printers' type. The irony is, as Carter pointed out, that the practical Morison, the man who revived old faces out of their historic context, undermines the other, theoretician Morison.

The first Morison is the one who could say in a discussion at a Double Crown Club dinner, in January 1947, that the whole body of type-faces, with which he was associated, was 'got out sometimes more according to enthusiasm than to knowledge', thus exploding the suggestion of the second Morison of a 'rational programme' of type-cutting and the concept of some kind of rational progression in type-design.

In an essay which Morison wrote for an Italian bookseller's catalogue of writing manuals, and which was reprinted with his essay for the *Type Specimen Facsimiles* in the book *Letter Forms*, he exhibits an obsession concerning religious authority and letter-forms. Morison's typographic utterances were often tinged with religion – the William Morris manner he characterized as 'High Church', Jannon's types as 'Jansenist', and in the second essay seems to have thought that Sixtus V (Pope from 1585 to 1590, and responsible for many public buildings in Rome) had a policy of 'Christianizing' the 'pagan' lettering on monuments. 'It must be confessed that it was a slight reform to be dignified by such a motive', comments Harry Carter.

The second project which took Morison deeper into the religious aspect, were his Lyell lectures on bibliography at Oxford, delivered in 1957, which Beatrice Warde proclaimed as 'that crowning work on the influence of political and religious Authority on the evolution of letter forms through 23 centuries'. The lectures contained a distillation of Morison's forty years of extensive theological reading, together with his concept of lettering development, and had the somewhat pompous title of 'Aspects of Authority and Freedom in relation to Graeco-Latin Script, Inscription and Type, sixth century B.C. to twentieth century A.D.', no doubt the invention of Morison, the ideologue; but the practical Morison told his audience that his lectures were more tenuous than the title suggested.

The lectures took an unusual form. He told Beatrice Warde: 'You see, long after the conventions of public lecturing were established, *they invented Printing*. I propose to take advantage of that fact. A draft of each lecture will be distributed

as a printed pamphlet to the people as they come in. They shall have the gist orally, and peruse the text at their leisure. In that way I'll be able to get in many more illustrative slides.' Whatever one may think was behind this unusual approach, if there was anything at all, the audience was duly presented with pamphlets, 'privately printed for S.M.' by the Cambridge University Press (four) and the Times Publishing Company (two). Morison purported to explain that causes in changes in alphabetic lettering in the West might be seen arising out of changes in the nature of authority, at times sacred and at times secular, that protected the chief forms of script, and, in the course of doing so, guided his audience through the maze of theological dispute between Western and Eastern churches. How interested his listeners were in the *filioque* clause, or the pious belief that Constantine was converted to Christianity by a vision in the sky, cannot be determined, but the connexion of the lectures with bibliography was certainly tenuous, and some listeners may have felt that they were being subjected to a Christian apologia against the 'heathens'.

In his research for these lectures, which was very extensive, Morison had been assisted by Arnold Bank, a talented and learned calligrapher, who eventually became a professor in an American university. Between them they reinforced, with a great deal of evidence, the origins of the Roman letter from the Greek, and the Greek origin of the sans serif or monoline letter, a valuable contribution, but the case that a change of authority involved a change in scripts is too extreme for many to swallow. To use a phrase of Harry Carter's, one is 'dragged along protesting' when reading Morison's lectures. He shows how the use of different writing tools and the way in which they were held made a difference to the shape of a letter, and yet the serif (if Morison is to be interpreted correctly) was something to do with the anti-image campaign (the current tide of 'Jansenism', as Morison calls it).

How much was the Carolingian minuscule to do with Charlemagne's ambitions? Alcuin and his successors knew better than to look towards Byzantium says Morison. To which one might protest: 'Why should they?' Today's Stationery Office typographers do not refrain from using Cyrillic type-faces because it would offend the Government, but because it would be completely outside their cultural outlook and that of their readers. Morison's idea that 'textura' was connected with the political plans of the Frankish kings overlooks the importance of the pen in letter-design, which one might have thought a follower of Edward Johnston would never forget, and also indicated Morison's preoccupation with the Roman letter to the exclusion of others, as a passage from Harry Carter's own Lyell lectures, of 1968, suggests: 'Delight in the power of the broad pen obliquely cut to produce contrast of fat and fine strokes, the fracture of what were curves, pressure on the nib making ornamental diamond-shaped excrescences – these things are found in the Frankish style of Hebrew as well as of Latin lettering.'

Morison seemed to forget ordinary convenience of methods of communication. Rulers, motivated by some form of philosophy, still want to communicate with the ruled. Because Karl Marx was a German and his first works were printed in a fraktur type, his followers, when triumphant in Russia, did not feel obliged to transmit his texts to the people in that type. They kept to Cyrillic. But the matter is much more complicated than such simple arguments would suggest, and is not helped by Morison's use of the word 'authority' in two senses – the power to enforce obedience, and intellectual influence. It is doubtful whether Church and State made particular kinds of lettering a matter of obedience, and

the second kind of 'authority' is so diffuse as to amount to the 'freedom' of Morison's title, of which he said: 'The authority which has been that of the State, of the Church, of Learning, of Taste, was now to be succeeded by the liberty of commerce.'

He tried hard to tie up his researches into the Greek monoline letter with 'authority' as the following passage shows: 'Today, as this slide of the British Railways proves, authority is given to a script that is virtually identical with that of the first slide we saw, i.e. of the sixth to fifth century Greece.' It is true that public transport authorities use a sans serif letter for announcements, as it is thought at the present time (but not necessarily for ever) that this is a more legible letter, but does it give it 'authority'? Is the traveller influenced to use this letter for his printed writing paper? The reason for the use of monoline sans serif in mass-circulation newspapers is because their front pages are of the nature of posters, and not because the publishers feel the letter is more 'authoritative'. Morison, speaking in 1957, gave the *Daily Mirror* as an example, but also mentioned the *Evening Standard* as using sans serif headlines. Later, the *Standard* changed to a seriffed letter, and there is no reason why other newspapers should not follow.

Morison in these two great summaries of his accumulated knowledge exhibited both his strength and weakness. He is at his best, as it is hoped has been shown, when finding out – 'I want information', he used to say – and at his worst when theorizing, particularly when it involved his search for a philosophic basis for the development of letter design.

From what has been written it can be seen that Morison was to a large and impressive extent self-educated; to H. P. R. Finberg he was the 'Prince of auto-didacts'. He certainly ranged over a wide field and his mind could encompass very broad issues, but, at times, it is understandable that he lacked particular detailed knowledge, and in the absence of collaborators he was capable of making striking errors. His non-specialist friends were almost awed by his knowledge of palaeography, but not so palaeographers themselves. His article 'Early Humanistic Script and the First Roman Type' (*The Library*, June/September 1943) can be considered in this light. The article was an attempt to define terms for those scripts and the founts which were modelled upon, and quickly succeeded them in the period now known as the Italian Renaissance.

The twenty-one illustrations were an obviously important part of the apparatus in this largely pioneer undertaking. A major figure discussed was Niccolo de' Niccoli (1363–1437), who 'used manuscripts written in the script known to palaeographers as the "Carolingian" minuscule'. Morison therefore took what he thought was a copy by Niccoli of Cicero *De Oratore*, written, as to the one part (*circa* 1405–15, according to Morison) in 'littera antiqua', or 'lettera anticha formata' (Fig.6); and as to the other (*circa* 1410–15, according to Morison) in 'lettera anticha corsiva' (Fig.7). He also took what he considered an example of Niccoli's 'lettera anticha corsiva corrente' from a text of Boccaccio *De Genealogia Deorum*, written '*circa* 1400–10' (Fig.10).

Writing in *La Bibliofilia* in 1950, David Thomas has this to say of the latter. 'It is written in a "corsiva corrente". This hand, from its firmness, Morison ascribes to 1400–10. As chance has it, this codex also lends itself to dating on the internal evidence of Morison's facsimile. In the first place the passage reproduced is not part of Boccaccio's De genealogia deorum gentilium, as is stated in both legend and text, nor is this work contained in the codex. The passage is from a commentary on Silius Italicus . . . According to Bandini . . . the first and last of

its contents may be ascribed to Domizio Calderini . . . If Domizio Calderini was the author of either of these, then the codex could not have been written by Niccoli because he was in his grave when Calderini was born.'

The same point was made by Professor B. L. Ullman (whose writings Morison acknowledges) in *The origin and development of Humanistic Script* (Rome, 1960): 'Bandini states that the epitomator was Domizio Calderini, though his name does not appear in the manuscript . . . Now Calderini was born about 1444 and Niccoli died in 1437! . . . Bandini thoughtlessly made the identification on the basis of handwriting and in doing so victimized Morison, who dated the copying between 1400 and 1410.' There is no exact agreement on the date of this manuscript, although it may have been written by Cennini in the 1460's.

Professor Ullman also criticized the attribution of Figs.6 and 7 (Cicero) to Niccoli: 'Two different scribes, neither of them Niccoli, copied the codex . . . The second scribe also served as corrector of the first part . . . Bandini identified only the second scribe as Niccoli; Morison believes that Niccoli copied the entire manuscript.'

Curiously, Morison did not give the location of the manuscript reproduced in Fig.7, but it may be the same as one in the Harleian collection, which is thought to have been written about 1440. Morison, in his palaeographic studies relied too heavily on his reading, and too little on original research. He must have studied the extensive works of Angelo Maria Bandini, particularly the three-volume catalogue of manuscripts in the Bibliotheca Leopoldina Laurentiana, Florence, and did not fully understand what he was reading. In his *The Typographic Arts* (Edinburgh, 1944), three of the five illustrations of scripts have incorrect captions, two being repeats from *The Library* article. The other shows a page attributed to Arrighi's *Missale Romanum*, but which, however, does not appear in that work, and is by another scribe.

It is true that Morison's eyesight was never good and he attempted more work than perhaps was good for his health. He was careless about dates and translations, and did not pay sufficient attention to detail. Moreover, consciously or unconsciously, he rewrote a certain amount of recent typographical history to enhance the part he played in early life. This may have derived from some psychological need for certainty, which, paradoxically, went against the Church doctrine of 'free will', and tended towards 'Jansenism', and even the Calvinistic theories of predestination.

Towards the end of his life Morison was more confused than he had been when he embraced Catholicism, to such an extent that some non-Catholic friends thought he was tired of the Church. This was not so, but to those not versed in, or indifferent to, religious doctrines, he may have given that impression. Morison's mind was full of oddly shaped pieces which he was always trying to fit together. He was a rationalist, eventually a non-Marxist socialist (although remaining interested in Marxism), and yet at the same time a conservative and traditionalist.

He therefore found in the writings of Charles Péguy what he needed – a sense of direction, based on Christian socialism, that is of a moral order, and not a purely economic doctrine, and yet also a sense of tradition, which he also found in the works of Edmund Bishop, enabling him to salvage historical religion. He would have found it difficult to have adopted one of the Protestant faiths, as this would not have conformed to his need for a continuous tradition.

However, by the accident of history, men such as Morison and Edmund Bishop (both converts to Catholicism at about the age of 20) did not grow up in Catholic countries, such as Italy or Ireland, but in England where, apart from its

retention by a few old families, Catholicism, particularly in the popular view, had been restored by Rome – which gave rise to the use of the words 'Roman Catholic'. To many, therefore, the Roman Catholic Church was an Italo-Irish institution, with all that that implies, and not a natural English growth. Bishop and Morison, later, found themselves in opposition to the *Roman* Catholic tendency, and thus in conflict with the priestly hierarchy.

Morison's rationalism, modified perhaps by scholastic thought, remained, and a study of Péguy reinforced his socialist ideas. But Morison's views did not remain static, and he tended to become less a rebel and more an authoritarian personally, politically, and in a religious sense; and then, finally, in his very last years, more liberal and understanding.

At the height of his powers he was so formidable that few cared to challenge him. On 7 March 1934 James Guthrie addressed the Double Crown Club on 'The Hand Printer and his work'. In the discussion Morison, 'in his most formidable style', proclaimed himself no artist, but an industrialist, and stated the prime object of the printer to be the production of the greatest numbers in the shortest time at the smallest cost. Such a view could have easily been opposed, but Guthrie declared himself content to differ with Morison. Four years later, on 27 April 1938, Morison's close friend Graham Pollard addressed the Club on 'The economic organization of the book trade 900–1900'. The paper was described as short and disjointed, but criticism and remonstrance were stifled at their birth by the challenge of Mr Stanley Morison who insisted that Mr Pollard knew so much that there could not possibly be anybody at the dinner capable of criticizing the paper for five seconds. Only one member felt himself strong enough in status to challenge Morison. That was Michael Sadleir, a distinguished bookman, who pointed out the enormous gap in Mr Pollard's consideration of the late eighteenth and nineteenth centuries. But Morison had so stifled the audience by his vehement assertions of their own incapabilities that nobody had the heart, except Sadlier, to pursue the discussion.

The conservative, traditional Morison had also absorbed more of the 'Roman' authoritative Catholicism than perhaps he realized himself, and he became increasingly uncomfortable over the Second Vatican Council, and the liberal attitudes and policies that flowed from it. Politically, he began to recede from the extreme left-wing during the Spanish civil war and was at his most conservative in defending *The Times* newspaper, even *The Times* of the past, long before his connexion with it.

Then in his last years Morison became more benign, coming to terms with the world about him, accepting collaborators gladly, and even trying to understand other people's religious beliefs. After all, the world had been coming to terms with Morison for some years, and he was delighted to be honoured by learned bodies. He achieved an unusual 'double' by receiving the gold medals of both the Bibliographical Society (1948) and the American Institute of Graphic Arts (1946), and during the 1950's was awarded honorary doctorates by the Universities of Cambridge, Birmingham, Marquette (Wisconsin), and Chatham, New Brunswick. He was elected a Fellow of the British Academy in 1954, and in 1960 (twenty years or more after first being offered the honour) he was made a Royal Designer for Industry. Whether he was offered and declined a knighthood three times, as had been said, is very doubtful. One refusal would be enough for the authorities, but somebody must have thought a great deal of him.

Even those who did not suffer Morison gladly, including Victor Lardent, received tributes. In Lardent's case praise for 'my friend Victor Lardent' was

Letter from Hutt to Morison, with Morison's replies (1) confirms that his objection to the word 'Royal' in 'Royal Designer for Industry' had been overcome by 1960 and (2) that he was still absorbed in his theories of 'authority' and typography.

1) Thanx. I should in obligation to the people say that it was offered me a score of years since, and then I had the backbone to resist — not the I or the D but the R.

2) Shall be glad indeed to see this, upon which you have been so long engaged. I hope I shall understand some of it. My mind *** with the political, ideological, interpretation of the Carolingian Minuscule; rather a distance from Ionic

S M.
1 Jul 1966

Dear Mprison,

1 Noting the trade press announcement this week of your R D I, I hasten to present my respectful congratulations. It is, after all, a genuinely exclusive thing, like the O M (and I suppose you'll be getting that soon).

2 Early this autumn I'll hope to present you with my OUP Newspaper Design book, which owes so much to you. For some reason Ridler seems unwontedly enthusiastic about it.

Yours
J. Allen Hutt

Stanley Morison Esq

posthumous, in Morison's *Splendour of Ornament* (Lion and Unicorn Press, 1968).

At the time of his death Morison had achieved fame and fortune, had accumulated a host of friends in many parts of the world, and departed this life knowing that his name would not be forgotten.

Morison will be remembered as the man who put the study of typographical history firmly on the map. He was not the only typographical historian, and certainly not the first, but for continuous attention to the subject and in terms of output of printed works he had no rival. His writings sometimes need to be studied with care, but, with certain exceptions, students may often find a corrective, if needed, from Morison's own pen. They are fortunate in having the Carter and Handover *Handlists* as their guide.

In specific terms, Morison was largely responsible for the discovery that the roman types of Aldus Manutius represent the origins of 'old face' and not those

of Jenson: he will be recalled for his analysis of the origins and use of the italic; for his revival of interest in English script types, and for his studies of typographic decorative elements. His rediscovery of Bell's type and his contributions to the history of the newspaper represent another major aspect of his work.

While Morison made his mark as a typographical scholar, his really great contribution was to inspire the production of text types, which, whatever their provenance, constituted a major source of typographical material, which enabled graphic designers to raise the standards of printed communication, particularly of books, to new heights.

Morison once said to Beatrice Warde: 'You know, I think I have only one really outstanding talent and that is for convincing powerful moneyed men that reasonable projects are in fact practicable.' That was a great understatement of Morison's talents, but it contained an element of truth, for very few men could have used the arts of persuasion so effectively on both 'powerful moneyed men' and artists of the calibre of Eric Gill, to produce an unrivalled range of type-faces, and, in doing so, turn London into the world centre of type-design.

The achievement of this feat required an extraordinary personality, which Morison possessed, but it also demanded a man of exceptional worldly experience, which he gained during an unorthodox life. This may have led him into errors of judgment and into mishandling personal relationships, but without his combination of a ruthless and enquiring mind, native and acquired cunning, joviality and good will, wide reading and study, authoritarian approach, and enormous capacity for work, there would never have been the actual, physical range of type and ornament readily available to the printing and publishing industries. Today's typographers and book-designers may find it hard to appreciate the frustrations of their predecessors of fifty or seventy years ago, but those who lived on into the new era were grateful to the handful of men of which Morison was perhaps the most outstanding figure, who had worked so hard to provide the basic material which enabled designers to plan good-looking printing not merely for the privileged few, but for the multitude.

The extraordinary response to even a rumour that American Type Founders was producing its 'Garamond' in the early part of the century is but one indication of the yearning there was for something better in the way of commercial text types than was generally available. Joseph Thorp, Britain's first 'typographer', not being a trained printer, who struggled to achieve some dignity in commercial printing with the travesties of type-faces available before 1914, when writing in his old age, in 1945, held no uncertain view when he referred to 'the inestimable contribution of the Monotype Corporation to fine letter-making, in restoration and innovation, under the inspiration and direction of Stanley Morison'.

It may be for posterity to judge the long-term implications of Morison's work, but as far as the twentieth century is concerned he will remain an overwhelming figure in the consideration of printing – the art preservative of all arts.

Specimen settings of some of the more important text typefaces mentioned in this book are provided below for the guidance of readers. They have been placed in alphabetical rather than chronological order for ease of reference; and they do not include Bembo, in which this book itself has been set.

Barbou

The emancipation of the printed book from the conventions of the manuscript is, after the invention, the most notable event in the annals of the craft. For a generation or two after Gutenberg, printing was everywhere bound by the limits of the Scriptorium. The noblest writing schools exercised their craft in Italy and it was in Italy that the printed book first won the respect of the calligraphers. The hand of one of the finest masters of the scrittura

Baskerville

The emancipation of the printed book from the conventions of the manuscript is, after the invention, the most notable event in the annals of the craft. For a generation or two after Gutenberg, printing was everywhere bound by the limits of the Scriptorium. The noblest writing schools exercised their craft in Italy and it was in Italy that the printed book first won the respect of the calligraph-

Bell

The emancipation of the printed book from the conventions of the manuscript is, after the invention, the most notable event in the annals of the craft. For a generation or two after Gutenberg, printing was everywhere bound by the limits of the Scriptorium. The noblest writing schools exercised their craft in Italy and it was in Italy that the printed book first won the respect of the calligraphers.

Centaur

The emancipation of the printed book from the conventions of the manuscript is, after the invention, the most notable event in the annals of the craft. For a generation or two after Gutenberg, printing was everywhere bound by the limits of the Scriptorium. The noblest writing schools exercised their craft in Italy and it was in Italy that the printed book first won the respect of the calligraphers. The hand of one of the finest masters of the

Ehrhardt

The emancipation of the printed book from the conventions of the manuscript is, after the invention, the most notable event in the annals of the craft. For a generation or two after Gutenberg, printing was everywhere bound by the limits of the Scriptorium. The noblest writing schools exercised their craft in Italy and it was in Italy that the printed book first won the respect of the calligraphers. The hand of one of the

Fairbank italic

The emancipation of the printed book from the conventions of the manuscript is, after the invention, the most notable event in the annals of the craft. For a generation or two after Gutenberg, printing was everywhere bound by the limits of the Scriptorium. The noblest writing schools exercised their craft in Italy and it was in Italy that the printed book first won the respect of the calligraphers. The hand of one of the finest masters of the scrittura umanistica, Antonio Sinibaldo, the Florentine, is obviously the prototype of the perfected roman of the

The emancipation of the printed book from the conventions of the manu-script is, after the invention, the most notable event in the annals of the craft. For a generation or two after Gutenberg, printing was everywhere bound by the limits of the Scriptorium. The noblest writing schools exercised their craft in Italy and it was in Italy that the printed book first won the respect of the calligraphers. The hand of one of the finest masters of the

Fournier

The emancipation of the printed book from the conventions of the manuscript is, after the invention, the most notable event in the annals of the craft. For a generation or two after Gutenberg, printing was everywhere bound by the limits of the Scriptorium. The noblest writing schools exercised their craft in Italy and it was in Italy that the printed book first won the respect of the calligraphers. The hand of

Garamond

The emancipation of the printed book from the conventions of the manuscript is, after the invention, the most notable event in the annals of the craft. For a generation or two after Gutenberg, printing was everywhere bound by the limits of the Scriptorium. The noblest writing schools exercised their craft in Italy and it was in Italy that the printed book first won the respect of the calli-graphers. The hand of one of the finest masters of the scrittura umanistica,

Garamond italic

The emancipation of the printed book from the conventions of the manuscript is, after the invention, the most notable event in the annals of the craft. For a generation or two after Gutenberg, printing was everywhere bound by the limits of the Scriptorium. The noblest writing schools exercised their craft in Italy and it was in Italy that the printed book first won the respect of the calligraphers. The hand

Gill

The emancipation of the printed book from the conventions of the manuscript is, after the invention, the most notable event in the annals of the craft. For a generation or two after Gutenberg, printing was everywhere bound by the limits of the Scriptorium. The noblest writing schools exercised their craft in Italy and it was in Italy that the printed book first won the respect of the calligraphers. The hand of

Perpetua

The emancipation of the printed book from the conventions of the manu-script is, after the invention, the most notable event in the annals of the craft. For a generation or two after Gutenberg, printing was everywhere bound by the limits of the Scriptorium. The noblest writing schools exercised their craft in Italy and it was in Italy that the printed book first won the respect of the calligraphers. The hand of one of the finest masters of the scrittura

Poliphilus

The emancipation of the printed book from the conventions of the manuscript is, after the invention, the most notable event in the annals of the craft. For a generation or two after Gutenberg printing was everywhere bound by the limits of the Scriptorium. The noblest writing schools exercised their craft in Italy and it was in Italy that the printed book first won the respect of the

Times New Roman

168

A selection of the University
Printer's Christmas books
designed by Morison at
Cambridge between 1930 and
1938. The first – John Dunton's
*The Tribute of a London publisher
to his printers* – is on the right in
the third row.

Morison persuaded Eric Gill to cut a bold sans-serif titling for the *Daily Worker*, on which a hammer and sickle were superimposed. Another Gill type-face – Perpetua – was used for the *Reynolds News* title. Morison was asked to design title-pieces for a number of newspapers, including the *Daily Herald*, for which he specified Baskerville Bold, and the *Daily Express*, for which he provided hand-drawn lettering in 1942, partly as a war-time economy in space.

A selection of Morison's writings: books

Stanley Morison was responsible for a remarkable output of printed work. No attempt has been made here to compile a comprehensive list, but a selection is provided to act as a general guide to readers of this book. It does not include references to introductions and notes by Morison for books mainly by others, but it does mention those written by him in collaboration (★) and those for which there is only introductory material (†). Three Morison handlists have been published: Ellic Howe, following an article by A. F. Johnson, *The typographic and calligraphic studies of Stanley Morison* (*Signature*, New series, No. III, March 1947); *A Handlist of the Writings of Stanley Morison*, compiled by John Carter, and indexes by Graham Pollard (Cambridge, printed at the University Press, 1950); and *A Handlist of the Writings of Stanley Morison 1950–59*, compiled by P. M. Handover, with additions and corrections to the original handlist by John Carter (*Motif* 3, September 1959). Since 1959 there have been a number of other publications by and about Morison.

1 Some Fruits of Theosophy
Harding & More Limited, 1919

2 The Craft of Printing
Pelican Press, 1921

3 On Type Faces
Medici Society and The Fleuron, 1923

4 A Brief Survey of Printing History and Practice
The Fleuron, 1923★

5 Four Centuries of Fine Printing
Ernest Benn Limited, 1924

6 Modern Fine Printing
Ernest Benn Limited, 1925

7 The Art of the Printer
Ernest Benn Limited, 1925

8 Caractères de L'Écriture dans la Typographie
Paris, à l'Enseigne du Pégase, 1927

9 The Calligraphic Models of Ludovico Degli Arrighi Surnamed Vicentino
Paris, privately printed for Frederik Warde, 1926†

10 Type Designs of the Past and Present
The Fleuron Limited, 1926

11 A Review of Recent Typography in England, the United States, France and Germany
The Fleuron Limited, 1927

12 A Newly Discovered Treatise on Classic Letter Design
Paris, at the Sign of the Pegasus, 1927†

13 German Incunabula in the British Museum
Victor Gollancz Limited, 1928†

14 Eustachio Celebrino Da Udene
Paris, The Pegasus Press, 1929

15 Andres Brun, Calligrapher of Sara-Gossa
Paris, The Pegasus Press, 1929★

16 The Treatise of Gerard Mercator
Antwerp, De Sikkel; Pegasus Press, Paris, 1930†

17 The Typography of The Times
Printing House Square, 1930

18 John Bell, 1745–1831
Printed for the Author at the University Press, Cambridge, 1930

19 The Tribute of a London Publisher to his Printers.
John Dunton's Sketches, etc.
Cambridge, Printed at the University Press by W. Lewis, University Printer, for his Friends in Printing and Publishing, Christmas 1930

20 Memorandum on a Proposal to Revise the Typography of The Times, 1930
Printed in the Office of The Times, 21 November 1930

Articles and pamphlets

167 German Press Study and the British Historian
Gazette (International Journal of the Science of the Press),
Leyden, 1955, I

168 On Learned Presses
A paper given to the Double Crown Club on the occasion of its
130th dinner
held in King's College, Cambridge, on 23 June 1955

169 The Origins of the Newspaper
Inaugural lecture arranged by the University of London, in
association with St Bride Foundation Institute
London, on 5 October 1954

170 Venice and the Arabesque Ornament
For the Oxford University Bibliophiles, 17 November 1955

171 Personality and Diplomacy in Anglo-American Relations
In Essays presented to Sir Lewis Namier (Macmillan & Co.)
published 23 April 1956

172 Kingship and Christianity
A paper read at Westcott House, Cambridge, 5 May 1956

173 Picture-Printing and Word-Printing
Penrose Annual (Golden Jubilee Number), London,
Lund Humphries, 1956

174 The Incomparable Collection of Kelmscott Press Books and
Other Works of William Morris
Sotheby & Co., 10 December 1956

175 The Lyell Lectures
Six pamphlets printed by the University Press Cambridge and
by The Times Printing Office
Delivered at Oxford, May 1957

176 Typographic Regia
Catalogue 167 of the Librairie Paul Jammes, Paris, 1957

177 Documents Typographiques Français
I. L'Inventaire de la Fonderie Le Bé selon la transcription de
Jean-Pierre Fournier
Paris, 1957

178 Review of Jeanne Veyrin-Forrer, Antoine Augereau, graveur
de lettres et imprimeur parisien (vers 1845–1534)
The Book Collector, Autumn 1958

Works consulted

Among the many works consulted by the author are the following:

Barker N. and Cleverdon D. (compilers)
Stanley Morison 1889–1967: A Radio Portrait
W. S. Cowell, Ipswich, 1969

Barker N.
The Printer and the Poet
Cambridge, privately printed, 1970

Bembo Pietro
On Etna
Officina Bodoni, Verona, 1969

Carter H.
A View of Early Typography
Clarendon Press, Oxford, 1969

Carter J.
Books and Book Collectors
Rupert Hart-Davis, London, 1956

Carter W.
Typographical note to Trypanis C.A.
The Elegies of a Glass Adonis
New York, 1967

Crutchley B.
Two Men
Cambridge, privately printed, Christmas 1968

Johnson A. F.
Type Designs
Grafton & Co., London, 1959

McMurtrie D.
American Type Designs in the Twentieth Century
Robert O. Ballou, Chicago, 1924

Schmoller H. and Steinberg S. H.
Stanley Morison 'Nonpareil' der Typographie und
Schriftkunde
Der Druckspiegel, June 1959

Simon O.
Printer and Playground
Faber and Faber, London, 1956

S.M. an original member of the Double Crown Club
Hazell, Watson & Viney, Aylesbury, Bucks, June 1968

Updike: American Printer and his Merrymount Press
The American Institute of Graphic Arts, New York, 1947

Updike D.B.
Printing Types: Their History, Forms and Use
Harvard University Press, Cambridge, Mass., 1922, 1937

Veyrin-Forrer Jean and Jammes A.
Les Premiers Caractères de L'Imprimerie Royale
Paris, 1958, Extrait de Caractère Noël, 1957

Williamson H.
Methods of Book Design
Oxford University Press, London, 1956, 1966

and the following periodicals:

Alphabet & Image
The Fleuron
The Imprint
The Monotype Recorder
Penrose's Annual
Signature
The Newberry Library Bulletin
The Journal of Typographical Research

Index

At a book exhibition in 1961:
Morison with Sir Francis
Meynell; and, below, a rare
photograph of Morison smiling,
taken by Beatrice Warde in
May 1963.

Morison with Beatrice Warde in
the garden of her Epsom, Surrey,
home during the 1940's.
Below: Morison on his way to
receive his honorary doctorate
at Cambridge in 1950.

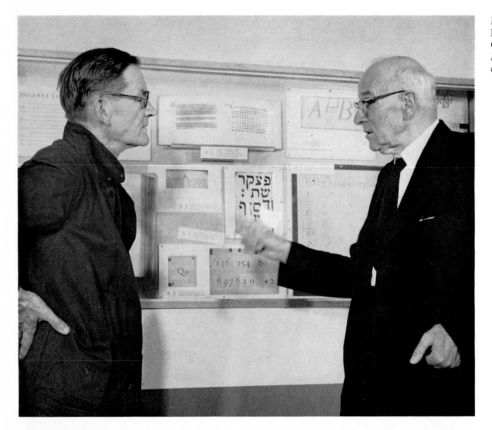

Morison discusses an exhibit with Harry Carter, archivist of the Oxford University Press, at the *Printing and the Mind of Man* exhibition 1963.

Morison looking at the grave of Karl Marx in Highgate Cemetery, 1952.

ST. MARY'S COLLEGE OF MARYLAND LIBRARY
ST. MARY'S CITY, MARYLAND

C59823